# Why Art Photogra

Contemporary art photography is paradoxical. Anyone can look at it and form an opinion about what they see, yet it represents critical positions that only a small minority of well-informed viewers can usually access.

*Why Art Photography?* provides a lively, accessible introduction to the ideas behind today's striking photographic images. Exploring key issues such as ambiguity, objectivity, staging, authenticity, the digital and photography's expanded field, the chapters offer fresh perspectives on existing debates. While the main focus is on the present, the book traces concepts and visual styles to their origins, drawing on carefully selected examples from recognized international photographers. Images, theories and histories are described in a clear, concise manner and key terms are defined along the way.

This book is ideal for anyone wanting to deepen their understanding of photography as an art form.

**Lucy Soutter** is a photographer, critic and art historian. She is a tutor in the Department of Critical and Historical Studies at the Royal College of Art. Her writings on contemporary art and photography include essays in *Girls! Girls! Girls! in Contemporary Art* (2011), *Appropriation* (2009) and *Role Models: Feminine Identity in Contemporary Photography* (2008).

# Why Art Photography?

by Lucy Soutter

Routledge
Taylor & Francis Group

LONDON AND NEW YORK

First published 2013
by Routledge
2 Park Square, Milton Park, Abingdon OX14 4RN

Simultaneously published in the USA and Canada
by Routledge
711 Third Avenue, New York, NY 10017

*Routledge is an imprint of the Taylor & Francis Group, an informa business*

*British Library Cataloguing in Publication Data*
A catalogue record for this book is available from the British Library

*Library of Congress Cataloging in Publication Data*
Why art photography? / Lucy Soutter.
pages cm
1. Photographic criticism. 2. Photography, Artistic. I. Title.
TR187.S68 2012
770- -dc23
2012030670

ISBN: 978-0-415-57733-5(hbk)
ISBN: 978-0-415-57734-2(pbk)
ISBN: 978-0-203-13058-2(ebk)

Typeset in Sabon
by Taylor & Francis Books

MIX
Paper from
responsible sources
FSC
www.fsc.org   FSC® C004839

Printed and bound in Great Britain by
TJ International Ltd, Padstow, Cornwall

# Contents

# Illustrations

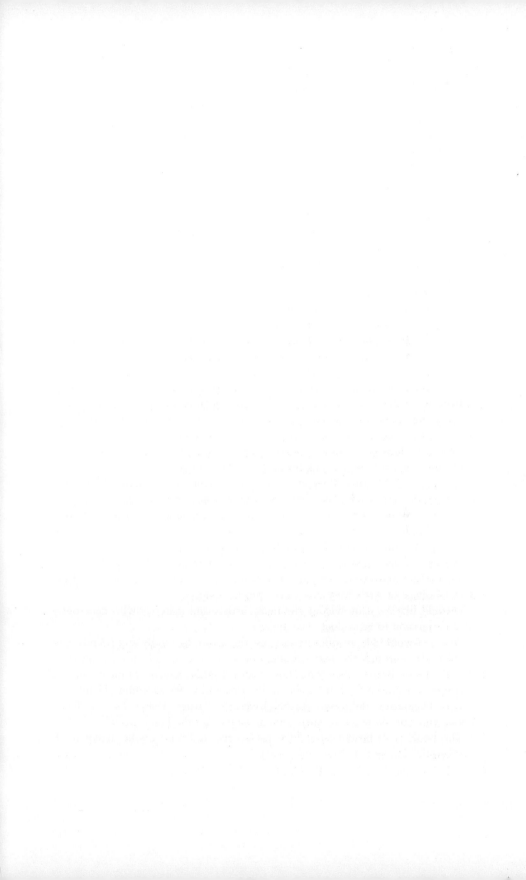

# Acknowledgements

This book could not have been written without the enduring enthusiasm and curiosity of photography students. I would like to offer my warm thanks to the many students and fellow staff members who contributed to the development of my ideas at the London College of Communication, the Royal College of Art and the Sotheby's Institute. In return, I hope that the text will offer some measure of understanding, encouragement and permission to those who make and enjoy photographs. I could not have undertaken the task without the example of the wonderful teachers I have had, especially Christopher James who taught me how to be a photographer, Suzanne Keen who gave me the courage to approach any text, Allan Sekula who opened a whole world of ideas, Johanna Drucker whose writing continues to inspire me and Jonathan Weinberg whose intelligent, compassionate history of photography lectures provided a model for my teaching.

I am very grateful to all those who helped to bring this book to fruition. Richard West commissioned the article that became the Introduction for *Source The Photographic Review* 53 (winter 2007). Kind friends and colleagues read drafts and provided comments along the way: Sarah Thornton, Juliet Hacking, Cassandra Albinson, Deirdre King, Frank Rodrigues, Peter D. Osborne, Alison Green, Rob Davis and Martina Margetts. My special thanks to Catherine Grant and Francis Summers whose last-minute suggestions were enormously helpful. Ginny Garramone and Tracie Davis gathered research materials. Heather Briant helped me to find my way to the finish line. My editorial team at Routledge – Natalie Foster, Ruth Moody, Liz Hudson, Stacey Carter and Eileen Srebernik – shepherded me through the process with grace. My thanks also to Jamie Gilham and David Crowley who helped me to access the support of the Royal College of Art's Research Development Fund.

I would like to acknowledge the many artists and galleries who generously gave permission to reproduce their images.

Finally, I would like to offer my deepest thanks to the family and friends who stood by me through the many months of writing, especially my parents and sisters, Honor Barber, Deborah Daly, Valija Evalds, Simeon Hunter, Marina Chatterton, Natasha Shapiro, Rebecca Flatters and Clare Sandling. Thank you also to Hannah Shambroom, Rachel Jones, Jo Barnes, Dekyi Tsomo, Jenna Cooke and Kate Warren for their vital assistance on the home front.

The book is dedicated with love to George and Violet who make it all worthwhile.

# Introduction

## Why Art Photography?

Contemporary art photography is paradoxical. Anyone can look at it and form an opinion about what they see. Yet it usually represents aesthetic and theoretical positions that only a small minority of well-informed viewers can access. This book is designed to bridge the gap between the remarkable photographic images being made today and the debates that underpin them. Each chapter provides a fresh twist on a discussion current in the field. Because the author is a photographer, critic and art historian, the essays reflect the concerns of makers as well as audiences and investigate how photography fits into the bigger picture of contemporary art and culture. This is an insider's guide, designed to empower readers to develop their own opinions about what is happening on the cutting edge of contemporary photography.

The chapters present major cross-currents in photography today and explain some of the ways in which value and meaning are assigned by key figures and institutions defining the field. They explore the broad spectrum of forms that contemporary photographic work may take (ranging from classic silver or C-type colour prints to appropriated imagery, text and image pieces, book works, mixed-media installations, performance documentation, web-based projects and combination forms, both digital and analogue). The introduction examines the different contexts in which photography operates as art. This section of the book also questions the purpose of art photography as described by critics and art historians. Although necessary for understanding the field, these issues are rarely discussed directly in texts on photography.

### The handbag question: value and meaning

What is the difference between an art photograph and a designer handbag? I pose this rhetorical question to my photography students from time to time. It is a crude provocation but opens up an important discussion about how and why we value photographs as art. The room polarizes sharply. Knee-jerk, common-sense-based responses gradually unfold into more complex positions. The students fall into roughly four camps on the relationship of photography to commercial culture. Some are natural modernists; they believe that an art photograph has aesthetic, expressive and craft value for its own sake and that it is

inherently more precious than a mass-produced fashion accessory. Others are critical realists. They argue that photography's function is to tell important social and political truths, whereas an expensive handbag is a mere frivolity; for them, the "art" potential of photography is secondary to its power to communicate. There is usually a small group we could call fashionistas who hold the view that the commercial fashion industry makes an important contribution to individuals' identity formation. These students may value the handbag more highly, unless the photograph is also concerned with aspects of experimental design and visual self-expression. Other students are cynics; as far as they are concerned, the photograph and handbag are only worth whatever someone is willing to pay for them, with contemporary art and fashion both at the mercy of booming international markets. All of these students are right in their own ways, and it is my job to help them to see each other's point of view. As an academic, it is also my task to introduce them to a broader range of debates – aesthetic, philosophical and political – that no casual viewer of photographs could glean without extensive reading or an expert guide.

The handbag question, as we could call it, helps students to articulate their own relationship to photography as art. For some of them, this may be the moment that they begin to identify themselves as art photographers or artists using photography (and to wrestle with the semantic confusion of these interlocking terms, to be discussed below). For others it is a defining moment of rejection, in which they choose to distance themselves from the use of photography within the institutional settings of art. Some will go on to work in fashion, advertising or entertainment and will leave art concerns largely behind them. From an educational standpoint, one of the reasons I pose the question is to make my own position clear, so as not to sweep the students along in my own personal net of taste and ideology. Yes, I am a believer in art photography – but it is not a matter of blind faith.

If art photography has value in our culture beyond its market price, what might that value be? Do we believe that there is "work" to be done by photographs within an art context? Is such work expressive, critical, or something else? And how do photographs go about doing such work? This introduction explores a range of possible answers to these questions. Issues raised by the handbag question – aesthetics, ethics, desire and market forces – will all play into my account. Along the way I will also discuss the ongoing tension between modern and postmodern positions, both still prevalent, though often taken for granted or repressed.

## Art photography vs. photography as art

Contemporary art photography has a number of tangled strands that are difficult to tease apart and often overlap in the work of a single image-maker. The different practices are categorized partly by the way they look and also by the constantly shifting ways they are framed by language and institutions. As with all other forms of art, the chief characteristics that define art photography are

the intentions of the maker, its similarities to other forms of art and the context in which it is presented. The distinction between art photography and photography-as-art has now largely collapsed, but it is still useful to identify some of the different ways in which photographers have engaged with the idea of art historically, as they provide points of reference for many of the works that will be discussed in the following chapters.

Since the 1830s, photographs have been made by established and aspiring artists who have attempted to make them look like art and placed them into art contexts. One of the most basic strategies for photographers wanting their work to be read as art has been the use of traditional genres from painting, including portraiture, the nude, landscape and still life. The term "genre" (to be discussed at greater length in Chapter 1) refers not only to subject matter but also to a set of pictorial conventions that allow audiences to recognize a particular type of image as art. Would-be art photographers in the nineteenth century also concerned themselves with many of the same debates that preoccupied painters, around issues such as beauty and truth. Artistic subject matter and elevated ideas were not enough in themselves to validate photography as an art form. Throughout the twentieth century, a small but steady procession of photographers, curators and critics on both sides of the Atlantic wrote persuasive essays on the subject. In the USA, this strand of modernist practice was spearheaded by Alfred Stieglitz and came to be known as fine art photography or simply art photography.[1]

In fine art photography, subjects from the most exalted to the most banal are transformed into pictures via the special properties of the photographic medium. This mode usually privileges the sensibility of the individual photographer, his or her own unique vision. Some photographers still work proudly within this modernist tradition, placing an emphasis on the formal and expressive properties of their images and the technical excellence of their prints.[2] When images originally made for some other purpose are drawn into an art context, it is often because they are seen as overlapping with the values of fine art photography.

While some art photographers have focused on photography as medium, many artists using photography have felt no need to isolate it as a separate form or activity. In Europe in the 1920s and 1930s, photography was part of a larger explosion of creative experimentation. Surrealists such as Man Ray or Hans Bellmer mixed photography with painting, printmaking and sculpture, creating single images, collages and composites that challenged conventional art forms while also confronting the conventional manners and outlooks of their day. Some of the most important, influential artists to work with photography in the twentieth century have been opposed to the very notion of art, explicitly rejecting fine art traditions. The language associated with photography by Soviet constructivist Aleksandr Rodchenko or Bauhaus instructor László Moholy-Nagy related to the medium's uniqueness, modernity and objectivity, rather than its merit as an art form. These avant-garde practitioners provide a touchstone for contemporary figures who prefer to frame themselves as artists using photography rather than as photographers.

The conceptual artists of the 1960s and 1970s embraced photography specifically because they did not associate it with art; they were looking for a kind of image that would be deliberately dull and ugly. If fine art photographers particularly value the viewer's aesthetic experience of the work's visual form, conceptualists such as Joseph Kosuth, Robert Barry or John Baldessari asserted an anti-aesthetic in which form was secondary to idea-as-art. There is a vast, complex literature about the role of the aesthetic in art. A key issue for this book's discussion is whether the aesthetic should refer primarily to the satisfactions we obtain from the visual properties of work (sidelined in much concept-based art), or whether it might be extended to other aspects of the works, such as the way they inform, transform, reveal, challenge, etc. The latter view, that ideas themselves may have aesthetic merit, has been prevalent in ambitious contemporary art since the 1960s.[3]

The artists and art historians who developed theories of postmodernism in the visual arts in the 1970s and 1980s followed in this path. Under the influence of German theorist Walter Benjamin and French post-structuralist theory, writers such as Craig Owens, Rosalind Krauss and Abigail Solomon-Godeau argued that the crucial task of art in the moment was to reflect back on the way that images make meaning.[4] As artist and writer Victor Burgin put it in his 1977 article, "Looking at Photographs:" "the photograph is a *place of work*, a structured and structuring space within which the reader deploys, and is deployed by, what codes he or she is familiar with in order to *make sense*."[5] Cut free of its modernist baggage, photography was seen as a perfect medium for enacting postmodern critiques of representation. Race, gender, sexuality, consumerism and various other cultural constructs came under scrutiny as part of this project. Work made with these ideas in mind asks viewers to develop a more active, combative relationship to official and commercial culture.

Postmodern theories brought a new level of seriousness and academicism to the study of photography. There was also playfulness in the postmodern embrace of eclectic styles and genres and in the transgressive shock of appropriation – images stolen from the culture and re-presented as if in quotation marks. A market for modernist art photographs had begun to develop in the 1970s. Large, colourful, visually dramatic and expensively framed, the postmodern work of the 1980s fed an exponential rise in the prices of photography as an art form. At the same time there was a puritan aspect to postmodernism, a purging of the modernist values of originality and authenticity, accompanied by a rejection of preciousness, craft and markers of personal expression. Although many of them work exclusively with photographs, artists working in this mould are not generally referred to as photographers, a distinction that marks their distance from a fine art photography tradition. The labels of "artist" or "photographer" are constructed by institutions and academic discourse. They can be seen as a form of cynical branding but also have a certain usefulness; they give us a sense of context and allow us to consider how different works are intended to be read – even if we choose to read them otherwise.[6]

Another key development in art photography in the late twentieth century has been the rise of large-scale images offering hyper-detailed and seemingly neutral serial views of categories of people, places and things. Technically, this work involves both a step back to large-format view cameras typical in the late nineteenth century and a step forward to the most state-of-the-art commercial printing and mounting facilities to produce images several metres across. Grounded in the influential teaching of Germans Bernd and Hilla Becher, these works are often discussed within the discourse of postmodernism. As we will see in Chapter 2, there is debate as to whether images by Thomas Struth, Candida Höfer, Frank Breuer, etc., should be read in relation to modernist visuality, postmodern criticality or in other more layered ways.

Academic photography programs can still be categorized by the degree to which they embrace the concept-driven, postmodern model of photography-as-art or continue to tolerate modernist values and aspirations. Photography students on their individual journeys of discovery are often baffled as they hit the invisible postmodern barrier. Some are disappointed when they discover that the subjective, expressive urges that brought them to photography in the first place are considered highly problematic within contemporary photographic education (an issue we will explore further in Chapter 4).

While much photographic art made since the 1980s has been led by ideas, aspects of visual – and specifically photographic – pleasure have persisted. At the same time as Richard Prince and Sherrie Levine made use of appropriation, other practitioners, less resistant to the label "photographer," were making work that explored issues around representation while also engaging with visual aspects of photographic aesthetics. Robert Mapplethorpe, for example, took advantage of the lyrical potential of platinum printing to address issues of sexual identity. Nan Goldin and Andres Serrano, among others, forged a new aesthetics for large-scale colour photography, using big grain and large areas of shiny darkness in previously unforeseen ways, underpinning confessional or shock-based content that transgressed cultural norms. Jeff Wall pioneered a new form within photography-as-art – the lightbox – to heighten the visual appeal of his large staged *tableaux*. This commercial form is far removed from the subtlety of traditional silver prints, yet Wall's work builds on modernist ambitions in claiming a grandeur and seriousness for photographs as art objects. Wall is interested in all the ways in which meaning can be constructed and communicated within photographs; he is also very much invested in the making of pictures. His conceptual framework for staging the photographs in relation to painting, social history and critical theory has allowed him to raise the production values of the work to commercial standards while projecting a sense of intellectual engagement.

## The importance of context

The context of photographic work is just as important as its appearance or subject matter in determining how it will be understood. Photographs with a

more formalist, modernist orientation tend to circulate in specialist photography galleries and fairs. The broader art world regards this photographic culture as somewhat insular and limited in outlook. A successful photographer who accrues critical attention and market value may graduate from an art-photography context to the institutions that exchange and promote photography within contemporary art, generally for higher prices. There is certainly overlap between the worlds, but distinctions remain. Whether fine art photographers, or contemporary artists using photography, the majority of practitioners discussed in this book are committed to photography as a serious field of enquiry, full of visual and intellectual satisfactions. They are united in regarding photography as a medium that is tied to the world but flexible in its relationship to appearances, and independent in its production of meaning. Throughout the book I will refer to these various strands of photographic practice with the umbrella term "art photography," though I will occasionally return to the distinctions between the different camps.

The model of art photography I have set up is very Western and operates on a New York–London–Düsseldorf axis. This has been the main orientation of photographic institutions, markets and scholarship for the past three decades. Photographic aesthetics read differently depending on their cultural context. In eastern Europe under Communism, for example, a melancholic mode of black-and-white photography was coded as a form of resistance against an official aesthetic of socialist realism. Czech photographers such as Jan Svoboda worked this way in the 1960s and 1970s, drawing on both conceptual art and surrealism. A contemporary Czech photographer, Marketa Othova, draws on these precedents, and the style of her work would become difficult to read for viewers unfamiliar with a Czech context. In Japan, Iran, India or any number of other specific cultural contexts, photographic aesthetics have a life of their own. A mode of art photography that seems culturally exhausted in one place or at one moment may provide a unique way of communicating in another. Over the next decade, the conversation about art photography will become far more international. I predict, however, that many of its established terms and debates will continue to be important, even as they are transformed in various contexts.

## Contemporary concerns

As we will see over the course of the book, modern and postmodern aspects persist and combine in different ways in contemporary work. As well as exploring these crosscurrents, the chapters set out to identify concerns that are particular to photography in the current moment. Chapter 1, "Hybrid Genres: Portraiture," examines some of the ways in which traditional genres of picture-making such as portraiture and the nude are being reconfigured in combination with conceptual strategies; this hybridity (and the ambiguity it generates) is a key characteristic of contemporary practice. Chapter 2, "Objectivity and Seriousness," unpacks the dominant "deadpan" aesthetic, investigating photographic objectivity in relation to ideas of disinterestedness, criticality and

banality. Chapter 3, "Fictive Documents," explores the way in which constructed imagery has come to be a valid tool for documentary practice, resting on the assumption that "truth" is just another man-made construction. Chapter 4, "Authenticity," looks at the way in which contemporary photographers are negotiating and performing subjectivity, exploring the "I" of the photographer while acknowledging postmodern ideas about the constructed, de-centered self. Chapter 5, "Digital Dialogues: Spectacle and Spectators," examines the way in which the digital turn has allowed some photographers to compete head-on with commercial culture for the first time, while others engage more explicitly with the materiality and social uses of new technology to reflect back on contemporary culture and our conditions of looking and being. Chapter 6, "Beyond Photography," discusses ways in which photography is being used as a medium within contemporary art more broadly, in ways that extend and transform our notion of the photographic. While the separation between photography and other art forms may have eroded, the conclusion argues for the continuing relevance of thinking about contemporary work in photographic terms.

We live in an era of choice. We have a palette of interpretive or critical screens available to us for viewing photography. There are as many approaches for interpreting photographs as there are ways of photographing the world. How do we decide? Where do we begin? Each of the chapters of this book offers an argument about an area of contemporary practice. The specific examples and the selection of themed debates are somewhat arbitrary. I could have chosen to drop in at any point in the discussion in order to begin building a sense of the big picture.[7] The case studies I have selected are ones that have arisen out of my own curiosity, passions and irritations and ones that have been brought to my attention by students. It is my hope that readers will use the book as the start rather than the end of their explorations.

## The arguments against art photography

To its detractors, art photography is elitist, pretentious, irrelevant, self-indulgent and even misleading – a kind of distortion of photography's proper function as a democratic medium for depicting the world we inhabit. These accusations sometimes cross over and attach themselves, *ad hominem*, to the photographer, critic or art historian who takes up the art-photography torch. The opponents of photography as an art form come from a number of different constituencies. Although the more intellectual detractors would distance themselves from the philistine view that photography is too easy and direct to be used for artistic purposes, the more subtle arguments against art photography still rest on a commitment to photography's relationship to reality. At stake are fundamental questions about what photography is, what it ought to be doing and how it ought to be disseminated and received.

Some writers are downright hostile to an art-based approach. For them, the specialized nature of art photography is at odds with the ubiquity of the medium as a whole. One of the criticisms of an art-historical approach to

photography is that it displaces and distorts photographs made for non-art reasons – the vast majority of photographs in existence. Writers such as Christopher Phillips and Geoffrey Batchen draw on social history, cultural studies and visual studies to describe violence done to the meaning of anonymous or vernacular images when they are shoehorned into elite museum collections such as that of New York's Museum of Modern Art and art-oriented texts such as Beaumont Newhall's influential *History of Photography*.[8] Such images, they argue convincingly, benefit from being studied from a more heterogeneous, interdisciplinary point of view. They find these non-art images fundamentally more interesting and illuminating.

Some writers are uncomfortable with the idea of art photography because they view the photographic medium as inherently voyeuristic, a form of image-making that preys on people, places and things with a kind of violence. Critic Susan Sontag emphasized this aspect of photography in her writing.[9] Art historian Benjamin Buchloh has gone even further in his critique of the medium, arguing that photographs cannot help reducing their depicted content to object, fetish and spectacle.[10]

## Art values

On the other side of the fence, some art historians and critics argue that it is in working out what is at stake, in negotiating the terms and terrain of the art debate, that art photography can make a valuable contribution to culture. Art may not bring about a people's revolution, but there may still be some worth in the notion of art activities that provoke contemplation, self-reflection and possibly resist the relentless pull of consumer capitalism. In his 1996 book *Modern Art in the Common Culture*, Thomas Crow admits that the radical ambitions of the artistic avant-garde are never fully realized: "Culture under conditions of developed capitalism displays both moments of negation and an ultimately overwhelming tendency toward accommodation."[11] For Crow, art's ongoing value lies in the way it struggles to maintain an independent identity for itself, even while being swallowed up by the market. For art is not addressed to the market but to audiences, who are diverse and constantly changing. On the one hand, the discourse about art is ever more abstract and specialized; on the other, contemporary art and photography exhibitions attract ever larger new audiences.

In his 1985 book, *Patterns of Intention*, art historian Michael Baxendall provides an extremely eloquent rebuttal to the oversimplified economic analysis of art. I quote at length because the web of interconnecting motivations that he describes for the making of paintings has direct relevance for the discussion of photography as art:

> In the economists' market what the producer is compensated by is money: money goes one way, goods or services the other. But in the relation between paintings and cultures the currency is much more diverse than just

money: it includes such things as approval, intellectual nurture and, later, reassurance, provocation and irritation of stimulating kinds, the articulation of ideas, vernacular visual skills, friendship and – very important indeed – a history of one's activity and a heredity, as well as sometimes money acting both as a token of some of these and a means to continuing performance. And the good exchanged for these is not so much pictures as profitable and pleasurable experience of pictures. The painter may choose to take more of one sort of compensation than of another – more of a certain sense of himself within the history of painting, for instance, than of approval or money. The consumer may choose this rather than that sort of satisfaction. Whatever choice painter or consumer makes will reflect on the market as a whole. It is a pattern of barter, barter primarily of mental goods.[12]

Of course it is not only art that participates in this kind of significant, pleasurable system of mental barter. Some people spend their time thinking about poetry, ceramics, computer games or haircuts. To some extent, all of these cultural forms – along with handbags – can carry symbolic as well as exchange value, can relate both to everyday life and to abstract ideas and can employ appropriation, intertextuality and a mixing of high and low forms of culture. But do they do it as well as art photography? To conclude this discussion, I will return briefly to the handbag question, and to the relative merits of the handbag and art photograph within contemporary culture.

## Criticality and complicity

Over the past few years, a legal battle has unfolded in France, in which Moët Hennessy Louis Vuitton, the world's largest luxury goods maker, has fought for the right to open its flagship store on the Champs-Élysées on Sundays. Under French law, this privilege is reserved for businesses that offer their customers some sort of cultural experience. This follows a traditional modernist assumption that culture is a more worthy endeavor than commerce, with art's value derived from its independence and potential criticality of the commercial domain. In summer 2007, the handbag-maker ensured a favorable ruling on Sunday trading by launching a small contemporary art space within the shop. The inaugural exhibition at Espace Louis Vuitton, of video and photographic work by artist Vanessa Beecroft, saw contemporary art and commerce at their most symbiotic.

As with many contemporary artists, Beecroft works across several different forms. In the Vuitton work, the videos and photographs were documents of a performance she had staged at the original opening of the shop in 2005. In *Alphabet Concept VBLV* (see Fig. 0.1), black and white female models, dressed only in make-up and pastel-coloured wigs, are arranged on the floor, their bodies forming the crossed L and V of the Louis Vuitton logo. The photograph is as visually seductive as a top-budget advertisement. Unlike 1970s

*Figure 0.1* Artist Vanessa Beecroft and Louis Vuitton's European President, Jean-Marc Gallot, standing beside a photograph from Beecroft's series *Alphabet Concept VBLH*, 30 September 2006. (Beecroft's series has since been withdrawn following a copyright challenge from Dutch graphic designer Anthon Beeke, whose *Nude Alphabet* of 1970 uses bodies to create letter forms.) Photo: Peer Grimm.

performance art, in which the documentation was a shabby afterthought, Beecroft's work places equal emphasis on event and image. Shot from above, and brightly lit, the final form of the photograph was clearly integral to the conception of the work.

On one level, the piece operates as branding: idealized female bodies promote the Louis Vuitton label (and the Vanessa Beecroft label, hence the title *VBLV*). For viewers trained in contemporary art, particularly postmodern critiques of representation, the work kicks up a number of disturbing questions about gender, race and consumerism. Part mannequin, part clown, part doll, these figures draw attention to the way in which the culture industry turns women into consuming, consumable objects. As a commission, exhibited in a commercial space, the work is surely more affirmative than it is critical of fashion or advertising. Yet the photograph is not straight advertising, it is art. In the gap between these two contexts a small space opens up for reflection. By being called art, by being framed institutionally as art and by relating to previous works of art, this photograph claims greater cultural significance than a handbag. It may not be good art, and not every viewer will like it. But it participates in a rich and well-established field of endeavor.

Among other things, art photographs are elite commodities, status symbols. Yet each one also represents a set of risks taken. In order for one image to be significant, expressive, critical, provocative, etc., there must be others that fail to be these things. Whether one views the Beecroft photograph as a success or failure is a matter of training, politics and taste. In my view, this particular image is repellent – like a drink with too much sweetener in it – but also fascinating in its visual punch and its deranged complicity with Louis Vuitton branding. (Do LV customers really aspire to such an image?) I view it as effective in that it functions as a kind of art parasite. It feeds on the commercial host while retaining its own perverse agenda.

While many artists like to think of themselves as playing oppositional roles, the culture and its institutions rely on them to do so. In her 2005 book *Sweet Dreams: Contemporary Art and Complicity*, Johanna Drucker describes this state of affairs in terms of a collapse of the model of criticality in contemporary art.[13] Yet Drucker argues that while the vast majority of contemporary art is fully complicit with the status quo, it may still have important things to do and say. Over the past few years, contemporary art has moved closer to entertainment and commercial culture, once seen as its antithesis. Along the way, interestingness and complexity have come to be seen as values in their own right, and visual pleasure has come to be regarded as empowering. This book will examine these shifts as well as works that continue to resist them.

The different constituencies within art photography are constantly at odds with each other. Many modernists are appalled by what they perceive to be the cold blankness of the deadpan typologists (photographer Christopher James calls them "the boring postcard people"). Postmodernists revile the makers of expressive or process-based photography as romantic and clichéd. Contemporary artists using photography want to escape from the confines of the

art-photography ghetto. Fine art photographers resent artist-photographers for being paid more money for their work (especially since it has usually been printed by somebody else). Yet for all the differences among their makers, the photographs have far more in common with each other than they do with other forms of cultural production. The manifold forms of art photography share a language, history and body of ideas far richer than handbags can ever hope to achieve.

## Notes

1 Several early contributions to the art photography debate (including an essay by Alfred Stieglitz) can be found in Alan Trachtenberg, *Classic Essays on Photography* (Stony Creek, CT: Leete's Island Books, 1980). There are many excellent histories of photography providing a broader context for this discussion. See, for example, Mary Warner Marien, *Photography: A Cultural History* (London: Laurence King, 2010).
2 For recent texts particularly sympathetic to the formal, process-based and expressive aspects of photography, see Robert Hirsch, *Seizing the Light: A Social History of Photography* (New York: McGraw-Hill Higher Education, 2009) and Christopher James, *The Book of Alternative Processes*, 2nd edn (New York: Delmar, 2008).
3 For an accessible discussion of the aesthetic in conceptual art, see Peter Goldie and Elisabeth Schellekens, "Aesthetics and Beyond," in *Who's Afraid of Conceptual Art* (London and New York: Routledge, 2009), pp. 80–107.
4 This approach was exemplified by the critical essays collected in Brian Wallis (ed.), *Art After Modernism: Rethinking Representation* (New York: New Museum of Contemporary Art, 1984).
5 Victor Burgin, "Looking at Photographs," in Victor Burgin (ed.), *Thinking Photography* (London: Macmillan, 1982), p. 153.
6 For a discussion of the construction of the term "art photography," see Alexandra Moschovi, "Changing Places: The Rebranding of Photography as Contemporary Art," in Hilde Van Gelder and Helen Westgeest, eds., *Photography Between Art and Politics: The Critical Position of the Photographic Medium in Contemporary Art* (Leuven: Leuven University Press, 2008), pp. 143–52.
7 The structure and format of this book limits the number of illustrations. One affordable volume offering a broader range of contemporary imagery in relation to parallel issues is Charlotte Cotton, *The Photograph as Contemporary Art*, 2nd edn (London: Thames & Hudson, 2009).
8 See, for example, Christopher Phillips, "The Judgment Seat of Photography," in Richard Bolton (ed.), *The Contest of Meaning: Critical Histories of Photography* (Cambridge, MA: MIT Press, 1993), pp. 14–47, and Geoffrey Batchen, "Dividing History," *Source: The Photographic Review*, 52 (autumn 2007): 22–5. Both take issue with formalist histories such as Beaumont Newhall, *The History of Photography: From 1839 to the Present* (New York: Museum of Modern Art, 1994).
9 Susan Sontag, *On Photography* (New York: Farrar, Straus & Giroux, 1979), and *Regarding the Pain of Others* (New York: Farrar, Straus & Giroux, 2002).
10 See "Interview between Benjamin H. D. Buchloh and Thomas Struth," in *Thomas Struth: Portraits* (New York: Marian Goodman Gallery, 1990), pp. 29–40.
11 Thomas Crow, "Modernism and Mass Culture in the Visual Arts," in *Modern Art in the Common Culture* (New Haven, CT: Yale University Press, 1996), pp. 3–37, at p. 37.
12 Michael Baxendall, *Patterns of Intention: On the Historical Explanation of Pictures* (New Haven, CT: Yale University Press, 1985), p. 48.
13 Johanna Drucker, *Sweet Dreams: Contemporary Art and Criticality* (Chicago, IL: University of Chicago Press, 2005).

# 1 Hybrid Genres

## Portraiture

The subject matter of a contemporary art photograph is usually easy to identify: whether it is a petrol station, a seascape, or a man with a hyena on a leash, we can usually name it. It is possible to take the work at face value – to assume that what is shown is the most important feature. But to insist on reading photographs literally is to miss out on a tremendous richness of ideas, especially in work made over the past few decades. Photographs communicate meaning in all sorts of different ways, with subject matter being only the most obvious. This chapter is designed to open up works to richer interpretations, in dialogue with those of makers, critics and historians. For after all, don't we want photographs to be able to do more than just point to things in the world that remind us of something we already know?

Art photographers have frequently used genres from painting, such as portraiture, still life or landscape, to trigger a sense of recognition and kick off viewers' process of interpretation. In our current era of eclecticism, many photographers now employ hybrid forms of recognizable genres, working against the grain of their original purpose and meaning. The resulting images have a seductive surface layer that operates like modernist photography, underpinned by layers of conceptual subtext. This chapter examines portraiture as a case study of this approach. It focuses on works that foreground the human figure, playing off the expectations of portraiture while overlapping with other art genres such as the nude and non-art genres such as soft-core pornography, fashion photography and the snapshot. As well as fascinating faces and figures, these works by Zoe Crosher, Katy Grannan and Collier Schorr draw on key strategies from conceptual and postmodern art to generate a deliberate ambiguity that is decidedly contemporary. The discussion will encompass three flashbacks to key moments in the history of art that have become particularly relevant to contemporary art photography: Marcel Duchamp's readymades, the conceptual art of the 1960s and the postmodern art of the 1980s.

Genres are the sets of codes used to identify and classify different forms of cultural production including literature, painting and film.[1] They operate as containers for content. Each genre offers conventions within which artists and writers can produce works that audiences will know how to decipher. Rule-bound, genres are inherently academic; they are discussed primarily in the

teaching and evaluation of art forms. Yet audiences recognize genres without any special training or effort. As we flip channels on the television it takes only a split second to identify the clichés of a soap opera, a game show or a western. In a culture obsessed with novelty, we might think that old-fashioned genres would fall by the wayside, to be replaced by entirely new forms. In fact, artists have returned to familiar genres again and again, both to satisfy the expectations of viewers and also to smash them.[2] In either case, the very notion of genre implies a relationship of complicity between the viewer and artist or reader and writer. Genres are also a way of entering into dialogue with history: the artist does not make them up but borrows them from the prevailing culture and from the history of their art form. Combining two or more genres into a hybrid form is an immediate way to introduce complexity to the work, inviting the viewer to connect the work to other ideas in the culture.

The main focus of traditional portraiture is the individual, the person depicted. The portrait is a site of identification and projection, inviting us to relate ourselves to the person or people in the image. We know that a portrait captures a person in just one of their many possible states, and we judge artists in part by their ability to select a representative face for the individual. Portraits can be particularly effective in a series, as when a court painter developed a long-term relationship with a particular monarch (as with Diego Velázquez and King Philip IV of Spain) or when a photographer works repeatedly with a family member or lover (as in the case of Alfred Stieglitz and Georgia O'Keeffe). Art historian Richard Brilliant describes portraits as purposeful constructions that present a particular proposition about a person, aiming to elicit a psychological response from the viewer. While it is helpful if the portrait offers recognizable aspects of sitters' appearance, it is even more important that it offer a sense of their social identity, a sense of what they are "like."[3] The success of a traditional portrait thus rests on its ability to stand in for the person, for the way we see them in the present, and the way we will remember them in the future. We know from experience how easy it is to take a picture that *fails* to capture the essence of a person. Postmodern theories of identity reject the idea of essence altogether, proposing that identity is a more constructed, patchwork project.[4] The portraits in this chapter oscillate back and forth between notions of fixed and fractured identity. On the one hand, they present us with identities that are being constructed and performed before our very eyes. At the same time, these contemporary works retain a kind of faith in the ability of a photographic portrait – even (and perhaps especially) a snapshot portrait – to capture aspects of subjective experience.

Snapshots lie at the heart of "The Reconsidered Archive of Michelle duBois," a particularly slippery portrait project by American artist Zoe Crosher. From 2008 to 2011, Crosher developed a composite portrait of a woman called Michelle duBois, a flight attendant and part-time escort in the 1970s and 1980s. Over numerous exhibitions and a set of artist's books, Crosher has drawn on an archive of vintage amateur images and memorabilia which she claims to have been given by duBois herself.[5] The artist presents items from the archive in

a variety of ways, often re-photographing them, framing them and arranging them in groups. Several aspects of the story are plausible; the images themselves are convincingly intimate, sleazy and varied. They show a young woman performing her femininity and sexual availability in a catalogue of ways. In Crosher's blown-up re-presentations of Polaroids and other period formats we see duBois in flamboyant outfits, wearing wigs and make-up, squeezing her upper arms inwards to enhance her cleavage and pressing herself up against a series of male companions.

The project has disturbing aspects that disrupt the voyeuristic pleasure of looking at someone else's personal snapshots. For example, in the "Polaroided" series, the skin of duBois's companions has been blacked out crudely. In images such as *Looking Away* (Fig. 1.1), the ink covers up the male figure's individual identity and also his race. Crosher offers no explanation for this defacement. We have no way of knowing whether, for example, the gesture reflects a desire to preserve the anonymity of the man, to diffuse duBois's memory of a failed love affair or merely to heighten the visual impact of the image.

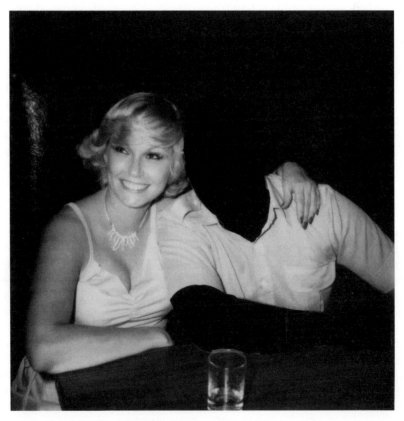

*Figure 1.1* Zoe Crosher, *Looking Away* (2008) from the series "Polaroided, The Unravelling of Michelle duBois."

Although, in theory, amateur photographers have total freedom in their image-making, in practice, snapshots tend to fall into very predictable types. DuBois appears to be a very colorful character, yet the images that record her life have the repetition and cliché characteristic of the amateur snapshot, a form French sociologist Pierre Bourdieu describes as "stilted, posed, rigid and contrived."[6] Paradoxically, the very familiarity and predictability of snapshots is what makes them read as authentic. With its familiar pose and unremarkable setting, *Looking Away* has the feeling of a genuine snapshot, a moment drawn from the everyday life of a couple. The blacked-out face and arm of the male figure inject a sinister ambiguity, all the more ambiguous because we do not know if the gesture belongs to duBois or Crosher.

If the images Crosher presents are convincingly snapshot-like, other aspects of the duBois project suggest that we are dealing with a fictional character. DuBois looks so different from image to image that we cannot even be certain she is always the same person. She has a number of pseudonyms, which are presented in a set of signatures forged by Crosher. The costume changes and postures in the images are strongly reminiscent of Cindy Sherman's famously staged self-portraits. And, indeed, Crosher's previous work has involved constructed identities and has played explicitly on Sherman's fictions. Whether or not the duBois archive is genuine, this is a very strange portrait. Rather in the way that we learn about celebrities through a medley of media sources, we can only develop interest or empathy for duBois in small snatches. Our sense of duBois as a person is fragmented, schizophrenic. DuBois is largely overshadowed by Crosher in her combined role as curator, archivist, artist and fan. The project as a whole is shot through with an acute self-consciousness, manifested in the details of Crosher's re-photographing, enlarging, cropping and campy titling (another series of Polaroids of duBois with various men is entitled "Obfuscated Mae West and the 1,001 Knights").

## Subtexts and backstories

How ever did art photography get so evasive in its interpretation and open in its ethics? How did it come to rely so heavily on stories about what the photographer does or intends? How did ambiguity come to be seen as desirable? These are some of the key features of much contemporary art photography; while it has clearly available subject matter, it also has a conceptual subtext, usually reliant on the promotional writing that surrounds its presentation and the critical writing around its reception. The relationship between these texts and the images is loose – the viewer has to go and find them in order to read them – but is indispensable to the full appreciation of the work. It is taken for granted in contemporary practice that we may need to read around the work to understand it. For example, we would now be surprised to enter a museum exhibition that did not have both introductory text panels and wall labels for individual works. More perplexingly, it is common for important background information to be held in a kind of limbo-zone, accessed, for example, only

through conversation with a gallery assistant or by scouring the footnotes of catalogue essays. There is little written about this paradoxical state of affairs, in which the ideas that circulate around art photography are both necessary for interpretation and yet frequently difficult to access. This is one of the most important and underexplored aspects of contemporary practice.

## Autonomy vs. contingency

Clearly, this was not always the case. In modernist art photography, prevalent from the 1910s through to the 1970s, photographers made particularly active use of formal elements of picture-making, such as point of view, arrangement of elements within the frame and printing techniques, to nuance the subject matter of their images. Although such artistry was understood to contribute to the value of the image, it was usually regarded as inseparable from the self-explanatory content (as in Ansel Adams's sublime western landscapes). Modernist art photographs were meant to be autonomous, that is, to stand alone, without need for extra information. This is not to say that modernist images do not benefit from interpretation – photographic criticism came into its own in the modernist period – but the prevailing paradigm under modernism was that the best art photographs were entirely self-sufficient.

Henri Cartier-Bresson's approach exemplifies this interest in the autonomy of modernist photographs. Cartier-Bresson took many of his photographs as a professional photojournalist, reporting on conditions and events around the world in multi-image picture-stories. Yet he regularly republished single images from these stories in anthologies with little or no captioning, elevating them in the process from a context of journalism to art.[7] In his writing, Cartier-Bresson argued that people, places and events could best be understood through elegant patterns of light and dark shapes, and that at their best such images could capture the truth of situations without need for further explanation: "Sometimes there is one unique picture whose composition possesses such vigor and richness, and whose content so radiates outward from it, that this single picture is a whole story in itself."[8]

How did work like Crosher's come to deviate so much from this mid-century model of photographic value, to embrace open-ended seriality, multiplicity and internal contradictions? Contemporary artists using photography usually draw less on the history of their medium than on theories and practices from twentieth-century avant-garde art more broadly. While autonomy was celebrated within the art-for-art's-sake model of modernism, avant-garde movements throughout the twentieth century focused specifically on undermining autonomy in order to reconnect art and life with various levels of shock, challenging art as an institution and attempting to change the way viewers understood the experience of looking at art.[9] Three developments in this history are particularly pertinent to contemporary photography and bear looking at in some detail: Marcel Duchamp's readymades, the uses of photography in conceptual art of the 1960s and 1970s and the notion of textuality embraced in postmodern art of the late 1970s and

1980s. Each of these moments challenged the autonomy of art in a different way, proposing that artists and audiences view artworks as contingent on the way in which they are presented and interpreted. While contemporary art photographers do not necessarily reference these historical precedents explicitly, they rely on them to legitimate their work and to ensure that ambiguities are read as desirable complexity rather than as indecision, weakness or failure.

## The Duchampian turn

In the 1910s, precocious young cubist Marcel Duchamp abandoned painting and launched a lifelong attack on the notion of art. In the 1910s he started exhibiting store-bought household objects – such as a bottle rack, shovel and, most infamously, a urinal (Fig. 1.2). Each one was graced with an evocative title and inserted mischievously into a fine art context. The urinal, for example, was entitled *Fountain* and entered under the pseudonym "R. Mutt" in an un-juried exhibition in New York, from which it could not, in theory, be rejected. (The committee, in dismay, rejected it for not being art at all, knowing that they were caught in a trap and would be heaped with scorn for breaking their own rules. The offending object was hidden out of sight.[10]) Artists have turned to the readymade repeatedly, relying on its ongoing transgressive charge. Although Duchamp's operation – choosing a non-art object, titling it and insinuating it into an art context – is now familiar to the point of cliché, it remains one of the most contentious moves in art, attracting ongoing outraged accusations of "the emperor's new clothes," particularly in tabloid coverage of the arts from Carl André's bricks to Tracey Emin's bed.[11]

What does Duchamp's attack on traditional art forms mean for photography? First, it allows for the possibility that any photographic image, no matter how insignificant or visually uninspiring, can be assigned art value within an art context through the intention of the artist. To be properly Duchampian, the image ought to be found or stolen (he himself made an assisted readymade, *L.H.O.O.Q.*, by drawing a moustache on a postcard of the *Mona Lisa*).

While many contemporary artists include found images or objects in their work, the readymade also provides justification for artists to make their own non-art or anti-art images from scratch and to thrust them into an art context. Duchamp's gesture lies at the foundation of Crosher's project. It matters less whether she has made or found the duBois snapshots than that they have been produced in the genre of amateur photography, allowing Crosher to place them in an art context while holding on to their seedy edge. Some writers argue that traditional portraiture has run its course, taught us all there is to know about conventional aspects of middle-class identity.[12] Crosher draws on Duchamp to make a portrait that is less a portrait of an individual than a hall of mirrors, a fun-house for thinking about the way in which women imagine and present themselves.

*Figure 1.2* Alfred Stieglitz photograph of Marcel Duchamp's *Fountain* (1917), as repro-
duced in *The Blind Man*, no. 2, 1917. Stieglitz photographed the urinal at his
291 gallery, following the 1917 Society of Independent Artists exhibition.

Katy Grannan's portraits are more traditional in offering single images of
particular subjects. Yet Grannan's work also bends and tests the conventions of
portraiture, in part by referencing other genres. Take, for example, *Tim,
b. 1981*, from her 2004 "Mystic Lake" Series (Fig. 1.3). In it we see a slim,
attractive black man in orange swimming trunks reclining in the shallows of a
clear lake. It is a dreamy, luminous image, with cool grey light reflecting off the
surface of the water and off Tim's skin. The figure is arranged diagonally so
that his toes point down to the bottom left corner and his slightly tilted head to
the upper right. Who is Tim, and what can we know about him from this
image? He appears calm and poised in front of the camera, as if graced with a

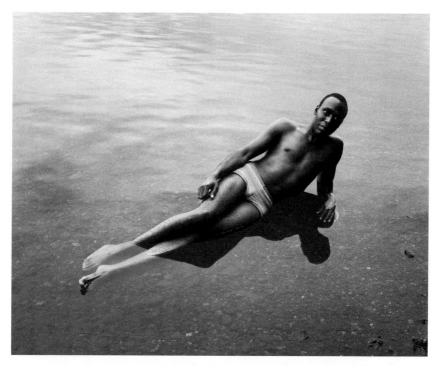

*Figure 1.3* Katy Grannan, *Tim, b. 1981* (2004), from the series "Mystic Lake."

certain confidence in his body. Rather than looking directly at the lens, he gazes slightly off to the right, perhaps looking for approval to the photographer standing beside her 4 × 5 view camera. This image tells us more about Tim's appearance than his personality. The semi-submerged composition is stylized, self-conscious, arty, like an assignment someone might shoot for an amateur camera club. While the recumbent pose comes straight from art history, the model does not blend comfortably into nature like a modernist nude by Edward Weston or Harry Callahan. In fact, this could be a fashion image; Tim's long slim limbs and handsome features could plausibly be those of a professional model, his bright, tight trunks by some sought-after designer. While the natural lighting of the scene is not in keeping with most fashion-magazine editorial images, it could be from an edgier indie fashion magazine.[13]

As with much contemporary work, the blurring of genres in Grannan's work makes more sense if we look at the whole series that includes this image and also at the photographer's broader project and approach. If we read around the work, we discover that Katy Grannan makes pictures that she describes as portraits, usually of strangers, using a particular working method designed to heighten and dramatize the relationship between artist and model; she runs short advertisements in local newspapers, seeking models to pose for a female art photographer.[14] This set-up contributes to an uncomfortable intensity

between the eclectic sitters and the photographer. Adults and children of both sexes, they pose singly and in pairs. There is usually something peculiar in their body language, as if they have been holding the position for longer than is comfortable. Tellingly, many of them mimic the poses of fashion models, pinups or porn stars, but without the physical perfection, charisma or gloss. They clearly expect to be seen, want to be seen and also convey a sense of vulnerability. These impressions are a function of the photographer's technique as well as the sitters' psychology; in "Mystic Lake," for example, most of the models have been photographed from the top of a stepladder, which has the effect of pinning them to the ground, eliminating any broader sense of their location. The result is striking pictures with a clearly recognizable style. These portraits tell us something about their sitters, about the culture of media and celebrity that has shaped them and about the photographer who has sought them out in this peculiar way.

Some photographic portraiture feels voyeuristic because we get the impression that the sitters would not have wanted to be portrayed in the way they have been. For example, Diane Arbus's and Richard Avedon's images can feel shockingly invasive and unkind, as if the photographers have been ruthless in imposing their own vision. Grannan's work is complicated by its conceptual subtext. She plays off the question of the collaborative portrait by letting it be known that this is how and where her sitters wanted to pose, this is what they wanted to wear (or not wear). Yet writing around the project indicates that like the stylist of a fashion shoot the artist stage-manages quite extensively to achieve her desired image.[15]

I once showed Grannan's work to a group of photojournalists – whose approach might be summarized as a commitment to depicting real-world situations responsibly. These individuals were flatly appalled by the idea that a photographer might invite a sense of collaboration with strangers only to override their wishes with her own agenda of making awkward, frequently unflattering images to present at large scale in a gallery context. They saw this as clear exploitation, a violation of the rules of documentary photography. The photojournalists were also disturbed by the way that information about Grannan's project circulated so loosely. For them, a key task of photography within journalism is to get text and image to tell a unified story. It seemed absurd to them that an artist would produce work whose meaning was reliant on outside knowledge floating vaguely out there in the world. But the terms of art photography are not those of photojournalism. As we will examine more closely in Chapter 3, breaking the tacit rules of documentary is one of the hallmarks of contemporary practice. As with the uncertainty about the authenticity of Crosher's duBois archive, the ambiguity of Grannan's relationship to her subjects is part of the point.[16]

To play devil's advocate, I could argue that it does not matter how we categorize the image of Tim, or to what degree it reflects how he might have chosen to represent himself. In some ways it is barely a portrait at all. Grannan has produced a striking, curious image, whose ambiguity holds the eye far longer

than average. As sophisticated contemporary viewers, we are fully aware that images (and their subjects) are constantly constructed and manipulated. This picture, and Grannan's project more broadly, draws its charge from these questions and invites us to place ourselves actively within the debate. The work rests on several assumptions common to all the examples in this chapter: art photography may rely heavily on external narratives; it can sustain contradictory interpretation and ethics; and the resulting ambiguities are part of the point.

## The conceptual shift

Contemporary art's reliance on external narratives can be traced back to the conceptual shift of the late 1960s and early 1970s. At a time of post-war political engagement, artists in western Europe and the Americas built on Duchamp's legacy to explore art without traditional objects, producing instead an art of actions, events, performances, systems, concepts and environments. Photographs were used to document these activities, generally rather casual, cheaply printed, black-and-white snapshots. In fact, this visual dullness helped viewers to understand that the art was not located in the picture but rather somewhere else. In this way, the anti-aesthetic activities of conceptual art spawned a kind of anti-photography that had little in common with fine art photography. Some contemporary artists such as Santiago Sierra still employ this gritty low-tech aesthetic in their photographic documentation. It has become far more common, however, for artists using photography to embrace a visual fullness, making large, detailed colour images – but to base these images on a conceptual rationale.

Certain conceptual artworks of the 1960s and 1970s were focused particularly on art forms and institutions. For example, Robert Barry exhibited a closed gallery, and Michael Asher removed the wall between the exhibition space of a commercial gallery and its office. Other pieces were pointed critically at events in the world, such as the Vietnam War or the spread of consumer capitalism around the globe. Conceptual art was intended to challenge traditional art on several levels – broadening Duchamp's investigation of the art object and art context to include all areas of life. Much conceptual art has been seen as opposed to the modernist idea of the artist as creative genius. If an abstract expressionist painter such as Jackson Pollock had presented himself a force of nature, the conceptual artist appeared to be more of a technician or bureaucrat, replacing personal gestures with impersonal ideas. Yet the work, with its perverse, quirky systems and empty centre, often demands some kind of explanation, which more often than not falls back on the artist and his or her activities. In order to understand what the work actually is, it is often necessary to tell an anecdote about what the artist did to create it. Thus, anti-expressive conceptual art opened the door both for a more narrative kind of art and also for art based in part on the activities and personality of the artist.

We can see an example of this in Eleanor Antin's classic conceptual work of 1972, *Carving: A Traditional Sculpture* (Fig. 1.4). A grid of 148 black-and-white

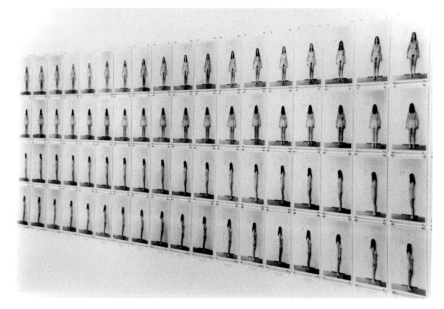

*Figure 1.4* Eleanor Antin, installation view, *Carving: A Traditional Sculpture* (1972).

photographs accompanied by a text panel, the piece has the serious, pseudo-scientific presentation common to much conceptual art (what art historian Benjamin Buchloh has called "the aesthetic of administration").[17] The work proposes a connection between the reductive methods of classical sculpture and the artist's attempt to "carve" her body into its "ideal" form, presented through daily front-back-and-sides documentation of the artist's 10 lb weight loss over thirty-six days. The work points to several possible interpretations. It provides a critique of the objectifying power of traditional sculpture and a response to the way in which women's creativity can be sapped by the pressure to conform to cultural ideals of beauty.[18] Antin herself has described her work of this period as a response to the dry, macho intellectualism of the male conceptual artists. As well as interrogating the identity and status of the artwork, *Carving* also points back to the artist; it is a tongue-in-cheek exploration of what it might mean for a highly self-conscious female artist to go on a diet. Antin was one of the few artists to acknowledge that in emptying out the visual fullness of the work, conceptual art reintroduced narrative via the back door. Contemporary artists such as Grannan and Crosher have embraced this bio-graphical, anecdotal component of the work, making it an active part of their projects.

Conceptual art was subversive, devoted to smashing expectations. Grannan's work is much more traditional, if with a small charge of danger (meeting up with exhibitionistic strangers in the woods will always be an edgy activity).[19] But it is Grannan's conceptual back story, the system around her work, that legitimates it as contemporary art. She and Crosher rely on an art world that

welcomes work with a loose narrative structure and plenty of unresolved elements.

Collier Schorr's "Jens F." project is a serial portrait that rides on the back of a pre-existing serial portrait: a set of paintings and drawings that American artist Andrew Wyeth did of his neighbour (and possibly lover) Helga Testorf between 1971 and 1985. In turn, Schorr photographed Jens, a German teenager, in a kind of homage to Wyeth's work, and collaged her images directly onto a catalogue of Wyeth's Helga pictures (Fig. 1.5). "Jens F." was first exhibited as page spreads and ultimately published as a book.[20] Jens has a soft, slightly feminine body and a pale complexion not dissimilar to Helga's, but it would be a stretch to say that he looks like her. In repeating such poses as lying down with one arm raised or such scenarios as looking out over a tree, Schorr is not reproducing Wyeth's images accurately but rather reenacting a kind of visual obsession. Schorr underlines this with handwritten notes on the pages, such as: "am more invested in approximating her sense of pose, rather than an exact copy. Good on the shadows on his hip & breast."

If we look at one page in particular, we see Wyeth's image of a nude Helga kneeling, "On Her Knees" as the text of the Wyeth book tells us. Layered over the top right corner of this is one of Schorr's photographs of Jens, in trousers but no shirt, also kneeling and looking down to the left. Both layers of image are mysterious, timeless. They do not tell us much about the where or when of this woman or boy, or what they would be like if we met them. Instead, they offer a brooding beauty laden with sexuality. Both images benefit from the ambiguity of being caught partway between portrait and nude. Wyeth and Schorr objectify their sitters, putting them in awkward poses that foreground their physicality. At the same time, the images, especially as part of a series,

*Figure 1.5* Collier Schorr, *Jens F. 114/115* (1999–2002).

give us glimpses of Helga's and Jens's personalities and of their relationships of slightly wary trust with the artists for whom they pose. As in Grannan's and Crosher's work, the biographical back story is also important. It is part of the content of the series that Schorr met Jens on a train through southern Germany and photographed him a couple of times before alighting on the idea of using him to reenact the Helga images. The collaboration between the gay, female, Jewish artist from New York and the German youth lasted for several years, contributing an emotional intensity to the project that is more oblique than Wyeth's frank (if sometimes rather harsh) heterosexual appreciation of Helga. As if these ambiguities were not enough, in parts of the series Schorr substitutes other models, a younger boy and three young women, one of them Jens's sister. The images themselves are cut into and layered with each other as well as with Wyeth's.

Again, as with most contemporary art photography, it is helpful to know something of the maker's broader project. Schorr's photographic practice since the late 1990s has focused on adolescent boys, and, more rarely, girls, providing a strange, gender-bending study of the erotics of looking. To this end she has drawn on a number of different genres, ranging from photojournalism to sports photography to fashion. Her career has included a number of editorial fashion spreads drawing on the themes in her artwork. This background of genre surfing sets the stage for her to juxtapose her images with paintings, to collage herself into the history of art. Her work has also flirted with the unacceptable and tasteless, as in her romantic images of attractive young Germans in Nazi uniforms, breaking a taboo which is not merely symbolic but also legal (wearing Third Reich insignia is forbidden in Germany).[21]

Some critics viewed the "Jens F." project as a shrewd, playful twist on the politics of representation, a female artist searching for a new vocabulary to portray desire, performing fascinating contortions to side-step the male-dominated gaze that has dominated Western art.[22] Others saw it as a weird academic exercise, forced and unsuccessful.[23] On both sides of this debate, the art writers are sharing assumptions about the terrain in which Schorr is operating and what kinds of goals her project might have. They see her as working deliberately with the codes that underlie images in our culture, and they imply that disrupting those codes, producing some kind of alternative message, is a desired outcome. The terms of this debate are drawn directly from the discussion around art that developed in the 1980s around postmodernism.

## Postmodern textuality

Postmodernism in art involves a loss of belief in the truth or unique value of the photograph. If modernism prizes singular images that reflect the world with great beauty or penetrating truthfulness, postmodernism rests on the idea that reality is constructed and unstable.[24] Within this theoretical framework, photographers use their medium not merely to reflect an existing reality but rather to produce new meaning. Artworks are viewed as cultural texts to be decoded

by informed critics and viewers. Much work from the peak period of post-modern photographic activity in the 1980s was read as a kind of illustration of Guy Debord's theory that advanced capitalism has ushered in an era dominated by leisure, consumption and the image, or of Jean Baudrillard's related notion that reality has been replaced by copies of copies.[25]

As theorists like Hal Foster describe it, postmodernism is a paradigm of recycling.[26] But the original form or idea is reproduced with an awareness of difference, often a gap or irony. Artists go back to the past with a view towards opening up a new space of working. This is intended to be a productive backward looking that may or may not engage with history. In the 1980s, postmodern artists such as Sherrie Levine, Richard Prince and Barbara Kruger appropriated found images (once again looking over their shoulders at Duchamp). Critics saw this work as offering a pointed critique of representation in art and consumer culture. While some well-informed viewers took on the complex allegorical reading of such works, casual observers would have continued to interpret the pictures in terms of their subject matter and style. In the past two decades the critical frame has broadened so that such works can be freely enjoyed for their formal properties too.

Richard Prince provides an instructive case study of this shift. At the time of his 1992 mid-career retrospective at the Whitney Museum, Prince was read as a political artist. His large re-photographed images of Marlboro cigarette advertisements were read as critical of the construction of masculinity in Western art and media (Fig. 1.6). Overblown, heroic models of manhood used to advertise an addictive carcinogen, Prince's Marlboro men were symbols of something

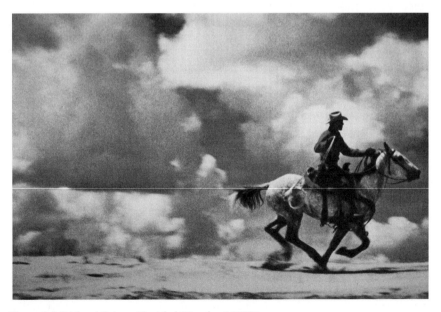

*Figure 1.6* Richard Prince, *Untitled (Cowboy)* (1989).

having gone wrong with Western masculinity and with the commercial culture that promoted it.[27] Flash forward to 2009, and Richard Prince's retrospective at the Serpentine Gallery in London. At this point, Prince's subjects are read less as political than as thematic. The artist is made over as enthusiast – as fan – with an equal passion for cowboys, hotrods and topless girls. In this reading, the Marlboro men are sexy (which they always were) and dangerous (likewise), but no longer re-presented to us by Prince in order to make us more alert to the role of representations in our culture. Now they are there for us to contemplate, to consume. As one critic put it, "it is hard to tell whether they are, in fact, a critique of consumerist culture or simply a symptom of it."[28] Prince's work retains a certain panache from the fact that it once sustained a politicized academic reading, but his enduring success surely derives more from the double punch of the work's almost inconceivable market success and its enduring formal appeal, thanks to the brilliance of the original ad-men, as well as Prince's canny cropping.[29]

Schorr's work has a complexity and intertextuality that benefits from being read through the lens of postmodernism. At the same time, the artist shares ground with Richard Prince the fan; she resists interpretation by embracing elements of political incorrectness and ambiguous eroticism. These aspects of the work are perhaps intended to be affective rather than textual. In other words, they are to be felt on a gut level rather than considered with the intellect.

So, we have these three ideas to frame the contemporary use of hybrid genres: the Duchampian turn, in which art is created via naming and contextual framing, held constantly in tension with non-art; the shift towards conceptual documentation, in which the photograph is driven by a conceptual premise and may point back towards the activities of the artist; and the postmodern paradigm, in which meaning is produced by the work rather than presented by it and work is read in relation to the codes of contemporary culture. Crosher, Grannan and Schorr all lean on these precedents, without necessarily quoting them explicitly – because they don't need to: the art world today assumes a fairly high level of academic training in artists as well as critics (with the MA or MFA in studio art or photography as the most common qualifications).[30] Also, as suggested by the example of Richard Prince, at the same time as work has become more layered and ambiguous the critical climate has become more permissive.

Ambiguity is absolutely key to the discussion of contemporary art. Ambiguity in art or literature was once seen as a failing unless it was very specific and pointed, such as a pun with a double meaning or a representation of the internal contradictions of a troubled mind or dream state.[31] Contemporary photography, however, embraces ambiguity on several levels. It is common for work to be ambiguous at the basic level of subject matter, resting on a visual confusion between male and female, child and adult, day and night, pleasure and pain, etc. Many works also offer a kind of moral ambiguity, deliberately flirting with offensive, transgressive imagery to create a politically incorrect charge (here we might think of Andres Serrano's *Piss Christ*). Most common of all,

however, is an ambiguity of meaning in which different interpretations – even mutually contradictory ones – may be held at the same time. Such interpretive conflict, which might have been regarded as artistic failure in an earlier moment of modernist autonomy or postmodern representational critique, is now regarded as a sign of desirable openness, reflecting the layered reality of experience in our time. It is not a coincidence that the younger photographers cited in this chapter are all women; feminist theory has been very influential in creating a more relativist worldview. The female photographers in this chapter are all starting from the position that identity is something to be negotiated rather than assumed, as reflected in their hybridized versions of portraiture.

The traditional portrait is a humanist enterprise, wrapped up in the project of reading, understanding and reinforcing what we know about human subjectivity. While many photographers still work with this model, some of the most successful contemporary art photographers, including the ones in this chapter, draw on a variety of genres and the radical gestures of twentieth-century art to produce a new kind of portraiture. Like a hybrid plant, it retains characteristics of its precedents, while bearing very different fruit. The lasting legacy of postmodernism has been its challenge to the master narratives of the twentieth century, including logic, certainty and truth. Contemporary art discourse thrives on works which are to some extent illogical, uncertain and riddled with elements of contradiction, fiction and fantasy.

## Notes

1 For an introduction to genre theory, see Alastair Fowler, *Kinds of Literature: An Introduction to the Theory of Genres and Modes* (Oxford: Oxford University Press, 1982). For a useful overview of the application of genres from painting to contemporary art photography see David Bate, *Photography: The Key Concepts* (New York and Oxford: Berg, 2009), pp. 137–40.

2 In recent years, many writers on photography have also revisited the idea of genre. See, for example, Susan Bright, *Art Photography Now* (London: Thames & Hudson, 2006) which divides its chapters by genre.

3 Richard Brilliant, "The Authority of the Likeness," in *Portraiture* (London: Reaktion Books, 1991), pp. 23–44.

4 See, for example, Stuart Hall, "The Question of Cultural Identity," in Stuart Hall, David Held and Tony McGrew, eds., *Modernity and Its Futures* (Cambridge: Polity Press, 1992), pp. 274–316.

5 Aperture has released Crosher's project as 4 limited edition, print-on-demand artists books. Zoe Crosher, *The Archives of Michelle duBois,* 4 vols. (New York: Aperture 2011–12).

6 Pierre Bourdieu, *Photography: A Middle-Brow Art* (Palo Alto, CA: Stanford University Press, 1990), p. 7.

7 The most famous of these is Henri Cartier-Bresson, *The Decisive Moment* (New York: Simon & Schuster, 1952).

8 Henri Cartier-Bresson, "The Decisive Moment," *The Mind's Eye: Writings on Photography and Photographers* (New York: Aperture, 1999), p. 23.

9 For a highly influential account of the split between formalist modernism and the avant-garde, see Peter Bürger, trans. Michael Stone, *Theory of the Avant-garde* (Minneapolis, MN: University of Minnesota Press, 1984).

10 For detailed discussion of Duchamp's *Fountain*, see Thierry de Duve, "Given the Richard Mutt Case," in *Kant after Duchamp* (Cambridge, MA: MIT Press, 1998), pp. 89–143.

11 For those who feel resistant to the readymade, it is perhaps worth pointing out that Duchamp was not acting alone. Attacks on traditional art forms and institutions were happening across Europe in the 1910s and 1920s, but Duchamp's particular avant-garde gesture has been one of the most influential and enduring. One hundred years of repetition may not have fully legitimized what is in effect a cheap trick, but Duchamp's readymades have spawned such a vast body of international art and criticism that to ignore it looks like philistinism. In short, it is much more interesting to join the Duchamp party than to stay out in the cold.

12 Art historian Benjamin Buchloh asserts this position in "Interview between Benjamin H.D. Buchloh and Thomas Struth," in *Thomas Struth: Portraits* (New York: Marian Goodman Gallery, 1990), pp. 29–40.

13 It is notable that Grannan and many other young art photographers also shoot editorial spreads for fashion magazines ranging from *AnOther* to *Vogue*.

14 This process is described in detail in Katy Grannan, *Model American* (New York: Aperture, 2005).

15 See Jan Avgikos, "Some Place Other Than Here," in Katy Grannan, *Model American* (New York: Aperture, 2005), unpaginated.

16 For more on contemporary portrait photography as negotiation, collaboration and "a dynamic practice of intervention," see Joanna Lowry, "Negotiating Power," in Mark Durden and Craig Richardson, eds., *Face On: Photography as Social Exchange* (London: Black Dog Press, 2000), pp. 11–20.

17 See Benjamin Buchloh, "Conceptual Art, 1962–69: From the Aesthetic of Administration to the Critique of Institutions," *October*, 55 (winter 1990): 105–43.

18 Discussed in Howard N. Fox, "Waiting in the Wings: Desire and Destiny in the Art of Eleanor Antin," in *Eleanor Antin* (Los Angeles, CA: Los Angeles County Museum of Art, 1999), pp. 15–157.

19 As acknowledged in Avgikos, "Some Place Other Than Here."

20 Collier Schorr, *Collier Schorr: Jens F.* (London: Steidl, 2005).

21 For a discussion of the disturbing appropriation of the aesthetics of power in contemporary work, including Schorr's, see Barbara Pollack, "Fascinating Fascism?" *Art Monthly*, 253 (February 2002): 1–4.

22 Vince Aletti, "Gender Blender: Collier Schorr's Collage of the Sexes," *Modern Painters* (February 2006): 35–7.

23 Brian Curtin, "Signs Taken as Signs," *Contemporary*, 88 (2006): 52–3.

24 For concise summary of postmodernism in relation to photography, see Andy Grundberg, "The Crisis of the Real: Photography and Postmodernism," in Liz Wells (ed.), *The Photography Reader* (London and New York: Routledge, 2003), pp. 164–79.

25 Guy Debord, *The Society of the Spectacle*, trans. Donald Nicholson-Smith (New York: Zone Books, 1994, first published in French, 1967); Jean Baudrillard, *Simulations* (Los Angeles, CA: Semiotext(e), 1983).

26 See, for example, Hal Foster, *Recodings: Art, Spectacle and Cultural Politics* (Port Townsend, WA: Bay Press, 1985).

27 See, for example, Lisa Phillips, *Richard Prince* (New York: Whitney Museum of American Art, 1992).

28 Sue Hubbard, "Richard Prince, Continuation, Serpentine Gallery, London," *The Independent*, Friday, 27 June 2008. Available online at http://www.independent.co.uk/arts-entertainment/art/reviews/richard-prince-continuation-serpentine-gallery-london-855277.html (accessed 24 September 2012).

29 On 8 November 2005, Richard Prince's *Untitled (Cowboy)* 1989 set a world record at Christie's New York, becoming the first photograph to sell publicly for more than a million dollars.

30 For a remarkable quantitative breakdown of art photographers' education in relation to their subsequent market sales, see Rebecca Hopkinson, "So You Want to Be an Art Photographer?" *Source: The Photographic Review*, 66 (spring 2011): 22–5. Hopkinson offers the statistic that 78 per cent of photographers represented by commercial galleries have postgraduate qualifications.

31 For a classic discussion of ambiguity in literature, see William Empson's 1930 book, *Seven Types of Ambiguity* (London: Pimlico, 2004). Empson reserves his most scathing remarks for the type of free-floating ambiguity we might associate with contemporary art: "An ambiguity of the sixth type occurs when a statement says nothing, by tautology, by contradiction, or by irrelevant statements; so that the reader is forced to invent statements of his own and they are liable to conflict with one another." *Seven Types of Ambiguity*, p. 176.

# 2   Objectivity and Seriousness

They have become ubiquitous in museums, galleries, private collections and corporate boardrooms: monumental, ultra-detailed photographs of places, people or objects arranged right in the middle of the frame. Their style has been called deadpan, a term originally used to describe an expressionless face. These works have undeniable presence. They are made with large-format view cameras and usually printed very large, as if intended for the walls of museums, commercial galleries and the spacious homes of collectors. They contain so much detail that the eye can get lost inside them; book or magazine reproductions cannot do them justice at all. Made with even lighting, frontal compositions and sharp-all-over focus, these pictures appear to present their subjects without any manipulation or hidden agenda. We may be tempted to take such images as transparent depictions of their subject matter. Yet it is important to remember that the desire for objectivity is itself a position. For those most involved in thinking and writing about such work, the cool, uninflected surface of deadpan photography provides a springboard for some of the most ambitious aesthetic investigations in contemporary art. For many viewers, however, this work remains perplexingly blank, impersonal and boring.

The central figures in this kind of photography are Germans Bernd and Hilla Becher, and the students they taught at the Düsseldorf Kunstakademie between 1976 and 1997.[1] Much has been written about their work, but little that gets to the grist of why, exactly, this group of photographers make deadpan images of repetitive and unexpressive subjects and how this version of objectivity might be understood (or indeed misunderstood) outside a German context. This chapter investigates the shifting role of objectivity over the twentieth century as well as examining notions of disinterestedness, criticality and banality we might use to interpret such work. We will look in particular at architectural interiors, cityscapes and landscapes by Candida Höfer, Frank Breuer and Thomas Struth. At stake is the question of why this anti-personal aesthetic has become so dominant in international art photography at the turn of the twenty-first century.

## Objectivity

So how do we begin to unpack this highly loaded term, "objectivity"? Terminology is crucial both to art criticism and to the history of art. Movements need to be named and trends described and labeled as accurately as possible. Shared terms are transpersonal; that is, they allow viewers with different tastes and perspectives to meet on common ground to discuss what might be significant about works of art. The problem, of course, is that our very individuality means that we will never fully agree on how and when to assign particular terms. Works of art are complex, varied and will often resist categorization. So critics and art historians must constantly reassess their terms, redefining them in relation to the works they describe and the contexts in which they are used. Objectivity is one such term. Its everyday conversational meaning is clear: it denotes a plain, straightforward attitude, uncolored by opinion or emotion. Yet in the history of photography, objectivity has been invoked innumerable times, bearing different connotations in each specific context. While writers and photographers are united in regarding objectivity as the opposite of a subjective approach, they have their own historically specific agendas for turning away from the individual, personal, expressive or emotional. It would take a whole book to provide a complete overview of objectivity in art photography; this chapter draws out a few key reference points, hoping in particular to clarify differences between the Anglo-American and German interpretations of the term in relation to contemporary photography.

Over the past few decades, objectivity has been challenged from all sides. As we saw in the introduction and the chapter on hybridized portraiture, postmodern theories replace the objective image with the textual image; instead of claiming to present objective truths, images within a postmodern paradigm are described as offering discursive strategies, critiques of representation and critical allegories about the state of culture and politics.[2] This discussion, however, has taken place largely in Anglo-American art history and criticism. As we will see, German photographers and writers have retained a stronger interest in visuality than textuality.[3] They value a kind of photographic directness, a commitment to observed reality and an ongoing engagement with material objects. These preferences relate to German history and philosophy as well as to their contemporary critical context.

For many art photographers in the early twentieth century, the notion of objectivity provided a counterpoint to nineteenth-century aestheticism, with its emphasis on an idealized past. The first international art photography movement, pictorialism, combined literary and art-historical subjects with artful, often hand-worked photographic processes. In the 1910s, modernist photographers on both sides of the Atlantic rejected the pictorialist aesthetic, judging blurry images of peasants, nymphs, ballerinas and the like to be undesirably sentimental and nostalgic. Following a pervasive modernist logic that art forms should foreground their unique properties rather than mimicking other forms, they embraced the camera's capacity to record the world sharply, and in great

detail. As American photographer Paul Strand described it in a 1917 essay, photography's unique strength "is an absolute and unqualified objectivity. This objectivity is the very essence of photography, its contribution and at the same time its limitation."[4] In his own photography, Strand proposed a new art for the Machine Age, based on everyday subject matter and the unique capabilities of the individual photographer. Depicting modern life in sharp focus with extreme close-ups and stark crops, he also made an argument that American art photography could free itself from the subjects and styles of European art. Strand was shaped by an education that emphasized the ethical agency of the individual.[5] A sharp, clear-sighted aesthetic of objectivity – layered with themes of the vernacular, Americanness and individualism – has recurred in the work of many influential American photographers such as Walker Evans (to be discussed further in Chapter 3) and Stephen Shore.

It may seem like a paradox to speak of objectivity tinged with individualism, yet this is exactly what a photographer like Shore provides. In *Church and 2nd Streets, Easton Pennsylvania, June 20, 1974* (Fig. 2.1), we can see a sharp image packed with information and taken with an 8 inch × 10 inch view camera from the middle distance. The image is uninhabited, the lighting is flat, and the street corner portrayed is entirely ordinary (although the heavy green window awnings and Volkswagen bus seem quaintly dated to today's viewer). At the time that this image was viewed in the influential

*Figure 2.1* Stephen Shore, *Church and Second Streets, Easton, Pennsylvania, June 20, 1974* (1974–2003).

"New Topographics" exhibition in Rochester, New York, in 1975, it was regarded as part of a trend towards photographic stylelessness, minimalism and ambiguity.[6] Viewers at the time saw the photographs as shockingly stark and ugly.[7] Yet certain aspects of the image point us back towards Shore's personal stance. The viewpoint of the image places us right on the street and makes us aware of the photographer's physical presence. The flash of red bus against the otherwise dull colors (color was still unusual in art photography at the time) gives the image a quirky punch. Crucially, in relation to the work we will discuss later in the chapter, this image was exhibited as an 8 inch × 10 inch contact print, i.e. as a small image, to be regarded up close, like the page of a book, not a large-scale mural print. Although focusing on the most unremarkable aspects of the everyday environment, Shore's work often feels intimate, inviting. Hilla Becher once described it as rendering the world "very affectionately," reflecting his love of his subject matter as well as of photography.[8]

The important thing to note for this chapter is that even when engaging with the idea of objectivity, much American art, criticism and philosophy remains open to the notion of personal or individual subjectivity. As we will see at various points in this book, European post-war theory has been highly critical of bourgeois subjectivity, regarding it as created by and complicit with consumer capitalism. While these debates are also present for American artists and writers, they have not influenced cultural production to nearly the same extent. American art remains far more tolerant of the individual as a source of value and meaning. Thus, in an American context, objectivity need not imply a total denial of authorial presence but might point instead to a number of different possibilities. Britt Salvesen summarizes some of these in her historical overview of "New Topographics" (which featured work by Bernd and Hilla Becher as well as eight Americans including Shore):

> Ultimately, objectivity proved so useful as a stylistic lynchpin because it could be correlated with a variety of authorial stances: non-engagement (Walker Evans), egalitarianism (cultural landscape studies), eclecticism (Learning from Las Vegas), irony (Ed Ruscha), anti-romanticism (Robert Smithson), activism (environmentalism), and anonymity (nineteenth-century photography and other utilitarian documents).[9]

Thus, in the context of American photography, objectivity refers to a styleless style that may – or may not – allow aspects of subjective vision.

Modernist photographers in Europe between the First and Second World Wars developed a rhetoric for new vision based on the clear-seeing mechanical eye of the camera. As László Moholy-Nagy, a key figure at the German Bauhaus in the 1920s, put it: "Thus in the photographic camera we have the most reliable aid to a beginning of objective vision. Everyone will be compelled to see that which is optically true, is explicable in its own terms, is objective, before he can arrive at any possible subjective position."[10] Trained as a painter, Moholy-Nagy

was reacting less against pictorialist photography than against the prevalent expressionism in German painting. His version of objectivity is tied into the politics of the European avant-garde: he hoped that the new photography would go beyond personal expression to transform individuals' relationship to the world.[11] To this end, Moholy-Nagy was willing to go much further into abstraction than Strand, Edward Weston or most of the other American modernists. For him, photographic objectivity offered a license to explore pure form: his abstractions, including photograms made with his wife Lucia Moholy, explore primal aspects of design. This version of objectivity valued photography for its constructive, experimental potential, not for its realism.[12] If Strand's version of objectivity was individualist and American, Moholy-Nagy's suggests a more collectivist, universal position. Contemporary Düsseldorf School photography carries with it some of Moholy-Nagy's interest in abstract design – in images that function as their own reality – as well as an interest in being freed from the limits of individual sensibility.

The most frequently cited influence on contemporary deadpan work is the photography associated with the German *Neue Sachlichkeit* or New Objectivity tendency in the 1920s and 1930s. Although there were differences between them, these photographers were united by an understanding of photography as capable of capturing the essence of objects and people. Their search for essence was not conceived as metaphysical but rather as material and scientific, a position supported by the use of typologies, serial images of a single category or thing, collected into archives. The risk of such an approach is that it equates seeing with knowing and can flatten out important differences. The most highly valued examples of this approach are those that are seen as inviting a dynamic comparison, contrast and analysis of subjects, in particular Karl Blossfeldt's encyclopedic study of plant forms and August Sander's catalogue of human types within rapidly changing Weimar society. These projects were characterized by their seriousness, sobriety and almost fetishistic attention to technical perfection – all features that continue to be associated with German photography.

The New Objectivity's ultra-detailed, detached approach has resonance with philosophy. The Continental, particularly German, philosophical tradition since the Enlightenment has placed a firm emphasis on observable things. For both Immanuel Kant and Georg Wilhelm Friedrich Hegel, for example, the world of objects provides us with the field of interaction that gives us the experience of ourselves as subjects.[13] In these terms, the visual strategies associated with New Objectivity photography – and related contemporary projects – could be seen as aids to philosophical understanding of things in the world and a consideration of our relationship to them.

## Bernd and Hilla Becher's disinterestedness

Is it possible to select a thing as representative of its type? What is the relationship between objects and the categories into which we place them? Is it even

possible to compare and contrast two objects when each has a seeming infinity of properties? Art historian Michael Fried sees this last philosophical question, which he draws from Kant, as central to the work of Bernd and Hilla Becher.[14] He describes their extensive documentation of pre-war industrial structures as ontological, arguing that their rigorous, systematic approach to objects sets up a consideration of the nature of being. It is key to the Bechers' project to photograph related – but disparate – structures in such a way that their similarities are emphasized, inviting comparison of forms that would not be possible in real time or space. In philosophical terms, we could see this kind of cerebral examination and discrimination as more exalted than mere looking. These kinds of references bring a gravitas to the discussion of the photographs that contributes to their value.

Many photographers reacted to the aftermath of the Second World War with a feel-good humanist approach, exemplified by Edward Steichen's blockbuster exhibition "The Family of Man," or with a kind of expressive subjectivism celebrated by German photographer Otto Steinert.[15] The Bechers, in contrast, developed a mode of working that repressed individual point of view.

Art historian Sarah James underlines that objectivity lies at the very center of their project: "Above all else, the photographic world of the Bechers is committed to *objectivity*. Their consistent, arguably impossible, aim has been to evacuate their own subjectivity from the work, to remove themselves as expressive agents as much as is humanly possible from the photographic act."[16]

The paradox, of course, is that the Bechers' non-style is itself a style. Individual images are easily identifiable by their pale-grey skies, low horizons and central framing; arranged in typological series printed to reduce differences in scale, the images are unmistakably the Bechers'. Key to the visual neutrality of the project is the location of the camera, seeming always to be the same distance from the subject; neither near nor far, the camera is always placed in the middle distance from the subject (a requirement that must have eliminated many otherwise promising sites).

The Bechers' working method was systematic. Their process often involved photographing a structure from many different angles (two, four or eight) as well as the best-known frontal views assembled into grids (Fig. 2.2). But although the structures they photographed – water towers, coal breakers, winding towers, etc. – were primarily functional rather than decorative, the Bechers' images reveal little of their actual use or history. On the contrary, they emphasize the abstraction and anonymity of the forms, playing down differences between structures built at different times or in different countries.[17] Why this strange push and pull between information and abstraction? Blake Stimson argues that for post-war photographers such as the Bechers, objectivity – as a visual approach and as an attitude – had become increasingly fraught. Photographs had been used as persuasive documents by all sides during the 1930s and 1940s. The apparent truthfulness of the medium had been exploited to produce propaganda of every kind. In this context, the Bechers rejected pre-war social

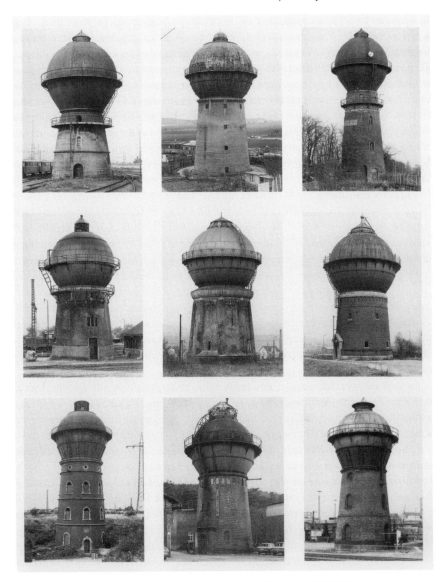

*Figure 2.2* Bernd and Hilla Becher, *Water Towers, Germany* (1965–82).

and political agendas and instead developed a form of objectivity that resists instrumentality. The uselessness of their work to engineers, historians, etc., is entirely intentional, serving to underline the work's autonomy.

The Bechers model a cool attitude of impartiality, or disinterest, in the style of their work and also in the way they present it. They have never asserted that their project is complete, authoritative or even that it is art, necessarily. As Hilla Becher declared in the early 1970s: "The question if this is a work of art

or not is not very interesting for us. Probably it is situated between the established categories."[18] Alongside this ambivalence about art, the Bechers provide a rationale for their work that asserts its existence as an autonomous field of enquiry: "We want to offer the audience a point of view, or rather a grammar, to understand and compare the different structures. Through photography, we try to arrange these shapes and render them comparable. To do so, the objects must be isolated from their context and freed from all association."[19]

The autonomy of art has been a key debate in modernism, and was of particular concern in the post-war era. Kant had proposed in the eighteenth century that art's value lay in providing an autonomous realm and had set forth the notion of disinterestedness – that aesthetic judgement should be separate from everyday needs and desires. Artists in the first half of the twentieth century debated whether art ought to be brought into the service of social and political agendas, whether it might be able to remain independent, or whether such freedom would necessarily be impinged by forces as concrete as commissioning patrons or as abstract as bourgeois subjectivity under capitalism. It is clear in the way that the Bechers have discussed and presented their project that the idea of autonomy appeals to them deeply; the work is specially designed to invite viewers' impartial consideration. At the same time, in systematically photographing subjects with such low cultural value and in contesting the very notion of art, they allowed their work to be read as anti-aesthetic and exhibited alongside the conceptual artists of the 1960s whose work directly challenged the autonomy of art.

As well as overlapping in some ways with conceptualism, the Bechers' work has affinities with minimalism. Like a number of tendencies in 1960s art, minimalist sculpture shifted emphasis towards the literal, the direct perception of the actual stuff of the work. In referring to their project as "anonymous sculptures" (part of the title of their breakthrough 1969 exhibit), the Bechers connected themselves to the industrial aesthetic and serial structures at play in the minimalist sculpture of the day. Their photographs could never function in the exact same way as minimalist sculptures because they are two-dimensional, experienced as images rather than as actual space-filling shapes to be negotiated by the viewer's body. But the Bechers were still very interested in the literalness of minimalism and wanted their work to function as a direct experience of a photographic reality. This directness, which we might refer to as a desire to present their photographs as objects in themselves, cuts across the work of their students as well.

The contradictions in the Bechers' work are surely key to their influence in an age that values complexity and ambiguity. Here is work that focuses on vernacular, humble, disregarded structures yet ends up reading as magisterial, authoritative, grand. The work denies the sensibility of an individual artist yet represents a lifetime – dual lifetimes – of single-minded obsession. In their cool black-and-white grids, the images resist the visual fullness or presence of traditional high art, yet their order and rhythm have deep visual and even philosophical satisfactions to a viewer who is willing to spend time with them. The

quest for objectivity lies at the heart of all these aspects of the work. In the Bechers' specific context, an aesthetic of objectivity offered a clear way to distance themselves from beauty and expression that had become tainted during the Nazi era; it allowed them a way to recuperate aspects of German modernism; and it connected them to the activities of conceptual art and minimalism. During a period when many Western photographers were challenging and deconstructing the real, the Bechers were at the core of a group of photographers enlisting serial structure, typologies and a deadpan style to signal a very different attitude. As Sarah James summarizes: "many German practitioners who engaged in sophisticated conceptual strategies – such as the Bechers – were united in their renewed commitment to realism and the objects of photography, to the possibilities of the medium's capacity for truth and objectivity."[20]

The Bechers' critical and market success over the past forty years has coincided with the globalization of the art world: an incredible boom in the number and internationalism of art schools, galleries, art magazines, auction houses, etc. While it may still make sense to speak of local or national contexts when tracing the roots of specific projects, ambitious contemporary photography is presented on an international stage. To some extent, this can produce a dumbing-down; subtleties can be lost in translation from one context to another. It can also lead to a kind of blurring of theories and arguments. Photography is notorious for offering a mirror to theorists, and images can be read differently according to whatever critical discourses seem to fit. The remainder of the chapter looks at three students of the Bechers and different ways in which objectivity has been interpreted in their work. It aims to draw out differences between projects that share a photographic rhetoric of objectivity.

## Candida Höfer and the question of criticality

Candida Höfer, an early student of the Bechers, is best known for her highly controlled images of architectural interiors, especially spaces associated with cultural value such as palaces, libraries, banks and architect-designed homes. Usually uninhabited, the photographs share a remarkable sense of order. When seen live, rather than in reproduction, the sharpness and detail almost boggle the mind. Höfer's compositions are uncluttered, tending towards the symmetrical. She frequently uses a square format, which produces an even more striking sense of monumentality. The camera position and angle are chosen to give the viewer maximum sense of visual control over the space. Many images are frontal, others are composed on a diagonal, with great care taken to avoid the perspectival distortions that can easily occur when photographing the insides of rooms. All the images appear to be bathed in the same cool light. Whether dealing with twentieth-century brutalism or an aesthetically exuberant style such as the French rococo, Höfer's clinical approach generates a highly recognizable style. Together, the images form an archive of power and privilege.

*Figure 2.3* Candida Höfer, *Banco de España IV* (2000).

In *Banco de España IV* (2000) (Fig. 2.3), we see a room with a shiny white marble floor, white walls and square, fluted pillars adorned with vertical strips of bright white spotlights. Paintings and prints are resting on the floor, leaning against the walls and pillars. Twentieth-century abstraction, figuration, baroque religious scenes, the pictures appear to be some motley corporate art collection, perhaps in transit from one branch to another or waiting to be hung. This image of valuable pictures waiting to be mobilized into meaning goes along with other Höfer images of empty libraries, empty shelves, archives of blank white boxes. Several questions arise. Does a dispassionate approach necessarily yield understanding? Couldn't it just as easily yield blankness? Didn't we decide a long time ago that the positivist equation of seeing with knowledge can lead to dangerous misunderstandings? Only in the actual inhabitation of Höfer's spaces, in the rituals and habits that turn potential into outcome, can a conference room produce a business deal, a theatre yield a performance or a library generate mastery of a subject. Otherwise the pictures are signs and ciphers, elegant but empty monuments to human self-importance.

Critics often describe Höfer's works as disembodied, arguing that the spaces do not invite us to project our own bodies into them but rather to contemplate them in the abstract. Art historian Michael Fried describes this as "the sense of sight operating in an almost wholly disembodied mode."[21] Höfer's particular aesthetic mode allows her to make architecture into image, power into picture. They allow us to contemplate privilege, but they also aspire to belong to it, to go on the walls of spaces just as loaded as those portrayed. They participate in the creation of cultural value that they document.

Several key shifts took place in Höfer's career in the 1990s. After more than a decade of being exhibited in Europe, her architectural images – along with those of her fellow Düsseldorf students – began to be exhibited on both sides of the Atlantic and acquired at rapidly escalating prices by American collectors.[22] At the same time, all the photographers in the group began printing their work larger and laminating it onto sheets of perspex in a process known as Diasec, producing photographic objects with the presence of academic paintings. Critics emphasize that Höfer was one of the last to make this change and suggest that she was motivated by a change in negative size rather than a desire to compete in market terms. Nonetheless, there is a dramatic shift from her works of the 1980s (38 cm × 57 cm) to the mid-1990s (85 cm × 85 cm) to the late 1990s (152 cm × 152 cm – 5 foot square and even larger).[23] Julian Stellabrass has described the shift towards enormous documentary photography in terms of "museum photography," arguing that in the 1980s and 1990s photographers actively began to project their work into the space of the museum and the academic discourses that come with such an exalted context.[24]

While individual viewers may disagree, the general consensus appears to be that large-scale photographs signal tremendous ambition and demand to be taken seriously. At the same time, they fill the viewer's entire field of vision, producing an immersive experience of visual detail that can be almost overwhelming. Combined with the conceptual and technical exactitude of the Düsseldorf School, this scale can contribute to photographs that seem confrontational, demanding and even pretentious.

The 1980s and 1990s also saw post-structuralist theory penetrate Western universities and make their way into art criticism. Writers such as Michel Foucault, Jacques Derrida and Roland Barthes provided intellectual approaches for challenging existing structures of power and privilege. In this context, some critics looked to the photography of the Düsseldorf School to provide visual analogues for these critiques.[25] The question that immediately rises, however, is whether to represent something as objectively as possible is any more likely to produce a critical image than a celebratory one? A glance at an image by a different kind of photographer – such as Robert Polidori's pictures of the overblown luxury of the Palace of Versailles or the visual devastation of New Orleans after Hurricane Katrina – provides an immediate point of contrast (Fig. 2.4). Polidori's swirling baroque compositions combine with the loaded history of his locations to produce images laden with melancholy, even hysteria. In contrast, Höfer's scrupulous efforts towards detachment may not

*Figure 2.4* Robert Polidori, *2520 Deslondes, New Orleans, March 2006.*

guarantee a critical attitude towards their subject matter, but they do encourage a cooler, more cerebral response.

To approach the matter from a slightly different angle, art writers (and photographers themselves) frequently want images to stand for concepts rather than mere observable phenomena. Many critics, particularly on the Anglo-American side, read the work of Höfer and her peers as critical allegories about culture, lessons to sensitize us to the world around us.[26] The work can sustain such readings to some extent but becomes more satisfying if we give more weight to the viewer's own experience of the work and allow the photographs to be pictures as well as critical texts.

The absence of a consensus about how best to appreciate deadpan photography has not hindered its dominance. For many young photographers, particularly on BA and MA courses in the 2000s, the set of variables modeled by Düsseldorf photographers appears to be a fail-proof formula; simply choose a subject (preferably something that comes in many variations) and shoot a taxonomy using a uniform composition and immaculate technique. Instant art! Some critics and historians would argue that it is in perfecting a formula – both formal and conceptual – that a photographer establishes the rigor and relevance of their project. Others would say that work in this vein is so monotonous, predictable and static that it is just plain dull.

## Frank Breuer and the threshold of boredom

In post-war intellectual culture, especially in Germany, seriousness has meant the refusal of frivolous pleasure and excessive affect. The post-war writings of

the Frankfurt School of philosophers proposed difficulty and negation as key strategies for activating readers and spectators to think for themselves, to fight against the passivity and false needs created by consumer culture.[27] The work of the Düsseldorf School proposes itself as high culture, rooted in photographic difficulty; as well as being extremely exacting to produce, the images declare their seriousness of intent through their size, degree of detail, seriality and titles. But what about audiences who find these images repetitive and stiff rather than rigorous and demanding, who find them, in short, boring? Are such viewers to be regarded as dunderheads (*dummköpfe*), or might they actually be onto something important?

The term "banal" is used most often in relation to the bland repetition of commodity culture. Artists and photographers turn to banal subject matter in part because it is familiar, producing what Eugenie Shinkle has described as "a kind of post-industrial realism, a turn away from the spectacular."[28] In an age dominated by the excesses of entertainment culture, banality can also represent a refusal of interestingness, a desire to underwhelm the viewer in the hopes of eliciting a more authentic or more critical response. Höfer's interiors are usually too grand to be described as banal, but other Düsseldorf-trained students have put the banal at the center of their objective investigations.

Frank Breuer was one of Bernd Becher's last students. His serial work pursues the prefabricated elements of the man-made environment, in bluntly titled series such as "Logos," "Containers," "Warehouses" and "Poles" (Fig. 2.5). Shot with low horizons and pale, timeless skies, Breuer's images have a consistency of approach that verges on the formulaic. Again, critics assert that the taxonomic approach allows viewers to move back and forth between the general and the specific in ways that spur contemplation. The roadside corporate logos float somewhere between the abstract seduction of successful branding and the abject reality of the dreary environments where they are placed. The international shipping containers have a satisfying monumentality – like giant stacks of children's blocks – marked with corrosion, anti-graffiti paint and polyglot logos that illustrate the global movement of capital. The utility poles are like a parody of portraiture; the photographer lavishes his expertise on individual poles that are functionally interchangeable. Although each location is specific, the series only underlines the anonymity of the ugly poles. If the Bechers' approach succeeded in monumentalizing their previously neglected subject matter, we could say that Breuer's work is more concerned with the failure of its subject matter to live up to the grandiosity of his approach. Art critics find pathos in the work, and also flashes of comedy.[29]

Not everyone will feel included in these responses. While different audiences will have different thresholds, there is going to be a point for many viewers at which the combination of deadpan approach and banal subject matter will fail to engage. Shinkle describes the way that banality in contemporary photography can be alienating, the more so once it has been given the art world's stamp of approval:

institutionally sanctioned banality neutralizes fleeting and contentless encounters with images … Disinclined to pass judgment on what they see, audiences, for their part, learn to leave such tasks to those more qualified – writers, curators, and other cultural pundits. When the temporary distraction of the active look starts to shift towards this more permanent kind of paralysis, perceptual boredom risks turning into perceptual ennui.[30]

Although their content ranges from the banal to the spectacular, the flat affect of deadpan photography risks pushing viewers into a state of boredom,

*Figure 2.5* Frank Breuer, *Untitled (Lexington, MA, USA)* from the series "Poles" (2004).

especially as this mode becomes more and more prevalent within contemporary art. On the one hand, it is easy to be bored when you do not fully understand what is in front of you. Being informed about the context and ambitions of this kind of work is conducive to having a meaningful experience. Sometimes work that initially bores or irritates can become more interesting the more we think about it. There is also the fact that work like Breuer's may deliberately avoid anecdotal interest or beauty because it seeks to challenge or inform rather than to please; it may propose boredom as a critical strategy, an extension of Frankfurt School difficulty. Whatever photographers may intend or critics may argue, aesthetic judgement rests on the individual experience of the viewer. Some work will leave you cold.

## Thomas Struth's photographic reality

Of all the photographers associated with the circle around the Bechers, Thomas Struth has made the most pointed exploration of the viewer's visual experience, most famously in his photographs of viewers in museums. He manages to be both one of the most dedicated exponents of photographic objectivity and also to give the impression of thoughtful self-inquiry, in part through his eclecticism. While many of his peers work within a single typological category, Struth has explored various subjects and genres, all the while maintaining the kind of distancing, careful framing and technical virtuosity we would expect from a Becher student. A common factor across these bodies of work is an attention to the experience created by the picture. As curator Ann Goldstein articulates it in terms inflected by the relativism of post-structuralist theory:

> By considering a photograph as objective, Thomas Struth is not describing a transparent window to the world; rather, his view is focused on the reality of the photograph itself – as it is both produced by and reflects the pictorial, formal and social relations inseparably connecting the camera, the photographer and the spectator.[31]

Here Goldstein invokes that most loaded term – "reality" – but uses it to refer to a dynamic network of relationships. Struth's reality is not simply "out there" in the world. She argues that it is created in the viewer's experience of the photograph and its context.

To close this chapter, I turn to Struth's "Paradise" series. These images are in many ways different from the other works discussed in this chapter. Focusing on nature, rather than man-made structures, they are enormous scenes of forests and jungles. Rather than viewing the scene from a distance, they give the viewer the impression of being right there; many of the branches and leaves are close to the picture plane, some even falling out of focus. *Paradise 1 (Pilgrim Sands) Daintree/Australia* 1998 (Fig. 2.6) offers us a large vertical frame bursting with tropical foliage. The low camera angle contributes to the viewer feeling engulfed. There is a tiny spot of white sky in the top centre of the picture, but

*Figure 2.6* Thomas Struth, *Paradise 1, Daintree, Australia 1998.*

otherwise the dappled green fills the composition to the edges. Struth has provided a focal point: a fan-shaped palm frond in the upper center of the image that is catching the sunlight. As with all the images in this series, the viewer's eye drifts about, finding some areas of deeper space to penetrate but mostly roving across the surface. Some images, such as *Paradise 9 (Xi Shuang Banna) Yunnan Province/China 1999,* have an all-over composition; the impenetrable forest growth creates a web like a Jackson Pollock painting. While most of the other photographs in this chapter offer at least a fantasy of visual mastery and

control, the "Paradise" images leave us feeling swamped, particularly when viewed together in a room as a photographic installation.

Despite Struth's resistance to explicit interpretation, critics have never doubted that meaning was there to be found. Considering Struth's earlier cityscapes, Peter Schjeldahl wrote: "A conviction of meaningfulness, like a pressure in the brain, grows on us. It is not a matter of anything normally 'interesting.' The place is unremarkable, merely real. At the same time, it seems a rebus urgent to be read."[32] Some writers go so far as to impose quite literal interpretations, for example, reading the "Paradise" series in relation to the fall of the Berlin Wall: "what would the world look like without the Wall, without good and evil, without conflicts?"[33] While these questions certainly have resonance in relation to the photographs, they are not adequate to contain them.

In Struth's work, objectivity is at its most unreliable and paradoxical. Viewers are thrown back again and again on their own experience of the image, an emphasis that is underlined in his museum pictures. Struth's background reinforces this emphasis on the viewer. A biographical approach is not particularly helpful in analyzing deadpan photography; the photographer's life and concerns are pushed out of the frame. However, Struth's intellectual influences may illuminate his approach. His academic studies included Wolfgang Köhler's *Gestalt Philosophy*, a book of 1929 that makes a compelling case against objectivity, arguing that reality is organized in the minds of individuals, each perceiving it separately in accordance with their own point of view.[34] Köhler's perspective, in turn, rests on Kant's basic assumption that we can never grasp things in themselves, just their attributes, as the reality of objects is constituted in our minds. To return to Struth's photographs, this set of ideas would indicate less concern with the real world photographed than with the reality of the photograph and, in particular, with the way in which reality is experienced by the viewer.

As this brief account of the Bechers, Höfer, Breuer and Struth begins to suggest, there has been no singular, monolithic notion of objectivity at play in German post-war photography. The work of the Düsseldorf School is a series of related investigations, sharing certain characteristics that link back to the idea of objectivity. This work rejects the personal, pointing away from the subjectivity of the photographer and creating an abstract space for disembodied thought. Rather than emotion, projection or identification, these works emphasize vision and cognition. They offer what is ultimately an academic gaze, painstaking, informed and informing, imbued with authority, yet often turned towards subjects that power might not choose to examine directly. The work is presented and received with such seriousness that it has come to dominate contemporary art as well as photography. It is seen as a suitable topic for academic study, reliable investment and as desirably neutral décor for corporate space.

The ubiquity of the deadpan mode has produced some intriguing variations. Several photographic projects have made parodic play on typologies with

*Figure 2.7* Bettina von Zwehl, *Profiles III, no. 4* (2005–6).

pseudo-objective typologies of things that cannot be adequately known or understood from photographic series, such as the one-year-old babies in Bettina von Zwehl's *Profiles III* (Fig. 2.7) or the controlled detonations of Sarah Pickering's *Explosion* series (Fig. 2.8). These examples underline the lack of necessary correlation between an objective visual style and the order, rationality and understanding that it might imply.

Especially with an Anglo-American context, deadpan images are often interpreted as revealing, even deconstructing, the cultural codes of the world they depict. Critics with an emphasis on the German background of these works read their commitment to objectivity more in relation to visuality and to the photographed reality. It can be tempting to read these large, hyper-detailed color images as simply a reaffirmation of the aesthetic values of modernism in photography. However, these pictures are a product of their time. They have become their own genre and are inevitably read in relation to each other as well as in relation to the photographic theories of their moment.

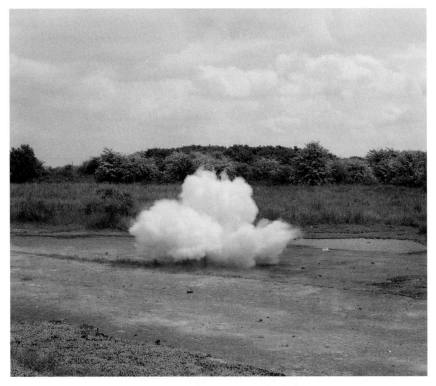

*Figure 2.8* Sarah Pickering, *Electric Thunderflash* (2004) from the series "Explosion."

They are so hyper-detailed and so specific as visual forms as to draw attention to themselves as well as the world they depict. The separate projects benefit enormously from being read in relation to each other and in relation to the work of the Bechers; being grouped together has given these photographers extra clout. Yet individual photographs stand or fall by the visual experience – which will be personal and idiosyncratic – that they produce for the viewer.

## Notes

1 For an overview of Bernd and Hilla Becher's activities and influence as teachers, see Stephan Gronert, "Photographic Emancipation," *The Düsseldorf School of Photography* (London: Thames & Hudson, 2009), pp. 13–69.
2 See, for example, the essays collected in Brian Wallis (ed.), *Art After Modernism: Rethinking Representation* (New York: New Museum of Contemporary Art, 1984).
3 This summary of German photography is indebted to Sarah James, "Photography's Theoretical Blind Spots: Looking at the German Paradigm," *Photographies*, 2 (2) (September 2009): 255–70.
4 Paul Strand, "Photography," in Alan Trachtenberg (ed.), *Classic Essays on Photography* (Stony Creek, CT: Leete's Island Books, 1980), pp. 141–2.
5 Paul Strand studied photography with Lewis Hine at New York's Ethical Culture School.

6 Alison Nordström, "After New: Thinking about New Topographics from 1975 to the Present," in Britt Salvesan and Robert Adams, eds., *New Topographics* (Göttingen: Steidl, with Center for Creative Photography and George Eastman House, 2009), p. 73.
7 Period viewer comments reproduced in *New Topographics*, p. 9.
8 Hilla Becher quoted in Michael Fried, *Why Photography Matters as Art as Never Before* (New Haven, CT: Yale University Press, 2008), p. 22.
9 Britt Salvesen, "New Topographics," pp. 11–67 at p. 52.
10 László Moholy-Nagy, "Photography," in Alan Trachtenberg (ed.), *Classic Essays on Photography* (Stony Creek, CT: Leete's Island Books, 1980), pp. 165–66, at p. 165.
11 Blake Stimson, *The Pivot of the World: Photography and Its Nation* (Cambridge, MA: MIT Press, 2006), p. 16.
12 For a useful overview of Moholy-Nagy's position within 1920s German photography, see Hal Foster, Rosalind Krauss, Yve-Alain Bois and Benjamin H. D. Buchloh, *Art Since 1900: Modernism, Antimodernism, Postmodernism* (London: Thames & Hudson, 2004), pp. 232–3.
13 Roger Scruton, *Modern Philosophy: An Introduction and Survey* (London: Penguin, 1994), p. 54.
14 Fried, *Why Photography Matters*, p. 324.
15 For a discussion of these different forces in post-war photography, see Stimson, *The Pivot of the World*.
16 Sarah James, "Subject, Object, Mimesis: The Aesthetic World of the Bechers' Photography," *Art History*, 32 (5) (December 2009): 874–93, at p. 875.
17 Stimson, *The Pivot of the World*, p. 149.
18 Carl Andre, "A Note on Bernhard and Hilla Becher," *Artforum* 11, no. 4 (December 1972): 59.
19 Stimson, *The Pivot of the World*, p. 143.
20 James, "Photography's Theoretical Blind Spots," p. 261.
21 Fried, *Why Photography Matters*, p. 286.
22 Constance W. Glenn, "Candida Höfer: Absence in Context," in *Candida Höfer, Architecture of Absence* (New York: Aperture, 2004), p. 16.
23 Glenn, "Candida Höfer," p. 16.
24 Julian Stellabrass, "Museum Photography and Museum Prose," *New Left Review*, 65 (September–October 2010): 93–125.
25 James, "Photography's Theoretical Blind Spots."
26 Fried describes this kind of reading of Struth's work as "therapeutic," *Why Photography Matters*, p. 387.
27 A core text in this area of critical theory is Theodor Adorno and Max Horkheimer's *Dialectic of Enlightenment* (first published in the mid-1940s and recently re-translated by Edmund Jephcott, Palo Alto, CA: Stanford University Press, 2002).
28 Eugenie Shinkle, "Boredom, Repetition, Inertia: Contemporary Photography and the Aesthetics of the Banal," *Mosaic*, 37 (4) (December 2004): 165–85.
29 Marcus Verhagen, Frank Breuer review, *Art Monthly* 268 (2003): 34–5, and Marcus Verhagen catalogue essay for Frank Breuer – POLES, published by Faulconer Gallery, Grinnell College, 2006.
30 Shinkle, "Boredom, Repetition, Inertia," p. 181. Shinkle's discussion applies primarily to banal images that invoke the everyday, the domestic, and the bodily (such as we will see in Chapter 4's discussion of authenticity) but can be extended to any photographs with commonplace subject matter.
31 Ann Goldstein, "Portraits of Self-Reflection," in Douglas Eklund, Ann Goldstein, Maria Morris Hambourg and Charles Wylie, *Thomas Struth, 1977–2002* (New Haven, CT: Yale University Press, 2002), pp. 166–73, at p. 166.
32 Peter Schjeldahl, "God's Struth," *The Village Voice*, 2 March 1998.

33 Maria Morris Hambourg and Douglas Eklund, "The Space of History," in Douglas Eklund, Ann Goldstein, Maria Morris Hambourg and Charles Wylie, *Thomas Struth, 1977–2002* (New Haven, CT: Yale University Press, 2002), pp. 156–65, at p. 156.
34 Hambourg and Eklund, "The Space of History," p. 159.

# 3　Fictive Documents

Photography's fraught relationship with reality has taken an unexpected twist in the contemporary gallery context. While many viewers still bristle at the blurring of fact and fiction, staged documentary is now a well-established tendency in art photography. This chapter examines the work of Luc Delahaye, An-My Lê, Adam Broomberg and Oliver Chanarin and Walid Raad to investigate how constructed imagery has come to be a valid tool for documentary practice within contemporary art. We will look at the way such work relates to classic strategies of mid-twentieth-century documentary and photojournalism, as well as to surrealism's use of documents and to the model of the *tableau* as embodied in eighteenth-century history painting. What distinguishes this chapter from previous discussions (of Jeff Wall's work, for example) is its inquiry into how an obviously fictional image has come to stand alongside a traditional documentary image as a model of experience. This is not merely a reiteration of the postmodern idea of representations replacing reality but rather an argument about the validity of fiction as a mode of discovery and experience in and of itself. These photographic works offer new ways to think about the complex reality in which we live.

## Document vs. documentary

A photograph may be a document without being documentary. The former implies a piece of primary information that asserts certain facts in visual form. Examples might include a passport picture, a police crime-scene photograph or the images accompanying an estate agent's advertisement. Documentary, on the other hand, describes a document or documents put to particular use. The term implies that an image has been shaped by an intelligence, an agenda; a documentary image both shows a specific situation and tells the viewer something about what it means. Furthermore, documentary has a traditional association with a progressive leftist social agenda. Documentary photography, since its roots in nineteenth-century social-reform movements, has sought to expose oppression, violence and exploitation, to trigger a response of empathy and, in some cases, to incite action. This branch of practice is often referred to as social documentary. Key to the tradition of documentary is its claim to truth. The

indexicality of film-based photographs – the fact that they contain actual physical traces of the light that made them – has been read as a talisman of the real.[1]

## Documentary constructions

Since the 1980s, writing about documentary photography has focused on the degree to which it is constructed, both by its makers and by its viewers. This constructivist view is not just a postmodern fad; photographers themselves have long been aware of their role in shaping photographic truth. While some documentary photographers describe their project in terms of a quest for objective truth, others are acutely aware of their own role – and ethical responsibility – in constructing particular versions of a visual story. As W. Eugene Smith put it at the heyday of his career at *Life Magazine*:

> Up to and including the instant of exposure, the photographer is working in an undeniably subjective way. By his choice of technical approach (which is a tool of emotional control), by his selection of the subject matter to be held within the confines of his negative area, and by his decision as to the exact, climactic instant of exposure, he is blending the variables of interpretation into an emotional whole which will be a basis for the formation of opinions by the viewing public.[2]

As a prominent photojournalist, Smith was one of the most vocal critics of the way in which magazine editors reshaped the meaning of his documentary work. When he pursued projects of his own, he enjoyed having more control over the way in which meaning was constructed in the presentation of his photographs.

Documentary photography is a realist form that developed alongside the modern novel. Although they are rarely discussed in relation to each other, documentary shares literary fiction's exploratory project, what theorist Frank Kermode describes as "finding out about the human world."[3] Key to both is the desire to present a reality that rings true to its audience. Walker Evans, one of the most celebrated documentary photographers of the twentieth century, known for his austere clarity of vision, was a great admirer of realist and symbolist fiction. Recent scholarship has confirmed the extent to which his work alludes to the writing of Gustave Flaubert, Ernest Hemingway and James Joyce.[4] In their construction of convincing fictional worlds, these authors were free to combine actuality with imagination. Evans, in contrast, has been scrutinized critically for making minor interventions in scenes that he depicted, for example rearranging furniture or tidying a room in a sharecropper's house to make a more harmonious composition.[5] The indexicality of the photograph carries an ethical burden alongside claims to truth. Writers may choose whether to operate in a journalistic, fictional or hybrid mode. Photographers working with real-world subjects have been granted much less leeway, even – or perhaps

especially – when producing images for an art context. While photojournalists have a clear code of professional practice and ethics, art photographers have the freedom and the responsibility to set their own parameters.

## Useless documents

Whether in the hands of social campaigners, government propaganda units or newspaper editors, documentary photography has been defined primarily by its uses. Since the early twentieth century there have also been photographers who have resisted the use-value of photographic documents, preferring to explore their value and aura as aesthetic objects in their own right. In the 1920s, artists such as Man Ray and André Breton explored how photographic documents could be given new meaning when looked at with surrealist intent.[6] Breton's novel *Nadja* is illustrated with blank images of Paris that become strangely sinister and loaded alongside his evocative text about searching for an elusive woman. This strategy cuts directly against the grain of social documentary; rather than trying to load pointed images up with specific, public meaning, Breton was recontextualizing bland record photographs, encouraging viewers to project their own subjective meanings, recomplicating reality. Documents and documentary images have increasingly crossed over into an art context since the Second World War, but not without tension. Photographers producing work for an art audience have been criticized for using a documentary approach uncritically, or, worse, for beautifying suffering.[7] Curators, too, have been criticized, for wrenching documentary images out of their proper context, allowing them to become merely objects for aesthetic appreciation.[8]

## Documentary dilemmas

Martha Rosler, herself an artist, has been one of the most insightful critics of documentary photography. In her seminal 1981 essay "In, Around, and Afterthoughts (on Documentary Photography)," she provides a scathing critique of the social-documentary agenda, which she had come to see as deeply flawed, along with the liberal, humanist agenda on which it was based.[9] She argues that rather than helping its depicted victims, documentary has too often served the interests of the privileged. Despite, or even because of, the good intentions of photographers, the work has taken on clichéd or institutionalized forms that become even more impotent and self-serving once they are absorbed into the domain of art: "The exposé, the compassion and outrage, of documentary fueled by the dedication of reform has shaded over into combinations of exoticism, tourism, voyeurism, psychologism and metaphysics, trophy-hunting – and careerism."[10] Rosler's proposed solution to this dilemma was a constant renegotiation of content and context through careful use of text and an acute self-consciousness. These strategies remain crucial for contemporary art photographers engaging with documentary as well as for a new wave of photojournalists revitalizing the project of witnessing world events.[11] For Rosler and

her peers – artist-photographer-writers such as Allan Sekula and Victor Burgin – the old model of documentary no longer seemed valid to meet their critical aims of resisting the social, political and economic status quo. Latin American conceptualists Alfredo Jaar and Oscar Muñoz have gone even further to challenge every possibility of representing human loss and suffering with alternative forms that push photography to the point of dissolution, non-image.

The photographers we examine in this chapter do not necessarily assume these forms of criticality. Although they engage with social and political issues, their work is not bound to a particular agenda. Their motivations are more ambiguous and sometimes self-contradictory. Classic documentary photography combines several functions at once; indexical evidence is interwoven with the aesthetic pleasure of well-crafted images and inflected with a political position. The fictional works discussed in this chapter foreground their aesthetic function. It is key to their meaning that they are seen and understood within the context of art. Nonetheless, their link to events in the real world is undeniable.

Luc Delahaye is an illuminating case study in this context, having turned his back on a prize-studded career as a war photographer and photojournalist with the celebrated agency Magnum to announce that he was becoming an artist. This biographical information takes prominence in accounts of his work, becoming part of its conceptual back story. Since 2001, Delahaye has continued to travel to conflict zones, but the pace and the presentation of his work have changed dramatically. Successful press photographs need to be graphically striking enough to pop off the page and timely enough to accompany current headlines.[12] Delahaye has turned to a completely different form of picture-making, large, ultra-detailed tableaux which are usually composites of several large-format negatives. He produces only a half dozen or so of these images a year, exhibiting them in commercial galleries and museums. Cynics have insinuated that Delahaye's move is pragmatic, that it is no coincidence that the shift came at a time when the outlets for serious photojournalism had dried up, while the market for limited-edition gallery photography had boomed. And, indeed, Delahaye's work sells extremely well.[13] Critics also write with some discomfort about the way in which Delahaye's work aestheticizes suffering. His most widely reproduced image, *Taliban* (2001) (Fig. 3.1), shows a corpse lying in a ditch. Yet the photograph is shockingly beautiful; the dead soldier occupies a relatively small space in the center of a panoramic autumn-hued composition, his draped limbs recalling a *pietà* rather than a crime scene photograph. At 109 cm × 236 cm, the image is dazzlingly detailed, presented for contemplation rather than quick consumption. Is this contemplation productive in some way, or merely pleasurable at the expense of a dead boy?[14]

## Tableau

Eminent French art historian Jean-François Chevrier has described the *tableau* as one of the key photographic forms of the present, a form so important that it

*Figure 3.1* Luc Delahaye, *Taliban* (2001).

has propelled photography to the forefront of contemporary art.[15] As he describes it, a *tableau* – from the French word for picture – is an autonomous, free-standing image that declares its own artfulness through careful composition. The work of Jeff Wall has been discussed extensively in these terms. The *tableau* presents itself to the viewer frontally, with clear borders containing all the action. Big and detailed, a *tableau* has a physical presence entirely different from a picture one might hold in one's hand. According to Chevrier, these features create a special relationship between image and viewer. Viewers do not merely regard the large-scale image, they are drawn to contemplate a fictional world, parallel to the one in which they stand. This effect leads Chevrier to describe the *tableau* as an event, a model of experience, rather than just a picture. Grand and ambitious, *tableaux* can be viewed as a shift away from dematerialized conceptual art back towards the fullness and pleasure of the traditional art object. At its best, Chevrier sees work by a photographer such as Delahaye as drawing on painting, cinema, computer montage, conceptual art and photojournalism to produce an ambiguous, challenging art form.

Delahaye's *Les Pillards* (*The Looters*) of 2010 (Fig. 3.2), set in Port-au-Prince, Haiti, has all the characteristics of a *tableau*. It is set against three colonnaded shopfronts working like proscenium arches in a theater to frame different stages of the action. The brightly colored image reads from left to right, receding on a diagonal. On the left, two young men are attempting to open a cardboard box, looking fearfully off to the left. In the middle ground two more figures are running away, one looking over his shoulder. Towards the right edge of the frame, the farthest figure makes off into the distance, also looking back. Although the figures are all different, the composition reads as a kind of serial narrative about pillaging and fleeing. Eighteenth-century French academic painters such as Jacques-Louis David often used similar architectural frames and horizontal arrangements of figures to compress more than one stage of a

*Figure 3.2* Luc Delahaye, *Les Pillards* (2010).

story into a single frame. The goal of such works was to find a way to depict the complexity of historical events and to distill their messages into stirring, dramatic images.[16] The titles of Delahaye's series have implied that he shares this aspiration. His 2001 series was entitled "History," a grand claim he appears to have retracted to some extent, as he gave his 2007 Getty Museum exhibition the modified title "Recent History."

When we look at *Les Pillards*, what do we learn that we did not already know about Haiti after the devastating earthquake? News reports brought us stories about extreme desperation, criminality and the breakdown of the social contract (alongside rarer stories of generosity, civility and personal sacrifice). Delahaye's image of young looters does not surprise us. It does not set up a critique of other images we have seen of Haiti or provide a counter-narrative. Chevrier would argue that the huge, carefully composed picture asks us to contemplate events on a different register of experience, in which our own eyes and bodies are placed in relation to those in the picture.

A number of contemporary art photographers are working in parallel with Delahaye, making museum-scale images that provide a detailed, slow look at places that have been in the news. Delahaye is different from so-called "aftermath" photographers such as Simon Norfolk, Sophie Ristelhueber or Paul Seawright in that his landscapes do not only show after-effects of war; the majority of his images are populated with participants in unfolding real-life dramas.[17] Manuel Cirauqui has described Delahaye as a kind of double agent,

with his work suspended between the functions of photojournalism and art.[18] His use of *tableau* tends to give the images a sense of coherence, as if by looking hard enough we could unravel the meaning of events depicted. Yet his compositions often portray an archetypal, clichéd version of events. Some critics write that perhaps the only real purpose of such work is to test the limits of what is appropriate in a museum or gallery context.[19] Delahaye's work remains troubling from the standpoint of both art and journalism, yet neither side can deny that there is something timely and fascinating about his practice. At stake is the question of art's relationship to reality and what role we are willing to allow fiction in photographic representations of the world.

## In search of the real

As we will examine further in Chapter 4, jaded contemporary viewers still want art that engages with the real. Many aspects of our culture incorporate shock or even trauma to puncture a pervasive sense of alienation. Traditional documentary photography carried the promise of the real but now seems either clichéd on the one hand (not real enough) or too manipulative (possibly real, but in the service of a deceptive, non-real agenda) on the other. The recent museum-scale photographs of world events have a mediated form that we can contemplate from a distance rather than feeling exploited or manipulated. David Campany argues that such images serve only to soothe a liberal conscience: "Mourning by association becomes merely an aestheticized response."[20] In contrast, Chevrier values Delahaye's work precisely because it triggers this aesthetic response. At stake between these two points of view is the question of which world is more important: the real world out there, or the audience's experience of a semi-fictionalized world. Is it not possible that both worlds have validity and that both lie within the scope of contemporary art?

## What is fiction?

We encounter fiction regularly in literature, films and television. While fiction is a device for inventing characters and events that have never actually existed, many fictional worlds are realistic. In other words, fiction is fake, but its goal is to reflect something about the way in which life is experienced.[21] Fiction is not experienced as a lie, because audiences recognize its artifice. We offer what Kermode calls our "conditional assent."[22] Thus, novelists and filmmakers can use fiction to explore thorny historical moments using multiple and competing points of view. This gives us a richer, deeper understanding of history, and sometimes of the present. Fiction is a mode of discovery, with ever-changing rules reflecting ever-changing times.[23] Problems arise when the line between fictional and non-fictional genres is crossed. For example, although every autobiography is to some extent a construction, readers never cease to be outraged when a memoir turns out to involve invented details that would have been perfectly acceptable in a novel.[24] Jeff Wall is not criticized for the ethics of his

staged photography. He usually works with hired models and thus avoids accusations of falsification or exploitation of actual persons. But while viewers and critics are more or less comfortable with photographs that are entirely fictional, they retain concerns about photography – even gallery-bound art photography – as a medium for realist fictions. Delahaye will continue to be controversial because he incorporates actual people's misfortune in his photographic constructions. Although photographers such as the ones discussed in this chapter have been using every means at their disposal to test the boundary between document and fiction, the line remains highly contested. As we will see, fictive documents become more acceptable to critics when such ethical concerns are addressed in some overt, self-conscious way.

An-My Lê takes a different approach to Delahaye in that her large-format images exploring military conflict do so without any photographic manipulation. Fiction enters the work in other ways. For her series "Small Wars" (1999–2002) she went to the American South to photograph Vietnam war re-enactors, military-history enthusiasts who restage battles down to the tiniest details of equipment. Lê's biography comes into play in the reading of her work; born in Vietnam, she has lived in the USA since she was a teenager. The Vietnam war that shaped her early life was known to her only through scraps of memory, Hollywood movies and photojournalism. She describes her experience of working with the re-enactors (who demanded her participation as a condition of the project) as creating "a Vietnam of the Mind."[25] She used the photographic tools at her disposal to heighten the drama and historical resonance of the work. The large-format images are in the monochrome black and white of most Vietnam-era photojournalism and echo compositions from nineteenth-century war photography.

In the "29 Palms" series of 2003–4 (Fig. 3.3) Lê worked with US marines training for Iraq and Afghanistan in the California Desert, photographing encampments, maneuver and training grounds. In his controversial 1991 book *The Gulf War Did Not Take Place*, postmodern theorist Jean Baudrillard argues that the Gulf War of 1990–1 was more media event than real war.[26] He claims that because it was predetermined by the inconceivable military might of the USA and took place at a level of technological distance, the event was in fact nothing more than a propaganda stunt, proof that real war has become impossible. Although "Small Wars" and "29 Palms" record simulations of war, they run against Baudrillard's position. The images capture the nitty-gritty of soldiers' daily lives, real if not really at war. Like Baudrillard, however, Lê explores something important about the symbolic place war has in the mind, in the imagination. As curator Karen Irvine describes the photographs: "They do not show us what war does, but they do contribute to our understanding of war in a new and interesting way. By bringing added resonance to the phrase 'theater of war,' Lê asks us to reconsider the fictions that cloud the ways in which war is experienced, remembered and represented."[27]

It is possible to read Lê's work as critical of war. Mark Godfrey writes, "Perhaps the most compelling quality of the '29 Palms' series is its ability to

*Figure 3.3* An-My Lê, *29 Palms: Colonel Greenwood* (2003–4).

forge a profound critique of American aggression without criticizing the subjects it images. The marines are as much victims of the war of fact and fiction as they are its perpetrators."[28] On the other hand, some of the more spectacular images of explosions in the night or tanks moving across the majestic landscape could be read as celebrations of military power. As with much contemporary art photography, it is productive to look at Lê's project more broadly, to consider the relationship of parts that produces a layered interpretation.

Lê's most recent work, photographed while "embedded" with the American Armed Forces around the world, has lost its overt fictionality. We are no longer looking at an act or a rehearsal. Still, the balanced compositions and distanced, sweeping views give the sense that we are looking at something carefully assembled. The lush color in these epic images contributes to the sense that they are managed, cinematic. A photograph such as *Manning the Rail, USS Tortuga, Java Sea, 2010* (Fig. 3.4), with its row of sailors gazing across a sea teeming with boats, is as much a *tableau* as Delahaye's *Les Pillards*. Lê's overarching project has established her desire and motivations for straddling fact and fiction. The work continues to provide a space for considering contemporary warfare in terms that reference the past while showing the present.

Compared to the pictorial approach of Delahaye or Lê, Adam Broomberg and Oliver Chanarin have used eclectic, even perverse, strategies in their exploration of documentary tradition. Sometimes they intervene in existing archival imagery. Their project *Afterlife* (2009) is a series of photographic

*Figure 3.4* An-My Lê, *Manning the Rail, USS Tortuga, Java Sea* (2010).

collages of cut-out figures pressed between glass (Fig. 3.5). Masked prisoners face a firing squad. The device of collage allows an uncanny repetition; some figures are shown simultaneously alive, dying and dead, others are shown from several points of view awaiting execution. One image shows four views of an executioner bending and turning as if to shoot a figure on the ground. Installed in a room, the cut-outs cast shadows, giving the piece a three-dimensional quality. As we have come to expect, conceptual back story is crucial. This piece draws on a famous Iranian news photograph from August 1979 showing a firing squad turned on a row of eleven Kurdish prisoners. One of the emblematic images associated with the Islamic Revolution, it won a Pulitzer Prize, although the photographer remained anonymous for political reasons. *Afterlife* came about as a result of research after the photographer's name, Jahangir Razmi, became public in 2006. Broomberg and Chanarin sought out Razmi and accessed the contact sheet from which the famous image had been drawn. Collage allowed them to combine different moments, compressing the visual information into new forms. The resulting works are dramatic, filmic, and also sculptural. If we were to be presented with the images alone, we might be disturbed by the way in which the absolute horror of execution is rendered graphic and seductive. The discursive framing of the work asks us to engage with it on a more cognitive level, to think through the photographer's position, both at the event and in the years since. In doing so, the series also encourages us to reflect on our own relationship to the violent but visually striking news photographs to which we are exposed every day.

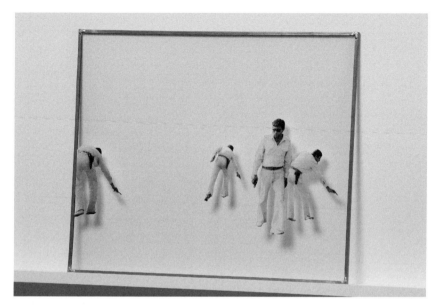

*Figure 3.5* Adam Broomberg and Oliver Chanarin, *Untitled (Afterlife 2)* (2009).

As well as recontextualizing preexisting imagery, Broomberg and Chanarin have produced their own strange, awkward documents. To realize the project *The Day Nobody Died* (2008), they traveled to the front line of the war in Afghanistan, carrying a box of mural-sized color photographic paper.[29] Once there, they exposed lengths of the paper to ambient light on six consecutive days, producing not photographs but a motley set of abstract photograms. Some are streaky, some are all black, a few are visually striking, but none of them satisfy the conventions for documenting a conflict. The exhibition of the images includes a video showing the box's roundtrip journey to Helmand, in the company of the British Army. Rather than producing an enhanced, fictionalized version of events, or photographing a fiction, they generated a project that was its own documentation, a self-referential loop that reverses the usual logic of documentary.

In this project, the concept is the key feature of the piece and the images – though important – are somewhat arbitrary. As witnessed by the video, the narrative of how the work was made is as important as the material outcome. As an audience, we are asked to put the pieces together and also to consider what is missing: there are no pictures of the collateral damage of war (for photographers embedded with the British or US military such images are generally forbidden anyway). The passage of the bulky box in cars, planes, helicopters, trucks and jeeps is patently absurd. Yet the video offers genuine glimpses into the experience of soldiers traveling to the front, and the box offers a grim metaphor for the coffins that have returned from Afghanistan (embedded photographers have rarely been allowed to depict the war dead, also on the

grounds that doing so would provide information to the enemy). The images record the traces of actual light on actual days, but nothing of the day's events. The titles of the images fill in the gaps, providing a textual record of certain events, such as *The Day of a Hundred Dead*, or *The Fixer's Execution*.

Broomberg and Chanarin have described themselves as operating "in a documentary mode" but also as exploring "fiction that emerges out of real experience."[30] The goal is not to produce some kind of new, improved documentary but rather to explore what might be interesting in "the failure of the medium to meet expectations."[31] Their attention to the way images are contextualized in text, or on the page, screen or gallery wall, reflects a background in journalism – in their case as the principal photographers and creative directors of *Colors* magazine from 1997 to 2003.[32] In this context, it is not surprising that their work comes across as accessible, confrontational and sometimes humorous.

## Refamiliarization

Johanna Drucker has written about the crisis of documentary photography in relation to a culture saturated with images and disillusioned with the ability of photographs to witness reliably. Traditional documentary, in synchrony with avant-garde art, aimed to defamiliarize the world, to make things strange, with the notion that shock would activate the viewer. A broad loss of faith in this effect leaves us with the need for a new critical strategy. Drucker proposes a new term, "refamiliarization," to refer to a recuperative approach. She argues that it is time for art to reveal the forces behind its own making and to reconnect us with lived experience:

> *De-familiarization* proposed a slap-in-the-face shock effect, a momentary surprise meant to transform habitual thought into awareness. But awareness of what? *Refamiliarization* asks images to show the contingent relations of complex systems, to expose vectors and forces of interests, desires, and power. The task of refamiliarization is to show that *what is* is *not* entirely simulacral, but connected to the lived experience of persons and peoples, organic beings, within cultural, political and vulnerable ecological spheres.[33]

Drucker describes a difficult project. Not all the photographers discussed in this chapter could be described in terms of refamiliarization. Delahaye's images carefully disguise their seams, the forces and interests that led to each being made. Lê's individual pictures offer a self-enclosed world, but her larger project may point to some of the ways in which the image of war is constructed in the imagination. Broomberg and Chanarin make the boldest moves towards using an art context to reimagine how documentary photography and interpretation might function. The installation of *The Day Nobody Died* ends up looking strangely elegant and consumable, like a roomful of abstract expressionist paintings. Together with the titles and video, the anti-event anti-photographs

illuminate the backstory behind photojournalistic images of war. As with *Afterlife* and its deconstruction of an iconic news image, *The Day Nobody Died* points to some of the networks that Drucker would like to see illuminated in the process of refamiliarization.

Walid Raad's curious project is perhaps best introduced with a series of questions. How do you represent the complexity of life in a part of the world that has been repeatedly misrepresented by the West? How do you record the everyday experience of living under the conditions of war, especially when a conflict is ongoing and casts doubt on the reliability of any official sources that speak about it? If history is written by the winners, how can we image or understand current wars with multiple antagonists and a tangle of victims and oppressors? Raad's work includes actual traces of everyday life during the civil wars in Lebanon (1975–91), yet these documents are complicated and short-circuited to the degree that they evoke fiction, fantasy and delusion.[34] For a long time, Raad presented himself as part of "The Atlas Group," a collective of his own devising, including a number of fictional participants.[35] Writers, curators and viewers did not necessarily know that Raad was the sole author of the work. Raad riffs on the conventions and authority of the archive. In doing so, he uses all different forms of information: photographs, video footage, interviews, lists, charts and diagrams. His main strategy for combining these forms is a quirky, unruly montage born of ceaseless research. He constantly undermines the credibility of his source material by inserting contradictions, impossibilities and disruptive visual elements.

For example, *Let's Be Honest, The Weather Helped* (1998/2006–7) (Fig. 3.6) takes the form of a series of photographs of collaged notebooks accompanied by a text. The notebooks, full of handwritten notes and diagrams about military ammunition, are overlaid with bland black-and-white photographs of war-damaged façades in Beirut. Each photograph is peppered with a series of multicolored dot stickers. The accompanying text reads:

> *Let's be honest, the weather helped* The following plates are attributed to Walid Raad who donated them to The Atlas Group in 1998. In the statement accompanying the donation, Raad noted:
> "Like many around me in Beirut in the late 1970s, I collected bullets and shrapnel. I would run out to the streets after a night or day of shelling to remove them from the walls, cars and trees. I kept detailed notes of where I found every bullet and photographed the sites of my findings, covering the holes with dots that corresponded to the bullet's diameter and the mesmerizing hues I found on bullets' tips. It took me ten years to realize that ammunition manufacturers follow distinct colour codes to mark and identify their cartridges and shells. It also took me another ten years to realize that my notebooks in part catalogue seventeen countries and organizations that continue to supply the various militias and armies fighting in Lebanon: Belgium, China, Egypt, Finland, Germany, Greece, Iraq, Israel, Italy, Libya, NATO, Romania, Saudi Arabia, Switzerland, USA, UK and Venezuela."

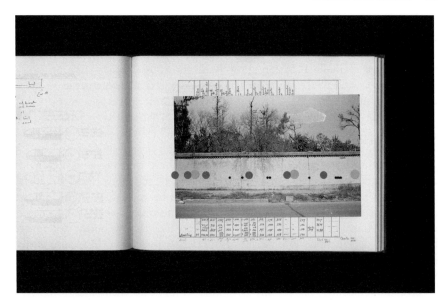

*Figure 3.6* Walid Raad/The Atlas Group, *Let's Be Honest, The Weather Helped (Libya)* (1998).

As with all of Raad's work, this strange composite document has elements of fact as well as fantasy. Bullets and shells were certainly fired in Beirut, and the countries on the list provided them. But were these photographs actually taken by a young Raad twenty years ago? While he might plausibly have recorded the sites of bullets found at waist height along a wall (a chilling image, evoking people being gunned down), how could he possibly have documented dozens of different hits on the roof of a building that looks near collapse? The system of coloured dots is logical to the alleged documentary task at hand, but their effect is to create a playful riot of color across black-and-white record photographs that might otherwise fail to catch our notice. As a source of factual information about the Lebanese civil wars, this set of plates is flawed, unreliable. The work offers the viewer several things at once: an aesthetic experience, a dose of documentary fact, a lesson in the globalization of the arms industry and a window into the personal experience of an artist growing up in a war zone.

Working as much with the contextualization and relationship of pieces of information as with the making of images, Raad is both conceptual artist and documentary photographer. He plants layered political messages in the work and simultaneously cultivates a poetics in his use of both visual materials and text. His creation of the Atlas Group as an umbrella of authorship allows him to use Walid Raad as a narrator, a compelling but unreliable sensibility to lead us through the material. In some ways Raad harkens back to the tone and mission of traditional documentary; he makes angry work that exposes deplorable situations and draws us into complicity with photography as witness. Yet

of all the artist-photographers in this chapter, Raad is the most slippery, offering misinformation and diversion. As Hélène Chouteau-Matikian describes it, "Raad never proceeds by direct denunciation, but always through assertion and displacement."[36] Tools of fiction allow Raad to explore reality without producing his own official account of events. Raad does not negate the value of documents but educates us to look at all images in more complex ways.

## Levels of fiction

As we have seen, contemporary art photographers are working with fictionality at several different levels. Some construct images to depict facts or events grounded in reality. Jeff Wall has often described his large-scale staged images as "near documentary." Luc Delahaye's composite images of actual scenes of conflict could also be read in these terms. Others use what we might describe as a "straight" documentary approach but in relation to real-world scenarios that are themselves simulations. Lê's photographs of war reenactments and military training exercises can be read in this light. Another approach involves re-presenting archival documentary images in ways that complicate them and force new readings; Broomberg and Chanarin have worked archivally in this way as well as producing performative, conceptual projects around photographic witnessing. Walid Raad deliberately blurs reality and fantasy, undermines authorship and challenges the very possibility of documenting events reliably. All of these photographers make reference to a documentary tradition from which they also clearly distance themselves, providing audiences with clear indications that their work is indeed constructed.

The mid-twentieth-century model of documentary dovetailed with a belief in the autonomy of the work of art and in the photographer as an agent of political activism. The photographers in this chapter operate in a different model in which meaning is socially produced and works of art are contingent texts, potentially activated by the interpretations of their viewers. Delahaye, Broomberg and Chanarin, Raad and Lê do not necessarily propose their work as offering critical resistance or opposition to the images of war produced elsewhere in the culture. Rather, they bring their viewers into an awareness of the circumstances surrounding the making of documentary images. In each case, we are not dealing merely with symbols and simulations but also with aspects of lived experience. As well as documenting real events to greater or lesser extent, these fictive documents provide the viewer with different models of experience.

Tangled up with political ideology, realism has been in constant crisis throughout the modern period. Writers and filmmakers have questioned and tested realist conventions in their own forms as photographers have in theirs. Photography's physical, chemical link to patterns of light and shade in the world has too often fooled viewers into thinking that it was a medium of transcription rather than construction. The works described in this chapter do not discount or replace photographs made with more traditional documentary agendas but they begin to suggest some of the possibilities for photography as a

medium for fiction. Fiction is not merely a mode for frivolous, diverting confections; it can provide tools for describing, testing and creating experience. Alain Robbe-Grillet, one of the theorists of the *nouveau roman* in the 1960s, made an eloquent pitch for fiction in his essay "From Realism to Reality:"

> not only does each of us see in the world his own reality ... the novel is precisely what creates it. The style of the novel does not seek to inform, as does the chronicle, the testimony offered in evidence, or the scientific report, it *constitutes* reality. It never knows what it is seeking, it is ignorant of what it has to say; it is invention, invention of the world and of man, constant invention and perpetual interrogation."[37]

Contemporary photographers and audiences are exploring the ways in which photography might participate in this project of discovery.

## Notes

1  For a historical overview of documentary and its critiques see Derrick Price, "Surveyors and Surveyed," in Liz Wells (ed.), *Photography: A Critical Introduction* (London and New York: Routledge, 2009), pp. 67–115.
2  W. Eugene Smith, "Photographic Journalism," *Photo Notes* (June 1948), pp. 4–5.
3  Frank Kermode, *The Sense of an Ending: Studies in the Theory of Fiction* (Oxford: Oxford University Press, 1967), p. 39.
4  See Gilles Mora and John T. Hill, *Walker Evans: The Hungry Eye* (London and New York: Thames & Hudson, 1993). John Tagg writes of Evans's work being suspended between documentary and lyric modes. See "Melancholy Realism: Walker Evans' Resistance to Meaning," in *The Disciplined Frame: Photographic Truths and the Capture of Meaning* (Minneapolis, MN: University of Minnesota Press, 2009), pp. 95–178.
5  See, for example, James Curtis, *Mind's Eye, Mind's Truth: FSA Photography Reconsidered* (Philadelphia, PA: Temple University Press, 1991).
6  Russell Roberts, "A Matter of Fact: The Rhetoric of Documentary 'Style,'" in *Fabula* (Bradford: National Museum of Photography, Film and Television, 2003), pp. 15–18.
7  For more on the ethics of documentary, see Susan Sontag, *Regarding the Pain of Others* (New York: Farrar, Straus and Giroux, 2002), David Levi Strauss, *Between the Eyes: Essays on Photography and Politics* (New York: Aperture, 2005), and Ariella Azoulay, *The Civil Contract of Photography* (Cambridge, MA: MIT Press, 2008).
8  See, for example, Christopher Phillips's critique of the curation of photography at the Museum of Modern Art in New York, "The Judgment Seat of Photography," in Richard Bolton (ed.), *The Contest of Meaning* (Cambridge, MA: MIT Press, 1993), pp. 14–47.
9  Martha Rosler, "In, Around, and Afterthoughts (on Documentary Photography)," in Richard Bolton (ed.), *The Contest of Meaning: Critical Histories of Photography* (Cambridge, MA: MIT Press, 1993), pp. 303–33.
10  Rosler, "In, Around, and Afterthoughts," p. 306.
11  With the Internet providing an important new outlet, photojournalism is having a renaissance, addressing many of its former blind spots head-on. See, for example, www.foto8.com. In the 1990s, American photography critic A. D. Coleman wrote an

essay recommending that committed photojournalists seek "a training in the crafts of writing, research, and graphic design, or in such relevant fields of study as anthropology, sociology, political science, economics, or psychology." This more academic approach has come to the fore with the advent of programs such as the London College of Communication's MA in Photojournalism and Documentary Photography. A. D. Coleman, "Documentary, Photojournalism and Press Photography Now: Notes and Questions," in *Depth of Field: Essays on Photography, Mass Media and Lens Culture* (Albuquerque, NM: University of New Mexico Press, 1998), pp. 35–52, at p. 46.

12 For more detailed definitions of documentary, social documentary and photojournalism, see Coleman, "Documentary, Photojournalism and Press Photography Now," pp. 35–52.

13 In an online *Guardian* article dated 31 January 2004, Peter Lennon notes that Delahaye's first series of thirteen images were sold at $15,000 a print. See http://www.guardian.co.uk/artanddesign/2004/jan/31/photography (accessed 24 September 2012).

14 For a meditation on the role of such images within art and culture, see Jacques Rancière, "The Intolerable Image," in *The Emancipated Spectator*, trans. Gregory Elliott (London: Verso, 2009), pp. 83–105.

15 Jean-François Chevrier, "The Tableau and the Document of Experience," in Thomas Weski (ed.), *Click Double Click: The Documentary Factor* (Cologne: Walter Konig, 2006), pp. 51–61. This essay builds on a discussion of *Tableau* that Chevrier laid out in an earlier essay, "The Adventures of the Picture Form in the History of Photography," in Douglas Fogle (ed.), *The Last Picture Show: Artists Using Photography, 1960–1982* (Minneapolis, MN: Walker Art Center, 2003), pp. 113–27.

16 For an account of the use of tableau in French history painting, see Thomas Crow, *Painters and Public Life in Eighteenth-Century Paris* (New Haven, CT: Yale University Press, 1987).

17 David Campany, "Safety in Numbness: Some Thoughts on 'Late Photography'," in David Green (ed.), *Where is the Photograph?* (Brighton: Photoworks and Photoforum, 2003), pp. 123–32.

18 Manuel Cirauqui, "Luc Delahaye," *Frieze*, 139 (May 2011): 127–8.

19 See, for example, Sean O'Hagan, "Luc Delahaye Turns War Photography into an Uncomfortable Art," *Guardian*, 9 August 2011. Available online at http://www.guardian.co.uk/artanddesign/2011/aug/09/luc-delahaye-war-photography-art (accessed 24 September 2012).

20 Campany, "Safety in Numbness," p. 132.

21 For a more detailed overview, see "Fictional Worlds and Fictionality," in Suzanne Keen, *Narrative Form* (New York: Palgrave, 2003), pp. 116–27.

22 Kermode, *The Sense of an Ending*, p. 39.

23 Kermode, *The Sense of an Ending*, pp. 126–52.

24 See, for example, the media furore over James Frey's semi-fictional memoir *A Million Little Pieces* (London: John Murray, 2004).

25 An-My Lê, Interview in *Cabinet*, 2 (spring 2001), available online at http://www.cabinetmagazine.org/issues/2/smallwars.php (accessed 24 September 2012).

26 Jean Baudrillard, *The Gulf War Did Not Take Place*, trans. Paul Patton (Sydney: Power Publications, 1995).

27 Karen Irvine, "Under the Clouds of War," Museum of Contemporary Photo, Chicago, IL, 2006, available online at http://www.mocp.org/exhibitions/2006/10/an-my_le_small.php (accessed 24 September 2012).

28 Mark Godfrey, "An-My Lê," in *Vitamin Ph: New Perspectives in Photography* (London: Phaidon, 2006), p. 154.

29 Documentation of the project, including the full video, is available on the artists' website: http://www.choppedliver.info (accessed 24 September 2012).

30 Adam Broomberg and Oliver Chanarin, talk chaired by Julian Stellabrass at the Courtauld Institute, London, 1 November 2009.

31 Broomberg and Chanarin talk.

32 *Colours* is an image-led magazine published by the research foundation of the Benetton apparel corporation.

33 Johanna Drucker, "Making Space: Image Events in an Extreme State," in Francis Frascina (ed.), *Modern Art Culture: A Reader* (London and New York: Routledge, 2008), pp. 25–45, at p. 138.

34 See Blake Stimson, "The True and the Blurry," in Achim Borchardt-Hume (ed.), *Walid Road: Miraculous Beginnings* (London: Whitechapel Gallery, 2010), pp. 123–9, at p. 123.

35 "The Atlas Group is a project established in 1999 to research and document the contemporary history of Lebanon. One of our aims with this project is to locate, preserve, study and produce audio, visual, literary and other artifacts that shed light on the contemporary history of Lebanon." See http://www.theatlasgroup.org (accessed 24 September 2012).

36 Hélène Chouteau-Matikian, "The Need for Profanation," in Achim Borchardt-Hume (ed.), *Walid Road: Miraculous Beginnings* (London: Whitechapel Gallery, 2010), pp. 131–9, at p. 135.

37 Alain Robbe-Grillet, "From Realism, to Reality," in *For a New Novel: Essays on Fiction*, trans. Richard Howard (Evanston, IL: Northwestern University Press, 1989), p. 161.

# 4  Authenticity

Authenticity has always been central to discussions of photography. The photograph's special relationship to the visible world has led to endless debates about the medium's claims to truth, validity and undisputed origin. This kind of authenticity has been fatally challenged by the theoretical and technological developments of the past few decades. Semiotics reduces the truth-value of the photograph to a set of crackable codes.[1] For example, we can easily identify the visual and contextual elements that would make a photojournalistic image operate in a convincing way to trigger empathy or outrage. This sense of constructedness makes it difficult for us to view any image as sincere. Post-structuralist theory goes even further to undermine notions of truth in photography and to reveal its inbuilt power relationships. Questions of whose truth and whose ideology might be at stake have made the quest for authenticity seem like a regressive humanist fantasy. The digital turn has led to the creation of images that have photographic features but are in fact partially or completely fabricated, with no indexical link to reality. Under these conditions, there would not appear to be much room for notions of authenticity without resorting to some kind of false naivety.

This chapter explores a particular set of ideas around the authentic in art photography after postmodernism. It will not be testing the truth-value of the subject of the photograph ("Is it real?"), nor will it be looking at whether specific images are verifiably attributable to particular times, places or makers ("Is it true?"). It is not even particularly invested in whether the pictures under investigation are true to the intentions of their makers ("Did they really mean it?"). The kind of authenticity at stake in this discussion is less to do with truth than with subjectivity as performed, enacted and negotiated in single images and in larger bodies of photographic work. We will examine a prominent strand of contemporary photography that is involved with this project.

Although they do not belong to any movement, the photographers in this discussion, including Nan Goldin, Wolfgang Tillmans, Muzi Quawson, Rinko Kawauchi and Ryan McGinley, have important similarities. In sharp distinction to the variants of objectivity discussed in Chapter 2, their works engage a sense of the subjective, the personal. They often include the photographer's own body

as well as his or her intimates. They depict everyday life with all its mess. Rather than pointing to a general state of affairs, they evoke idiosyncratic states and fleeting moments. Their focus is on feeling: physical sensation, emotion and sensibility.[2] The images have an informal style, related to the snapshot, and are usually presented in a serial flow. While many photographers could be invoked who fit this broad-brush description – and while authenticity can be an important issue in any mode of photography – these case studies crystallize key aspects of the authenticity debate.

My investigation of this topic began with a specific teaching problem: many photographers, especially students, want to make personal images that feel true to their own physical and emotional experience. Following the example of Goldin, Tillmans, et al., they photograph themselves and their environment and expect the images to reflect the intensity of their own feelings. In the context of photography education, however, such images may be criticized as essentialist, trite, self-involved, blankly disengaged from the broader world and failing to take control of what and how they communicate to a viewer. Yet for the photographers this mode remains very compelling. It seems to offer them a way to express their authentic, creative selves, and no amount of reasoned critique will dissuade them. This conflict becomes more pressing when the culture at large produces related images in ever-increasing numbers for the purposes of social networking and advertising.

In academic circles and in many aspects of mass culture, the past half-century has seen a postmodern view of the fragmented, socially constructed self eclipse of the Cartesian/Enlightenment view of the unified, autonomous subject. Yet much art photography continues to explore the notion of the self, vacillating between a traditional idea of self-expression and a range of more ambivalent positions. Such works may take many forms including the self-portraiture, portraits, still lifes, interiors and landscapes discussed here. Theorists with a commitment to the post-structuralist critique of subjectivity sometimes dismiss such work as romantic, hackneyed and bogged down in bourgeois self-delusion. Fans argue that – at its best – this mode of photography captures the essence of its makers' passionate lives. This affirmative stance, which might be characterized as humanist, has never disappeared altogether from art criticism and is currently resurgent.[3] As with many aspects of postmodern culture, it is possible to hold contradictory views simultaneously, to regard these images both as clichéd constructions *and* as expressions of pure feeling.[4]

The following discussion will sidestep the binary opposition between the post-structuralist and humanist positions on subjectivity – and even assume their uneasy coexistence – to examine some of the ways in which authenticity is addressed within contemporary literary theory, performance studies and philosophy. These disciplines, along with feminism, psychoanalysis and queer theory, offer some terms that may be used to make exploration of the self more relational and less self-indulgent. The goal is to discover fresh approaches to the problem of authenticity in photography after postmodernism.

## Deadpan vs. authentic

To clarify the problem, let us take a few moments to compare two sets of images. On the one hand, there are the deadpan images from Chapter 2, by Bernd and Hilla Becher (Fig. 2.2), Candida Höfer (Fig. 2.3), Frank Breuer (Fig. 2.5) and Thomas Struth (Fig. 2.6). On the other, there are the photographs we will examine in relation to the idea of authenticity: portraits, self-portraits and still life images by Goldin (Fig. 4.1), Tillmans (Fig. 4.2), Kawauchi (Fig. 4.5), Quawson (Fig. 4.6) and McGinley (Fig. 4.7). These two kinds of work circulate in the same markets and institutions but are valued in relation to different sets of priorities. The comparison is somewhat artificial but provides insight into the assumptions adhering to these different strands of contemporary photography.

The deadpan images, as we have seen in Chapter 2, are usually large, enormously detailed and evenly lit. Following in the tradition of the Bechers, they show their subjects from a distance, usually frontally, with a lack of obvious anecdote. The images that I am discussing in relation to authenticity, in contrast, come in all different sizes. Their presentation is often low-tech, their compositions casual, their lighting erratic. Their subject matter is usually figurative or drawn from everyday experience, presented in such a way as to be obviously personal, such as Tillmans's dirty dishes or Goldin's black eye. If a deadpan image like Höfer's is cool, presenting a deep space in a dispassionate way, an image like Quawson's is hot, drawing the viewer into a physical intimacy with the human subjects of her images via shallow depth of field. As we have seen, images like Breuer's are constructed to give a clear sense of distance, detachment, disinterestedness. A picture like Kawauchi's just-eaten melon, in contrast, is composed to give an impression of personal vision, a sense of the "I" of the photographer in the immediate moment of photographing. Bringing to mind the cool sweetness of the fruit, the image makes a claim on our senses of touch and taste as well as sight. Writers such as Michael Fried have argued that images like Struth's *Paradise* series create a field of pure, disembodied visuality, anti-theatrical and anti-narrative, producing a state of contemplation in the viewer. We could say that Goldin's work is designed to have an opposite effect, to evoke empathy, a kind of embodied, experiential recognition. The theatrical, narrative elements of her work draw viewers into projection and identification. To sum it up, we could say that if the deadpan images are read as primarily objective, their key affect is seriousness. The other set of images propose a connection between the subjectivity presented in the work and the subjectivity of the viewer. To achieve this, their desired affect is, above all, sincerity.

## Authenticity and the real

While little has been written about authenticity in contemporary photography, the topic overlaps with a recent revival of interest in the real. Writers have

begun to react against the idea that postmodernism ushered in an age of post-realism in which photography can only present simulacra and critiques of representation. Hal Foster invokes psychoanalytic terminology from the work of Jacques Lacan to describe a "return of the real," in which artworks with obscene and abject elements rupture the image-screen of representation.[5] He includes among his examples of this traumatic realism Cindy Sherman's pictures in which the body is grotesque, on the verge of dissolution. For Foster, such works reach out for the real by breaking down the body, the subject and the distinction between self and other.

In Lacan's psychoanalytic theory, the real is described as always just out of reach. It is the primal state of nature that we can never regain because we have entered language.[6] Foster describes photography as perpetually restaging the trauma of our missed encounter with the real.[7] Thus, following Roland Barthes, he regards all photographs as traumatic on some level, piercing our sense of self.[8] This reading is especially apt for projects that depict the human body *in extremis*. The real erupts when we are brought up against the limits of our bodies. This is certainly one version of authenticity, providing a potent antidote to the irony and detachment of much postmodern culture. Further examples of the traumatic real might include Boris Mihailov's ravaged homeless Ukranians or the raw eroticism of Nobuyoshi Araki's bound and tied nudes. Much of Nan Goldin's work can be seen in this light, particularly documentation of abuse, addiction and the fatal effects of HIV/AIDS on some of her dearest friends. However, the other photographers at the core of this discussion work in a more subdued, domestic register, seeking to touch rather than all-out shock the viewer. They can be read as reaching out towards the real, without intending to rupture the traditional representational image. Rather than a total breakdown of the self, they propose a subtle renegotiation of the barriers between private and public, self and world and self and other.

Foster's model of traumatic realism is theoretically based and favors photography that depicts the body. David Bate describes a more general shift. He writes of "a return to description, originality and actuality," in contemporary art photography, in direct opposition to postmodern appropriation, genre-mixing and semiotic play.[9] He sees this turn back towards the real as anti-theoretical, "a resistance to meaning and a negation of explanation, reasserting the old values of realist representation in a new way."[10] Bate regards this refusal of interpretation as a backlash against the heavy burden of textuality placed on photography within postmodernism. The version of the real Bate invokes is closer to the vernacular reality of our everyday experience and fits more closely with the images under discussion. Both Foster and Bate are describing a breakdown in the traditional relationship of photographs to the subject matter they depict, a new state of affairs in which images present more than they represent.

In a related account, "From Presence to the Performative: Rethinking Photographic Indexicality," David Green and Joanna Lowry also describe photography as having moved away from language and interpretation, instead

emphasizing the technology's capacity to point at things in the world. They underline this pointing as a gesture or performance. Green and Lowry see this tendency particularly in descriptive work that foregrounds the body. Their assessment of this work provides an overview of its visual tropes and also drips with critical disdain for the kind of project I am discussing in relation to authenticity:

> In the work of Nan Goldin, Jack Pierson, Corinne Day, Juergen Teller and Wolfgang Tillmans, the historically familiar tropes of realism – the every-day, the low and the mundane – are reworked through an iconography of the abject squalor and detritus of contemporary existence lived in a state of social and psychic restlessness. Seemingly consistent with this imagery is the language of rough-edged snapshot photography with all the signs of "bad" photographic technique and deliberately displaying a form of ama-teurism ... Whilst this styleless-style might not be particularly original, its studied casualness befits the subjective, autobiographical and diaristic nature of such a practice, not least by the fact that it foregrounds the notion of personal testimony in the evidence of an embodied vision. Indeed it seems to us that what these often blurred, badly focused and ill-composed images seek to do above all is to declare the bodily presence of the photo-grapher within a sensory field and to anchor a reading of the image in terms of an utterance designated by a first person pronoun.[11]

The key point of this passage is that such photographs function similarly to performative speech acts, as described by philosopher of language J. L. Austin. In Austin's view, spoken utterances can state facts ("The car is blue") or act upon the world in some way ("I declare war!"), and arguably in most cases do both.[12] For Green and Lowry, the photographs of Goldin, Tillmans et al. are performative in that they go beyond stating the visual facts of subcultural life-styles in announcing the presence of the maker's body within the world of the work. Such work uses visual clues of subject matter and photographic style to foreground an embodied, subjective "I" that guides the viewer's looking. Lowry and Green do not regard the subjectivity that emerges from the work as leading towards any kind of interpretation but rather as pointing mutely. As they put it: "Thus these forms of photographic practice, in their casual prolificness, do not so much represent the world as declare it to exist."[13]

All three of these discussions move photography away from postmodern critiques of representation, yet none of them wants to describe what is hap-pening as a move backwards into tropes of modernism. In particular, all three avoid any reference to the intentions of the maker. Foster goes so far as to identify his model as part of the post-structuralist critique of subjectivity, noting that within psychoanalytic theory, trauma has no subject.[14] Is it possible to speak of authenticity without speaking of the author? Why would we want to?

## From author to narrator

The images under discussion examine subjectivity and search for an authentic self. The subjectivity at stake, however, is not necessarily the author or artist as the key to all intention and meaning in the work. While the artists listed above are sometimes discussed in terms of unreconstructed humanism or even romanticism, they could also be discussed in relation to models of subjectivity that are responsive to the theoretical developments of the past few decades. Roland Barthes and Michel Foucault famously demolished the unquestioned authority of the author over the text, giving power of interpretation to the reader.[15] Yet Foucault argued in "What Is an Author?" that rather than being abandoned altogether the notion of the author should be "analysed as a complex and variable function of discourse."[16] In other words, he proposed that the author is less interesting as the origin of meaning than as a persona generated by and through the work of art.

Post-war literary theory has examined the author as constructed and reconstructed within a web of social and ideological strands.[17] This approach allows for the consideration of various shifting subjectivities within a text. The essays by both Bate and Green and Lowry seem to argue that photographic images are not operating as texts any more, that they just sit there and show, or – slightly more active – sit there and point. As we have seen in previous chapters, individual contemporary images are often resistant to interpretation. However, the serial structure and discursive framing (with titles, press releases, etc.) of most photography projects sets them up to be interpreted as texts. Without referring unnecessarily to biography or intention, it is possible to read photographs in relation to other images by the same photographer, within projects that have overarching themes, formal motifs and conceptual rationales. This might lead us to discuss photographs in relation to the "author-function" or to think of the photographer as a narrator with options about what kind of subjectivity or subjectivities he or she chooses to perform within the work.

For example, the photographer Sally Mann worked extensively with her own children in her "Immediate Family" series, taking lush, even erotic images of them looking dirty, bruised or under threat. A superficial reading of her work (and there were many in the 1990s) might simply regard Mann as a bad mother, abusing and exploiting her children. The approach suggested here would allow us to consider the ways in which Mann may be performing the role of negligent mother – alongside or overlapping with the roles of tender mother, controlling mother, all-knowing mother. Thinking of Mann as narrator of her work provides some space to consider the way in which she has skillfully crafted her pictures as texts, for example generating a kind of Southern Gothic, psychologically charged atmosphere evocative of the writing of William Faulkner or Tennessee Williams. This reading allows for the work to have the same intense, emotionally charged affect for viewers, but it also allows some breathing space between Mann's identities as mother and as maker. This makes it possible for the work to be read in more complex and satisfying ways.

## The authentic and the personal

Nan Goldin is even more tangled up in the reading of her photographs than Mann is with hers. Goldin's turbulent life is invoked time and again as proof of her work's authenticity. The photographer has used her public persona to reinforce this view across decades of interviews. She remains a potent role model for young photographers. This is because her project represents a struggle for authenticity on several levels, some of which transcend her own biography and motives to have more general implications for contemporary photography.

Most accounts begin with Goldin herself. She has described her work as arising intuitively, the result of an obsessive urge to photograph, rooted in her own body and subjective experience. In her words:

> People in the pictures say my camera is as much part of being with me as any other aspect of knowing me. It's as if my hand were a camera. The camera is as much a part of my everyday life as talking or eating or sex. The instant of photographing, instead of creating distance, is a moment of clarity and emotional connection for me.[18]

At the same time, critics have pointed out the degree to which Goldin's images are consciously crafted.[19] David Rimanelli has underlined this view by comparing her with Cindy Sherman: "the much-discussed 'construction' of Sherman's mise-en-scènes and Goldin's famous snapshot aesthetic are more similar than they first seem."[20]

Although it began as a live slideshow, narrated by Goldin in East Village nightclubs in the 1980s, Goldin's celebrated *Ballad of Sexual Dependency* has been reworked so many ways for different contexts and markets that it has become a case study in how subcultures are presented to mainstream culture. It is no longer possible to imagine that this is just raw, unmediated Nan. As one writer puts it: "*The Ballad of Sexual Dependency* is simultaneously a document of feral immediacy and a retrospective mediation on how such immediacy is figured."[21] At stake here is a set of paradoxes, that Goldin's work can be simultaneously instinctive and contrived, spontaneous and self-aware.

We could regard this as a situation of admirable complexity rather than as hopeless confusion. One thing we seem likely to agree on nowadays is that photographs are layered and ambiguous, contingent on their immediate as well as historical contexts. It is also commonplace for contemporary photographers to employ a range of disparate visual approaches within the same overarching project, producing an array of mixed messages. Goldin's work is often described in relation to a "snapshot aesthetic." Casual arrangement of shapes within the frame, use of flash and 35mm slide film blown up to expose its grain in large-scale and contrasty Cibachrome prints contribute to a sense of the work being immediate, diaristic, as in the iconic *Nan One Month After Being Battered* of 1984 (Fig. 4.1). Yet peppered throughout her oeuvre are images – some of them made with a large-format camera – which are more deliberately

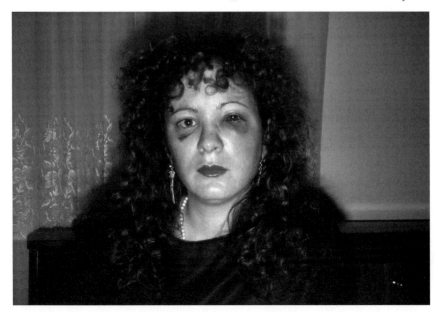

*Figure 4.1* Nan Goldin, *Nan One Month After Being Battered* (1984).

composed. *Self-Portrait in My Blue Bathroom* (Berlin, 1991) has complex lighting and precise framing that bends space and creates a taut psychological narrative. Is one of these images more authentic than the other? The earlier image has visual markers of authenticity and acts as a kind of signpost image within Goldin's project, contributing to a broader discursive frame within which the more formally structured image can also be read as authentic. In other words, Goldin's larger project is a vehicle through which she may negotiate viewers' trust.

For some viewers, Goldin's work misses the mark of authenticity. Some critics have accused Goldin of exploiting herself and her subjects to produce manipulative, sensationalistic images. Others find her work formulaic, such as Mark Zimmermann, for whom it "is merely trite and passably academic, most successful for its creation of an advertising style than for what it says of the lives, including her own, she chronicles."[22] Goldin has been a prominent photographer for almost thirty years, but her sustained investigation of subjectivity, relationships and loss continues to serve as a potent model for young photographers. It was the search for a critical framework to discuss the mechanics of her work that led me to consider the concept of authenticity more broadly, to seek its roots and ramifications for the current era.

## Authenticity in context

Authenticity is an interdisciplinary term, central to Western art and culture. It has been a subject for philosophy since classical times (with Aristotle's moral

perfectionism as an early example), and the search for the authentic self played a key role in twentieth-century psychology and literary theory. In the late twentieth century, the concept became tainted by its associations with sensationalist romanticism, essentialist humanism and commercialized self-help movements. In *On Being Authentic*, his illuminating overview of the topic, American philosophy professor Charles Guignon traces the history of authenticity and makes a compelling argument for its ongoing usefulness as a cultural idea.[23]

The project of authenticity involves the pursuit of self-knowledge. At its core, authenticity involves withdrawing from any posturing or false self in order to turn inward. Second, it requires action: living the life that expresses the self discovered within. It is a key aspect of authenticity that it is hard won, not a default position, and without constant vigilance it can easily slip away. Some aspects of our contemporary notion of authenticity have come to us from classical philosophy and Christian theology, both of which pursued the goal of turning inward in order to come closer to a truth outside the self. Some of the most powerful influences on our current conception come from late-eighteenth- and early-nineteenth-century romanticism and from modern psychology, both of which locate truth internally. From the romantics, we take the view that personal freedom is a key goal of self-discovery; from the psychologists we learn that our childhood feelings, desires and needs lie at the core of who we really are. Guignon is quick to point out that both of these models can be dangerously asocial. The goal of freedom makes eminent sense in the face of oppression, but in an already free and democratic society can lead an individual into solipsism. The pitfalls of a worldview privileging the unfettered desires of our inner child are all too clear.

What makes Guignon's account particularly relevant to the current discussion is his sensitivity to both the benefits and drawbacks of post-structuralist theory. While, on the one hand, our entire intellectual framework has been transformed by the postmodern view of the de-centered self, there are vital elements of our lived experience that cannot be adequately understood or contained within discourse and representations. Guignon argues that most of us simply cannot manage without some working model of subjectivity in our own lives. Contemporary North American philosophers, including Charles Taylor and Stanley Cavell, have argued that the project to discover and be true to the self is not self-indulgent, but essential. They describe being authentic as a project involving constant vigilance, attentiveness, activism and open and free conversation with others.[24] The body cannot be ignored. As Taylor puts it, "Our understanding itself is embodied. That is, our bodily know-how and the way we act and move, can encode components of our understanding of self and world."[25]

These aspects of the discussion might lead us back to Goldin's work, inviting us to test her oeuvre against the idea of authenticity as a project rather than a state to be attained, as something struggled for and easily lost. This model of authenticity is useful because it allows us to assess her project more broadly,

allowing for the fact that it may fall down in places, and that certain images may ring false. For example, in her "Heartbeat" series (2000–1), we see a slide show of 245 images of four couples making love, accompanied by a soundtrack of Björk singing John Tavener's "Prayer of the Heart."[26] Several of the individual images draw us into a compelling sense of intimacy within a fleeting moment. Others feel awkward and make us creepily aware of Goldin as voyeur. The music and flow of images sweep the viewer into a live sensory experience that is periodically punctured.

Part of the problem lies in Goldin's changing position in relation to her subject matter. Photographing herself and her peers, she has relied on the closest possible relationship to her subjects. As Andy Grundberg put it in 1986: "What makes Goldin's unquenchable desire to depict such things palatable is, in part, her willingness to turn the camera on herself with equal candor. She is as unsparing of her own privacy as she is of that of her subjects."[27] This dynamic has necessarily changed over time. While Goldin continues to photograph herself, her friends and lovers, she also counts on the credibility she has established as a narrator to introduce new characters, not all of whom are plausible as intimates of Nan Goldin the author. Some of the young European couples in *Heartbeat* come across as glamorous exhibitionists performing for Goldin's celebrated lens. Yet the piece as a whole is an ambitious attempt to capture physical and emotional intimacy. The struggle for authenticity is palpable if not entirely successful.

Photographers have a number of different elements at their disposal for negotiating a sense of authenticity. Subject matter – and a direct relationship to it – is the most obvious, but style and presentation are also crucial to the way that viewers perceive the work. In keeping with the idea that authenticity is an ongoing project, it is important that the visual form of the work does not appear formulaic.

## Presenting the authentic

Wolfgang Tillmans has constantly tested new modes of presentation to revitalize his practice. Emerging as an artist during the recession of the early 1990s, against a backdrop of grunge rock and "heroin chic," Tillmans made an impact with his conspicuously casual approach. In sharp contrast to the slick framing and signature styles that were becoming the norm for photography in art galleries, Tillmans's early exhibitions at New York and Cologne featured a non-hierarchical jumble of colour, black-and-white and inkjet prints, in all different sizes, pinned or taped to the wall (Fig. 4.3). Throughout his career his subject matter has encompassed all aspects of his life, scene and preoccupations, ranging from dirty dishes to house mice and from nightclubbers to Concorde flying overhead (Fig. 4.2). Treating his imagery as a DJ might treat his record collection, Tillmans recycles various favorite images from show to show and indiscriminately mixes in his own postcards and magazine spreads. The governing logic is Tillmans's own sensibility and his preoccupations of the moment.

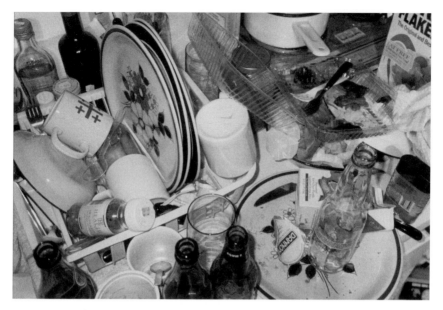

*Figure 4.2* Wolfgang Tillmans, *Kitchen Still Life* (1995).

*Figure 4.3* Wolfgang Tillmans, installation view, untitled exhibition, Buchloz & Buchloz, Cologne (1993).

Tillmans's scrappy eclecticism has evolved into a distinctive signature style. He has a particular attitude to living and a sense of visual style that is linked to the artistic and bohemian subcultures in which he participates. His sensibility is personal, but it is explored in an unusually rigorous manner. Each exhibition, which he treats as a site-specific installation, can be regarded as an investigation into his life, relationships and context. Over time, this idea of an interrogation of the everyday has become even more prominent, with an exhibition in the mid-2000s entitled *truth study center* (Fig. 4.4), presenting a mix of old and new imagery in wood vitrines. The message of all this studied casualness is, of course, that Tillmans takes living authentically very seriously. He uses photography both as a mode of documentation and also as a means of processing and sharing his findings. Tillmans's constantly evolving installations encourage active, participatory reading.

An innovative, questing approach to presentation characterizes the work of many photographers associated with the idea of authenticity. While these modes of presentation are usually drawn from a familiar repertoire of possibilities, they are reconfigured and made new from one display to another. For example, Rinko Kawauchi's work has a striking directness, provided in part by the forms in which it appears (Fig. 4.5). Unframed, her images are either pinned to the gallery wall or mounted to float in loose constellations, encouraging viewers' eyes to drift and roam. Kawauchi's photographic books are sequenced in a non-linear manner, with exquisite attention to detail. In her book *Cui Cui*, for example, one photograph may have a slight visual or thematic echo with the next, but image size, orientation, format and genre are kept in flux. *Cui Cui* is in some ways an album, documenting Kawauchi's family and personal

*Figure 4.4* Wolfgang Tillmans, installation view, *truth study center*, Maureen Paley, London (2005).

*Figure 4.5* Rinko Kawauchi, *Untitled*, from the series "Cui Cui" (2005).

experience over thirteen years. Careful attention to presentation belies the idea that the work is somehow just transparent, unmediated subjectivity. It creates a frame in which viewers can form their own associations alongside the photographer's "I."

Muzi Quawson first displayed her *Pull Back the Shade* as three 35mm slide loops, each projected onto its own screen (Fig. 4.6).[28] Focused around the experience of a central female character, young mother and musician Amanda Jo Williams, the series of fleeting images builds an intimate portrait that unfolds in the dark space of the gallery, accompanied by the click of projectors and the whirr of their fans. Recording all manner of private, mundane moments over a four-year period, the series also documents the sympathetic presence of the photographer. The extended portrait is visibly rooted in a personal relationship of affection and trust. Quawson's gritty, attractive images of life in America are filtered through well-known influences from art (not least Goldin) and 1970s American film. Yet the installation – holding the images in a space

*Figure 4.6* Muzi Quawson, *Inside the Bluehouse*, from the series "Pull Back the Shade" (2002–6).

partway between still image and film – provided a carefully modulated sense of immediacy.

## Performativity

A number of recent articles about photography have followed J. L. Austin's theory of performativity in language to postulate an active function for certain photographic images. Certain images primarily show, depict or point at their subject matter while others add to this function a more active, performative relationship to the world. If we can "do things" with photographs, what might we choose to do with them? In a separate discussion from the article cited earlier, Joanna Lowry has noted a recent shift away from considering photographs as images in favour of examining them as a set of performative practices that allow the technology to perform different functions. As she puts it:

> Surrealism, Conceptualism, performance art, postmodernism, and installation art have each, at different moments in time, played a role in suggesting how photographic technologies could engage with meaning in the world. They have responded to the technology's potential for inventing, documenting, archiving, mimicking, enacting, and engaging, in ways that are far more provocative than most theoretical debates.[29]

To take this discussion to another level, we could describe certain types of photography in terms of their ostensible function, what they set out to do. For

example, the traditional functions of documentary have included to reveal, to unmask, to defamiliarize or to criticize. Narrative photography could be read as setting out to dramatize or even to entertain. Alternatively, we could describe this performativity in terms of the ways it might activate a viewer, i.e. to move, to irritate, to awaken, to activate empathy or imagination. In this model, photographs could be understood as actions, rather than being decoded as meanings, a shift that places the work in the realm of the social and thus need not necessarily be located in the intention of the author. In this sense, images like the ones discussed above could be read as propositions or provocations rather than as transparent records of states or events. Also drawing on the idea of performativity, we might refer to a writer such as Judith Butler, and the idea of identity as a performance (operating from compulsion and coercion as well as from conscious choice).[30] This view activates us as audience members to consider the ways in which the photographers are embedded in maps of social power relationships rather than looking to the individual makers as origin and endpoint of meaning.

The emphasis on the recipient of the work is carried through in some of the literary theories we might apply to think more deeply about authenticity. Literary theorists from Mikhail Bakhtin and Raymond Williams to F. R. Leavis have explored the possibility that subjectivity may be investigated through fictional means, i.e. that texts may educate a reader without being true, or even that they may be hypocritical in instructive ways. For example, Madame Bovary, Gustave Flaubert's most celebrated heroine, is a mass of romantic delusions. Some theorists have read her as a model of inauthenticity, a paragon of how not to be. Others have viewed her more sympathetically, as a well-rounded figure, deeply flawed, but still worthy of our compassion.[31] In either interpretation, her life as represented in the novel is a serious exploration of human subjectivity, a lesson in living pursued through a fictional account of the life of a fantasist. Much literary theory continues to posit self-knowledge and understanding as key aims and to assert that the aesthetic cannot be separated from the moral in the work of literature.

## Marketing the true self

In photography as in literature, a work of art can only be or become authentic in its social context, use and reception. Some contemporary critics regard the exploration of authentic subjectivity in art as fatally compromised because it is inextricably bound up with the neoliberal formulation of personal freedom sold to us through advertising. Since Goldin and Tillmans came to prominence in the 1990s, there has been a remarkable blurring of the line between our private selves and the vision of ourselves provided by consumer culture. One of the most obvious symptoms of this change is the way that many of us use social-networking sites to display our lives, simultaneously providing personal information to corporations. Many are comfortable with the idea of being defined by consumer choices, for example allowing online purchases to be tweeted

automatically to contacts. In her 2011 book *Where Art Belongs*, Chris Kraus presents American Apparel's highly successful global marketing campaign as a case study of this blurring of self-expression and consumerism: "The company keeps apartments in dozens of cities where employees take retro-porn pictures of each other – the same kind of pics taken and archived by millions of people on Facebook – that will be used in company ads. Business is transacted as flow."[32] American Apparel uses this approach to tap into the authenticity produced in the lived experience of its attractive young employees. The goal, of course, is to attract other young people to the company's products with the image of a creative, sexy lifestyle. Kraus identifies this meltdown of image and market as the inescapable condition of contemporary art as well as life.

Several of the photographers discussed in this chapter have lent their skills to fashion editorial and advertising assignments. Tillmans's early project was partially premised on the interchangability of his ultra-hip anti-fashion magazine work with the rest of his imagery. Ryan McGinley stands for further collapse of the supposed separation between authenticity and consumerism. A self-promotional prodigy, McGinley followed up a self-published artist's book of his undergraduate photography work with a solo show at New York's Whitney Museum of American Art when he was only twenty-six. The images soon began appearing for sale at photography fairs: grainy 35mm images of naked boys and girls having fun, blown up much larger than life and expensively framed. An image like *Kiss Explosion* of 2005 is representative; young and good-looking, the two male nudes are intertwined in an embrace, with a foamy liquid (beer?) spewing from their joined mouths (Fig. 4.7).

The work is marketed with claims about the photographer's immersive relationship to his subject matter:

> Youth, liberation and the joy of losing yourself in the moment are elements that feature in Ryan McGinley's work, from his early roots in documenting the urban adventures of his downtown Manhattan friends to his subsequent cross-country travels in utopian environments throughout America to his most recent studio portraits.[33]

The McGinley myth also includes tales of his privileged background as New York club kid and protégé of Larry Clark and his easy rapport with a staff of carefully screened assistant-model-friends. His visually appealing pictures have won over many viewers. Does it matter that the spontaneity on view has been stage-managed at great expense or that it overlaps significantly with the advertising and fashion campaigns that he has produced over the same time period?[34] Does McGinley succeed in producing a convincing narrative "I," in conveying a compelling link with his subjects?

Despite tremendous success in terms of sales, commissions and exhibitions, McGinley has not been the subject of much scholarly writing. Some of the most heated discussion of his work takes place in the blogosphere. Online critic Jonathan Blaustein describes initial reservations rooted in ambivalence about

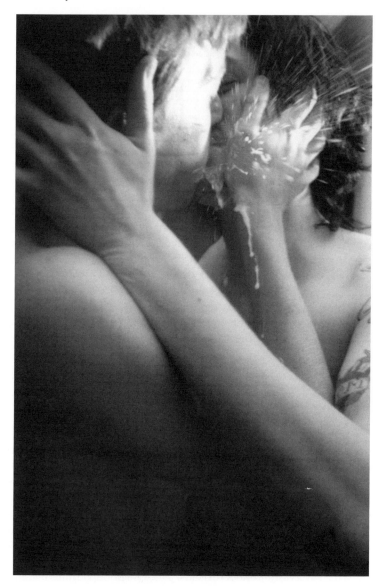

*Figure 4.7* Ryan McGinley, *Kiss Explosion* (2005).

its easy consumability: "How hard is it to sell a photo of a gorgeous naked hot chick? Anyone can do that. Whatever."[35] However, in reviewing McGinley's 2012 monograph *You and I*, Blaustein describes being gradually won over by a cohesive artistic vision, a consistent shooting style and a seductive palette: "There are easily more than a hundred plates, shot over a ten year time range. What I mistook long ago as cynical booty-peddling has clearly become the artist's obsession and passion, as valid as anyone's."[36]

Despite attempts to articulate it in more concrete terms, the test of authenticity continues to rest largely in the eye of the beholder. McGinley has convinced a previously skeptical blogger. But for me, sustained visual enjoyment is not enough. McGinley's pictures continue to miss the mark of authenticity because they offer style rather than struggle. They embody the upbeat, uncomplicated version of the authentic favored by advertising. Artistic authenticity does not necessarily involve pain, although it has frequently been associated with the darker side of life, with violence and unreason.[37] But there must be a palpable sense of inquiry, something I have sought to establish in the work of Goldin, Tillmans, Quawson and Kawauchi. McGinley uses nakedness as a shorthand and pleasure as an easy endpoint. His lovely subjects seem more or less interchangeable, so their relationship to the "I" of the work does not develop.

Moral indignation about McGinley's endless summer party may be dull but it is appropriate to the discussion at hand. Authenticity has traditionally been a moral mode, its goal is – at least to some extent – didactic. As Lionel Trilling describes it in his book *Sincerity and Authenticity*, "The authentic work of art instructs us in our inauthenticity and adjures us to overcome it."[38] The project is not merely to be at one with ourselves but to revise ourselves for the better. Even if we choose not to commit to the idea that art can improve us, we might still want to take a stand for art as something that unfolds.

## Outside interpretation

We have seen that a number of writers are moving away from discussing photography in relation to theories of representation and discourse (the focus of postmodernism in photography), moving instead towards some version of the real. This shift is paralleled in recent French philosophy.[39] If the structuralist and post-structuralist paradigms of meaning focused on the discursive and the coded, philosophers in the 1990s have revisited phenomenology, returning to discussions of finite lived experience, the symbolic and the real. A philosopher like Jean-Luc Nancy explores the way that the subject is constituted in and by the materiality of the real. If postmodernism described subjectivity as an effect of discourse, a byproduct of language, Nancy describes subjectivity as a process, a material operation that is based in concrete sensory engagements with reality.[40] While few writers on photography have begun to engage with this set of ideas, it certainly parallels an interest by the photographers in this chapter to explore the subject as something that emerges from the body in relation to other bodies.

The postmodern view of cultural artefacts as texts put a great deal of responsibility for art's meaning into the hands of critics and art historians. As we have seen at various points in this book, this model has worn thin over the past few years, with artists increasingly interested in short-circuiting interpretation to give precedence to viewers' direct experience of the work.

Contemporary art photography can be read as offering openings onto the real, not merely representations of events taking place in another time and place but also sensory encounters that are present in themselves. The trouble with these terms is that they are so open as to let in just about any image.

Perhaps this radical openness lies at the heart of the matter. Is authenticity really about interpretation, moral efficacy or value judgements? Or is it about a kind of immediacy, presence and immanence of the artwork, an experience that cannot be denied? The pendulum has swung in contemporary art, and in the past decade there have been far more works whose meaning is ambiguous or even opaque that warmly embrace the list of negatives ascribed to the hypothetical student photographs at the beginning of the chapter. The left-leaning, theoretically engaged writers who drove postmodernism in art might be appalled, but this may well be where the quest for the authentic image is leading at this moment in history: towards individual meanings that may or may not connect to each other.

As we have seen, however, the photographers in this chapter are not producing images in a vacuum. While their pictures may sometimes circulate singly, and are available to be read as fields of pure presence, they are made in series, within an art system that still values interpretive frameworks. In other words, it is almost impossible for a contemporary art photographer to produce a purely visual experience for the viewer, as the work is accompanied, however loosely, by concepts and theories articulated in language. Thus, every artwork is experienced on more than one level, both as a distinct moment of individual experience and also as part of a shared discourse.

To return to the central theme, how might we sum up this quest for authenticity in the practice of certain contemporary photographers? Their work presents a particular sensibility or subjectivity, articulated as being in the first person, i.e. narrated by an "I" interdependent with others. The work often refers to the body with a poignancy, verging on trauma, that may touch the viewer's own sense of self. At its best, the work is constituted by an active mode of address, a performance of this sensibility or search for self-definition, made manifest via a particular subject matter and presentation, both of which are negotiated without ever being completely resolved. This gives a sense of an investigation of and into the self, with competing strands. The work usually contains a refusal of completion: these are not self-enclosed *tableaux*. With their rough edges and loose ends, the pictures remain deliberately contingent. Individual images strive for a sense of immediacy and presentness, while larger bodies of work articulate particular versions of the struggle for authenticity via presentation and textual framing.

It is no easy task for photography – the medium of outward appearances – to look inward. The project is fraught with risk and often comes with accusations of self-indulgent romanticism or outmoded humanism. No wonder so many photographers prefer to stay inside the safety zone of visual neutrality. The term "authenticity" bears fresh possibilities in the era following postmodernism. It provides a theoretical prism for considering how photographic art might

pose alternatives to the inauthenticity of our consumer culture. Even if we regard ourselves as de-centered subjects constructed by culture, we still need a working – and ever-evolving – understanding of ourselves to remain in relationship with others. While the idea of photographic authenticity has traditionally relied on the idea of an unmediated transparency between photographer and subject matter, literature has operated on a more flexible model in which the authentic can be constructed, modulated and nuanced through narrative. We have seen some of the ways in which photographers make use of these strategies and ways in which viewers might benefit from interpreting images in these terms. Performance studies suggest some of the ways images might activate us as viewers, freeing us further from the need to locate meaning in the photographer's intention. Although subjectivity came under attack in post-structuralist theory, some philosophers have returned to an examination of the embodied subject. The photographers examined in this chapter present this project in visual terms. Authenticity is an elusive, ever-moving target. Although impossible to attain fully, it remains a worthy goal for the contemporary photographers who seek it.

## Notes

1 Classic texts on the semiotic analysis of photography include Roland Barthes, "Rhetoric of the Image," in *Image–Music–Text*, trans. Stephen Heath (New York: Noonday Press, 1977), pp. 32–51, and Umberto Eco, "Critique of the Image," in Victor Burgin (ed.), *Thinking Photography* (London: Macmillan, 1982), pp. 32–8.
2 Theorist Rei Terada highlights the dual nature of feeling, defining it as "a capacious term that connotes both physiological sensations (affects) and psychological states (emotions)." Her work offers productive ways to consider emotion alongside post-stucturalist theory. See *Feeling in Theory: Emotion After the "Death of the Subject,"* Cambridge, MA: Harvard University Press, 2001, p. 4.
3 Critic Sally O'Reilly describes a recent "re-admittance of humanism into art" particularly as regards the human body as a signifier of lived experience. *The Body in Contemporary Art* (London: Thames & Hudson, 2009), pp. 7–8.
4 For an example of sustained interpretive contradiction in postmodern art, see Hal Foster's reading of Andy Warhol's disaster silkscreens: "Can we read the 'Death in America' images as referential *and* simulacral, connected *and* disconnected, affective *and* affectless, critical *and* complacent? I think we must." "Death in America," *October*, 75 (winter 1996): 36–59, at p. 39.
5 Hal Foster, "Obscene, Abject, Traumatic," *October*, 78 (autumn 1996): 107–24. This essay is extrapolated from a broader discussion in Foster's book *The Return of the Real* (Cambridge, MA: MIT Press, 1996).
6 For a concise account see Ellie Ragland-Smith, "The Real," in Elizabeth Wright (ed.), *Feminism and Psychoanalysis: A Critical Dictionary* (Oxford: Blackwell, 1992), pp. 374–7.
7 Foster, "Death in America."
8 Margaret Iverson's essay "What Is a Photograph?" elucidates the links between Barthes's *punctum*, Jacques Lacan's notion of the real and the understanding of trauma in psychoanalysis. In Geoffrey Batchen (ed.), *Photography Degree Zero: Reflections on Roland Barthes's* Camera Lucida (Cambridge, MA: MIT Press, 2009), pp. 57–74.

9  David Bate, "After Thought: Part 1," *Source*, 40 (autumn 2004): 30–3, at p. 33.

10 David Bate, "After Thought: Part 2," *Source*, 41 (winter 2004): 35–9, at p. 38.

11 David Green and Joanna Lowry, "From Presence to the Performative: Rethinking Photographic Indexicality," in David Green (ed.), *Where Is the Photograph?* (Brighton: Photoworks, 2003), pp. 58–9.

12 Austin considers the possibility that "constative utterances," or statements of fact, may become performative in contexts in which they become actions (such as answering a question or contradicting another statement). He also argues that constative functions such as stating, reporting and describing are themselves active, and no less performative than arguing, betting or warning. J. L. Austin, *How to Do Things with Words* (Cambridge, MA: Harvard University Press, 1962).

13 Green and Lowry, "From Presence to the Performative," p. 59.

14 On the other hand, Foster notes that within psychology and popular culture trauma is the absolute guarantee of the subject. Thus he sees much of the art of the 1990s as being shadowed by a "zombie" author. Foster, "Obscene, Abject Traumatic," p. 124.

15 See Roland Barthes, "The Death of the Author," in *Image, Music, Text*, trans. Stephen Heath (New York: Noonday Press, 1977), pp. 142–8, and Michel Foucault, "What Is an Author?" in *Language, Counter-memory, Practice*, trans. Donald F. Bouchard and Sherry Simon (Ithaca, NY: Cornell University Press, 1977), pp. 124–7.

16 Foucault, "What Is an Author?" as quoted in Janet Wolff, *The Social Production of Art* (New York: New York University Press, 1981), p. 123.

17 For a useful overview of critiques of authorship, see Wolff, *The Social Production of Art*, chapter 6.

18 Nan Goldin, *The Ballad of Sexual Dependency* (New York: Aperture, 1996, first published 1986), p. 6.

19 See, for example, Susan Fisher Sterling (ed.), *Role Models: Feminine Identity in Contemporary American Photography* (New York: Scala, 2008).

20 David Rimanelli, "Being Nan Goldin: David Rimanelli Gives His Class Homework," *Artforum*, 43 (10) (summer 2004), pp. 85–8.

21 Chris Townsend, "Nan Goldin: Bohemian Ballads," in Alex Hughes and Andrea Noble, eds., *Phototextualities: Intersections of Photography and Narrative* (Albuquerque, NM: University of New Mexico Press, 2003), pp. 103–18, at p. 114.

22 Mark Zimmermann, "Review: Nan Goldin and Lyle Ashton Harris," *Performing Arts Journal*, 19 (1) (January 1997): 44.

23 Charles Guignon, *On Being Authentic* (London and New York: Routledge, 2004).

24 Guignon, *On Being Authentic*, p. 162.

25 Charles Taylor, *Philosophical Arguments* (Cambridge, MA: Harvard University Press, 1995), p. 170.

26 "Heartbeat" was produced as a commission for the Centre Pompidou in Paris to be the centerpiece of a major retrospective.

27 Andy Grundberg, "Nan Goldin's Grim 'Ballad,'" *The New York Times*, 30 November 1986, reprinted in *Crisis of the Real: Writings on Photography Since 1974* (New York: Aperture, 1999), p. 97.

28 "Tate Triennial 2006: New British Art," 1 March–14 May 2006, Tate Britain, London. In later gallery exhibitions some of the images have been displayed as light boxes.

29 Joanna Lowry, "Desiring Photography," in James Elkins (ed.), *Photography Theory* (London and New York: Routledge, 2007), pp. 313–18, at p. 316.

30 See, for example, Judith Butler, *Gender Trouble: Feminism and the Subversion of Identity* (London and New York: Routledge, 1990).

31 These two views, representing Nathalie Sarraute and Lionel Trilling, are discussed in Trilling's essay "The Heroic, the Beautiful, the Authentic," in *Sincerity and Authenticity: The Charles Eliot Norton Lectures, 1969–1970* (Cambridge, MA: Harvard University Press, 1972), pp. 81–105.

Authenticity 91

32 Chris Kraus, *Where Art Belongs* (Los Angeles, CA: Semiotext(e) Intervention Series, 2011), p. 136.

33 Press release, 2011, from the Galerie Gabriel Rolt, Amsterdam.

34 McGinley estimates that a three-month road trip costs $100,000. Philip Gefter, "A Young Man with an Eye and Friends Up a Tree," *The New York Times*, Sunday, 6 May 2007, Arts Section, p. 21.

35 Jonathan Blaustein, "This Week in Photography Books: Ryan McGinley," 12 March 2012. Available online at http://www.aphotoeditor.com/2012/01/27/this-week-in-photography-books-ryan-mcginley (accessed 24 September 2012).

36 Blaustein, "This Week in Photography Books."

37 Trilling, *Sincerity and Authenticity*.

38 Trilling, *Sincerity and Authenticity*, p. 100.

39 For an introductory discussion of contemporary French thinkers such as Jean-Luc Marion, Jean-Luc Nancy, Bernard Steigler, Jacques Rancière and Alain Badiou, see Ian James, *The New French Philosophy* (London: Polity, 2012). My brief account of Nancy is heavily indebted to James's eloquent lectures at the Royal College of Art over the past few years.

40 See Jean-Luc Nancy, *The Sense of the World*, trans. Jeffrey S. Librett (Minneapolis, MN: University of Minnesota Press, 1997), and Marta Heikkilä, "The Body of Sense," in *At the Limits of Presentation: Coming-into-Presence and its Aesthetic Relevance in Jean-Luc Nancy's Philosophy* (Frankfurt: Peter Lang, 2009), pp. 114–18.

# 5 Digital Dialogues
## Spectacle and Spectators

Digital photography is not new any more. Today's artists are heirs of the digital revolution. They no longer need to agonize over the identity of digital photography or questions of digital truth.[1] They use digital technology both to make photographs that operate in traditional ways and to generate forms that could not have been anticipated twenty years ago. The first generation of digital imaging was dominated by illusions and fantasies.[2] Contemporary practice includes a much wider range of strategies, many of which are grounded in aspects of vernacular image-making. This chapter does not propose to describe the full spectrum of current digital activities but rather to explore a particular axis. It explores, on the one hand, photographic works that create immersive visual spectacles and, on the other, works that foreground their materiality, engaging more with the everyday uses of digital images.

First we will explore works by Andreas Gursky and Gregory Crewdson involving high budgets, elaborate technology and, in some cases, full cinematic crews. While their subject matter is very different, these artists both use digital technology to push their images into the realm of hyper-photography, an impossibly perfect mode of heightened representation.[3] This is the closest art photography has ever come to matching the visual seduction of commercial entertainment culture. In counterpoint to these eye-popping digital spectacles, we look at more modest works by Eva Stenram, Jon Rafman, Kenji Hirasawa and Richard Kolker. These photographers use a range of technologies – internet image appropriation, thermographic imaging and three-dimensional animation software – to reflect on identity, perception and experience in a digital age. Their works have spectacular aspects but take specific material forms that open up a discussion about the nature of contemporary spectatorship.

Throughout the twentieth century, art photographers were expected to maintain a critical distance from mass culture. Some of the photography examined in this chapter appears to affirm or even celebrate the production values formerly associated with mainstream cinema, computer games or high-end advertising. How should we read such works? Are they meant to offer implicit critiques of the world they depict? Or are they offering something different from the critical stance that has long been the measure of seriousness in contemporary art? We enter this debate by revisiting the art-world discussion

around the society of the spectacle and examining some recent theories about the role of the artist, the artwork and the viewer. We will look at some of the ways in which both art photography and critical writing are tracing a shift in emphasis from the critique of the spectacle to the experience of the spectator. While this dynamic is present in contemporary art more broadly (and will be discussed further in the final chapter), here we will look at particular ways it is mediated in contemporary digital works.

When digital photography was first introduced, there was a kind of hysteria on the part of some writers and audiences, a panic that the new technology would undermine the truth-value of the photographic image.[4] Some argued that images made up of infinitely manipulable code would no longer carry reliable traces of the visible world. Of course this anxiety rested on a misunderstanding of traditional photographs. As we saw in Chapter 3's discussion of documentary, truth has always been subject to a photographer's agenda and technique. Staging, editing and manual retouching were all prevalent within an analogue paradigm, bringing us falsified news images, the erasure of ousted Soviet political figures and the idealization of Hollywood gods and goddesses.[5] Digital technology not only makes these kinds of alterations easier but also provides us with new tools for identifying them.[6] Now that most of us carry a digital camera phone and many of us have some experience with the basic tools of digital image manipulation, we are more sophisticated consumers of visual images generally. Our culture is insatiably hungry for both photographed realities and photographic illusions. Digital photography feeds both these needs impartially and cannot be said to be innately more or less truthful than film photography.

Some optimistic writers describe the introduction of digital technology as the dawn of an era of infinite creative possibilities for photography.[7] It is now possible to make virtual images, pictures that appear to be photographically realistic without bearing any actual trace of the scene they appear to show. (For an example of this kind of simulation, see Richard Kolker's work discussed at the end of the chapter.) Any image is possible. Writers in the techno-utopian camp also write of the present as an era of unprecedented access. They argue that digital photography is part of a network of technologies, including mobile communications devices and social media, with the potential to enhance freedom of information, equality and human rights. Certainly it is true that digital camera phones and the Internet have allowed a boom in "citizen's journalism," and the global proliferation of images that would once have been much more difficult to make or share. Digital images have played their role in the revolutions that are currently unfolding across the globe, though their part has sometimes been gruesome and misleading as well as informative and empowering.[8] Time will reveal whether the evolving digital technologies have more to offer to the individuals who use them or the commercial interests that drive them. It is becoming clear, however, that despite some predictions, the proliferation of vernacular digital imaging has not decreased the public's growing appetite for art photography. On the contrary, its manifestations are multiplying.

For many contemporary photographers, the gradual eclipse of analogue has posed a primarily technical challenge: how to keep making work that looks and reads the same while using the new equipment and processes. This could be described as a digital recoding of photography.[9] Thomas Struth, for example, has started to work digitally in the past decade. This is less because he is engaged with the creative potential of digital technology and more because the entire industry is converting rapidly and he does not wish to appear committed to outmoded means of production.[10] What this means for audiences is that a digital Struth image will not necessarily be distinguishable from an analogue one. Rather than altering the meaning of the images, digital technology merely represents an advance in their manufacture.

## Pure image

In many cases, digital technology allows an extension of the modernist fantasy of the immaculate image – the photograph with a seemingly unmediated relationship to its subject. Although some modernist photographers, such as Alfred Stieglitz and Ansel Adams, discussed technique as part of their artistry and praised the individual character of handmade prints, others placed all their emphasis on the moment of selection.[11] Edward Weston, for example, liked to imagine that the final image was completed in his mind's eye:

> Since the recording process is instantaneous, and the nature of the image such that it cannot survive corrective handwork, it is obvious that *the finished print must be created in full before the film is exposed*. Until the photographer has learned to visualize his final result in advance, and to predetermine the procedures necessary to carry out that visualization, his finished work (if it be photography at all) will present a series of lucky – or unlucky – mechanical accidents.[12]

This deep drive to deny process persists in much contemporary photography, sustaining the fantasy of the pure image. Even if we momentarily bracket the matter of digital post-production, the labour involved in making photographic prints remains highly skilled and complex. Very few photographers do their own printing, instead entrusting the work to professional lab technicians. Walking through an exhibition of large-scale mounted photographs, any photographer with printing experience cannot help but be staggered by the sheer technical demands of making massive images, seemingly "untouched by human hand." Contemporary prints may be the result of analog, digital or hybrid processes (film negatives are frequently scanned to produce digital prints, or digital files outputted onto C-type paper that is then chemically processed), but in all cases tone, colour and contrast must be carefully calibrated through a series of tests. Even rolling and unrolling huge sheets of photographic paper without denting or creasing requires tremendous care.[13] Skill must be carried through to the process of framing or mounting (commonly sandwiching the

print between aluminium and perspex), to avoid damage to the finished prints. Needless to say, many prints are discarded along the way. Mounted prints remain very fragile and must be transported with utmost care, as a single scratch on the surface of perspex can spoil an entire work. All this artistic labor is even more repressed than in traditional silver prints – not even fine art photography connoisseurs pay much attention to the contemporary colour print (rather than the image it presents) as a locus of craftsmanship or aesthetic pleasure for its own sake.

Thus we are faced with a contradiction. Critics and art historians argue for the codedness of every image. In a classic essay on the production of meaning in postmodernism, Craig Owens described the way ambitious artworks signal their critical intent through a deliberate "gap" or "unresolved margin of incongruity" in their construction.[14] Yet, in some cases, digital technology allows an even more exaggerated version of the modernist fantasy of pure representation – every gap is sealed. Andreas Gursky provides one of the most prominent examples of a photographer working in this mode with his project sitting on the fault-line between critique of representation and immersive visual experience. We are caught between wonderment and shudders of disgust at vistas that recall Aldous Huxley's *Brave New World*.

Gursky works with digitally heightened image files to make immaculate pictures. His early works of the mid-1990s dealt in a fairly straightforward way with the experience of mass leisure and the movement of consumer goods around the world. His mural-sized color photographs of public swimming pools and shipping ports provide striking visions of late capitalism in action. In keeping with the tone of the time, they were generally read as critical allegories of globalization (see Chapter 2 for further discussion of criticality in the photography of the Düsseldorf School). Over time, however, Gursky began to tweak his images digitally, combining source images and exaggerating dizzying spatial relationships. A practice that had launched from the deadpan mode became gradually more delirious, until Gursky became known as the leading practitioner of a contemporary sublime.[15] And, indeed, his images are sublime in several aspects: not only do they have the grandeur associated with Edmund Burke's eighteenth-century formulation, they inspire awe both in their form and in their content.[16] They not only reveal the conditions of life under advanced capitalism to be overwhelming, terrifying, but also make it strangely pleasurable by presenting it from a distance. The viewer is placed in visual command of all he or she surveys. Photographers have aspired to produce seamless montage since the mid-nineteenth century. But while Oscar Rejlander or Henry Peach Robinson set out to rival the visual presence of academic painting with dramatic illusions of reality, Gursky's project pushes into hyperreality, raising the stakes for photography within fine art. The most relevant point of comparison no longer seems to be representational painting but rather the scale and visual opulence of cinema.

During the years that Gursky has heightened his digital post-production techniques, he has seen his work's value spiral upward. In 2007 he sold a pair of

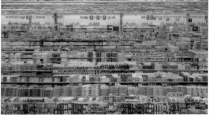

*Figure 5.1* Andreas Gursky, *99 cent II, diptych* (2001).

images, *99 Cent II Diptychon*, 2001 (Fig. 5.1) for $3.34 million, at the time the highest price ever paid for a photographic work and exponentially more than the prices commanded by his peers. Digital manipulation transforms the cheapest of commodities into an image of dazzling excess. Gursky quadruples the visual extravaganza by adding reflections of merchandise on the ceiling and then presenting the images as a pair. Gursky's 2007 Formula 1 pit-stop series, "F1 Boxenstopp," moves even further into visual fantasy. The frieze-like images have two tiers: a row of spectators in a glass gallery gazing down at uniformed mechanics swarming like ants around the cars. Combined from images of grand-prix races around the world, these photographs have a basis in actual activities, but the post-production they have undergone pushes them into the realm of hyper-photography. The prints are colossal: 222.4 cm × 608 cm). They are some of the largest, slickest, most detailed color photographs ever produced. One newspaper critic summed up their overwhelming effect on the viewer's perception with the headline, "It's enough to make your eyeballs sweat."[17]

Gursky's project is as complex as his range of subjects is broad. He has photographed private islands, institutional carpet, ecstatic nightclubbers, totalitarian mass spectacles and deluxe boutiques. It is not nearly enough to say that his work celebrates capitalism, even if the F1 series could be read as an advertisement for the lifestyle of the super-rich. The notion of the sublime conveys the horror as well as the pleasure that his work can inspire. What is important to emphasize in this context is the fact that his project cannot be read as straightforwardly critical of its subjects.[18] It fully participates in the spectacle it presents.

This aspect of Gursky's work was strikingly new when it came to prominence in the mid-1990s. Throughout the twentieth century, photography was understood as one of the most democratic art forms. While some kind of camera and darkroom access cost money, they were within the reach of almost any dedicated would-be photographer. This contributed to the cliché of the art photographer as a solo operator, an outsider able to operate from the fringes of society without academic training or institutional support. While professional portrait or advertising photographers often used studios, sets and lighting to produce images with commercial production values, art photographers have privileged a more spontaneous way of working. One way to read the history of

art photography would be as a set of visual moves by which artists and photographers attempt to mark their distance from professional practices: such as Hannah Hoch's choppy photomontages from the 1930s, Robert Frank's large grain and blur in the 1950s or Andy Warhol's Polaroids.

One of the baseline assumptions of most critics and art historians in the modern era has been that the job of ambitious art is to challenge and subvert official culture. Artists and photographers have been judged by the degree to which their work resists the forms produced by the culture industry, to question the social and political assumptions of the day or to provide some kind of alternative vision. So where does this leave us with work like Gursky's? If his work is shocking, it is shockingly seductive. Rather than undercutting a commercial aesthetic, his seamless hi-res collages share the production values of top-budget Hollywood digital film-making and CGI special effects. Is his work provoking a thoughtful inquiry, inviting us to submerge ourselves in entertaining spectacle or an ambivalent combination of the two?

## Spectacle

The notion of spectacle is not new to the discussion of contemporary art but continues to have potency. In the 1960s, French writer Guy Debord brought the term to prominence with his book *The Society of the Spectacle*, describing the overwhelming changes effected on the world by the increasing dominance of capitalism.[19] While these changes have tangible social, political and economic forms, Debord focused on the abstract, symbolic realm, as he believed that this is the level on which our hearts and minds are dominated most effectively. He describes a present in which images have taken over from religion and family, mediating and replacing social interactions: "All that once was directly lived has become mere representation."[20] The spectacle is the set of images that disguise and replace reality. Following the critique of commodity culture that Theodor Adorno and Max Horkheimer had established in *The Dialectic of Enlightenment*, Debord describes the way in which spectacle seduces people into a set of pseudo-needs for commodities that can bring only momentary pseudo-gratification. While spectacle overlaps with advertising, it reflects something much deeper, a loss of underlying reality. In the era of Facebook, drone warfare and so-called reality television, Debord's message continues to have great resonance.

Since the allegory of Plato's cave, philosophy has been suspicious of images, endowing them with the potential to mask or distort reality. Debord followed in this tradition. Although his notion of the spectacle is still commonly used to describe contemporary image culture, both artists and theorists have shifted in their relationship to the idea of spectacle, no longer assuming that the only appropriate attitude to take towards it is resistance and negation.

Gregory Crewdson makes images as spectacular as Gursky's but with very different content; he presents hyper-detailed fictions of small-town American lives riddled with unexplained mysteries and disturbing scenarios. While this

world is familiar from horror or science-fiction films, Crewdson's particular mode of photographic presentation frames a different form of optical experience. At the 2005 London exhibition of Gregory Crewdson's photographic series "Beneath the Roses," viewers behaved in strange and unexpected ways. Some sidled up to the large images and then backed away, cocking their heads to one side and staring as if perplexed. And with good reason: these huge colour images offer minute detail, incredibly sharp all-over focus and multi-source lighting that would be impossible in an ordinary photograph. Standing in front of one of Crewdson's dramatic – even melodramatic – staged images, the eye is lured and hooked in a pleasurable way that is novel for photography, though perhaps familiar from the experience of being drawn into the visual opulence of a Hollywood film. At a moment before Crewdson's elaborate process was commonly known this made the work enigmatic to viewers knowledgeable about photography. The eye and mind literally boggled. Viewers innocent of photographic process tend to describe the images as enthralling, but more in the way that Crewdson had in mind:

> Because when somebody is looking at my picture, I want them to just fall into the world of the photograph. So anything that moves against that transparency is too much about the medium ... So I don't want grain, and I don't want pixels, I just want pure image. And that's a hopeless impossibility.[21]

To achieve these results, Crewdson combines the practices of film director and advertising photographer. For "Beneath the Roses" he worked for several months with crews of about forty people, including a director of photography (cinematographer), camera operator, production designer, location manager, casting agent, actors, light and prop crews, digital printer, etc.[22] Some works were produced on location in small-town Massachusetts, others on sets. Individual images were worked up from a series of sketches or even scaled architectural models. Every image involves forty to fifty plates of 8 inch × 10 inch film shot from a fixed camera, combined in months of post-production at a digital studio. Composite negatives allow Crewdson and his team to exceed the limits of an individual photograph. Separate parts of the picture can be tweaked and enhanced, the overall mood adjusted. The result is an image of such intensely overloaded visuality that it holds the eye far longer than the same subject would in an ordinary picture.

What of the content of these works? We might expect Crewdson's unprecedented photographic process to produce surprising new narratives, but the scenarios feel like stills from second-rate movies or like illustrations of clichéd Freudian dilemmas. This familiarity is so carefully nuanced that is clearly intended, and perhaps worth further consideration. In *Untitled (Birth)* (2007) from "Beneath the Roses," the picture places the viewer outside, in the snow, looking into a motel window at a woman in a nightgown sitting on a bed looking down at a newborn baby (Fig. 5.2). The mother's expression is blank,

*Figure* 5.2 Gregory Crewdson, *Untitled (Birth)*, from the series "Beneath the Roses" (2007).

inscrutable. The baby, lying exposed on the bed, could be either sleeping or dead. Every surface in the image has been wrought to an astonishing level of believability – the dirty snow, the clapboard wall of the motel, the grungy lampshades. The time-based narrative of a film might allow us to empathize with this character. Still photographs are also more than capable of stirring our emotions. But in keeping with the current preference for ambiguity, this particular still image stands aloof, merely inviting us to wonder about the woman, to gaze at her in the same impassive way she looks at her child.

## Complicit artworks

In Debordian terms, Crewdson's work is pure spectacle, an accumulation of capital that crystallizes into an image that retains little visible trace of its making. Over time, however, our relationship to spectacle has become more nuanced. No one could argue that our image culture has not become more powerful, manipulative and potentially deceitful than ever before. At the same time, it is true that we have occupied a state of advanced capitalism for decades now, and we insist more than ever on our own agency as viewers. Emerging theories are more empowering to the viewer and less pessimistic about our present and future relationship to images. In her book *Sweet Dreams: Contemporary Art and Complicity*, Johanna Drucker questions prevailing assumptions about viewers' relationship to works of art. She argues that art writing has been dominated for too long by the model of avant-garde criticality. A stance that was originally intended to challenge the powers-that-be has become an

orthodoxy supported by art institutions all over the world. Criticality loses its force when it becomes officially sanctioned. Drucker proposes that something much more interesting can happen when we stop expecting works to occupy a position of opposition, transgression or subversion and instead look to them for self-conscious, reflective artifice. The academy may still be expecting art to employ strategies of negation, "But artists in large part are working in recognition of their relations of compromise and contradiction, their more self-consciously positive – or nuanced and complex – engagements with the culture industry."[23] In these terms, Crewdson's imaginative push and pull between photographic and cinematic, alienation and immersion, become more interesting. (Drucker uses his work as a case study in complicity.) The point is not that criticality is no longer a valuable position for artists or viewers to take but that art may offer many other possibilities for reframing our relationship to the culture in which we live. As with much contemporary art, the ambiguity of Crewdson's images precludes firm, communal interpretation. The meaning is outsourced to the viewer. Rather than regarding this as a failing, we can interpret it as an invitation to take responsibility for our own relationship and response to the work. In this context, interpretation is more likely to produce a process than a result. The intellectual pleasures of this process are a key part of the enjoyment of the work.

## Emancipated spectators

Drucker's emphasis lies with the work of art and its relation to the culture that receives it. Other writers have reconsidered questions of art's value and meaning in the age of the spectacle by turning to the beholder. In the past couple of decades, theorists including Jacques Rancière and Jean-Luc Nancy have explored a phenomenological approach to philosophy that was sidelined within post-structuralism. Their theories offer ways to rethink the viewer's embodied experience of works of art. Rancière's notion of the "emancipated spectator" overturns the assumption, put forward by Debord and widely shared, that spectatorship is a passive position. On the contrary, Rancière argues, "Emancipation begins when we challenge the opposition between viewing and acting: when we understand that the self-evident facts that structure the relations between saying, seeing and doing themselves belong to the structure of domination and subjection."[24] With this theory, he rejects the notion – passed down from Bertolt Brecht – that committed cultural production involves activist artists rattling the cages of somnambulant audiences. For Rancière, this model for the political efficacy of art was doomed from the start. It proposed a direct relationship between perception, comprehension and action that could not be sustained.[25]

Now that the society of the spectacle is even more advanced than it was in Debord's time, do we still believe we can reverse it? Do we even want to? What might we use our emancipated status to do? Rancière does not provide a manifesto for the spectator but gives us a sense of the potential of our own agency.

He describes us as active interpreters, constantly participating in narrating and translating what we see, making it our own. For Rancière, art's political efficacy is in disturbing assumptions about how human bodies relate to each other and their society. He writes of discreet affects, of work of art that surprise us in small ways by reversing our expectations.[26] Our active responses can alter the balance of what can be perceived and produced.

With their helicopters, cranes and teams of assistants, Crewdson and Gursky represent an extreme of spectacularity. For audiences who first encounter their astonishing works, however, it is certainly possible that they could trigger a fresh response, a new perspective or an unexpected dialogue. The rest of the chapter will look at solo photographers who operate in far less ostentatious ways. Each makes use of digital forms drawn from the culture at large. Their technical and conceptual interventions in these forms may (depending on the viewer) produce the spark of discovery that Rancière describes. The catch, unfortunately, is that he argues that this affect must be unanticipated. In articulating the mechanism of these works, this text may thus undermine their impact. Hopefully, it will also provide some ways of thinking about contemporary digital photography that readers can employ to experience new works in related ways as they encounter them.

Eva Stenram uses photography files from the Internet, mediated in quirky ways to produce uncanny projects with what Freudians would call a "return of the repressed." If technology is sometimes figured in terms of power and mastery, Stenram evokes a technological unconscious ruled by thwarted desire, whim and unreason. Her "pornography/forest_pics" is a series of strangely blank forest landscapes, exhibited as unusually small, low-resolution prints. The conceptual backstory of the work brings it to life in the viewer's mind. Stenram began by trawling the Internet for hard-core amateur porn images set in the forest. Once she had made a selection, she set about erasing the figures pixel by pixel, replacing them with pixels drawn from elsewhere in the image. The resulting landscapes with their squashed grass and empty picnic blankets are not just unoccupied, but uncannily voided, echoing with the absence of their protagonists. In the pixelated colour prints the empty forest becomes a seedy, sinister place, the opposite of erotic. Stenram's digital erasure transforms the context, function and meaning of the original images. Removing what pornography viewers most want to see, she provides art viewers with a pointed response to the endless tide of pornography on the Internet, by some estimates more than a third of total web pages.[27] The low resolution of the source files limits the size of the work, so that the exhibited pictures retain an intimate scale. Audiences must come in close to view them.

In a more recent series, "Per Pulverem Ad Astra," Stenram once more plays on the genre of landscape, but with a different turn of the imagination (Fig. 5.3). The pictures depict reddish desert landscapes, swept with blurred whitish lines and shapes, like ghostly tumbleweeds. Again, process is key. The internet sources – images of Mars – have been beamed back to the earth from space, and accessed through the NASA website. Perversely, the artist has taken

*Figure 5.3* Eva Stenram, *Per Pulverem Ad Astra 1.4* (2007).

images that have only ever existed as code (indeed digital imaging was invented for the American Space Program) and has converted them into medium-format film negatives.[28] Left neglected on the floor of her flat to gather dust and hairs, the negatives have subsequently been printed, complete with detritus, producing a strange fusion between super-high-tech and home-spun surrealism. To produce an edition of unique prints, each negative has been printed several times with different combinations of dust, a move that both parodies the logic of the photography market and meshes with it perfectly. National space programmes have often been used as examples of Debordian spectacle. Transforming state money into technology into images, they have fringe benefits for the taxpayers who fund them (freeze-dried food being the classic example) but, according to cynics, serve primarily to fund military developments and to shore up the status of the governments that fund them. In Stenram's hands, NASA's technical wizardry is reduced to a playground for dust mites. Like automatic drawings, the images invite us to project whatever we want onto them.

## Poor image

In contrast to the fantasy of the pure image, we could see Stenram as engaging with the materiality of "the poor image," a term coined by critic Hito Steyerl to describe low-res picture files which are shared and re-shared over the Internet.[29] Steyerl celebrates these substandard, often stolen, images because they are accessible, popular, resistant to value judgements and can be used and shared in myriad ways to create platforms for common interest. She argues that in their

everyday use poor images have the potential to break down the boundaries between makers and users. Poor images are complicit with the culture that produces them, yet may have subversive effects; although they are frequently drawn from commercial media and circulate via networks that support corporate and state interests, they have the potential to undercut spectacle in the ways that they are used.

Although intended for a gallery context, Stenram's chunky pixels and flagrant dust spots share the defiant scrappiness of the poor image. Signs of process are kept in view as traces of idea in action. The transformations Stenram has imposed on the images are irrational and perverse. Using low-tech means to further degrade low-res images, the works project a mocking, irreverent attitude towards their source images, whether they are the products of amateur pornography or state-sponsored space exploration.

Montreal-based artist John Rafman also works with images from the Internet, blurring the roles of image consumer and producer, though in a different way from Stenram.[30] His ongoing project *The Nine Eyes of Google Street View* draws on one of the fastest-growing archives of digital imagery in the world: Google Street View. Google's ultimate goal for this website is to provide seamless 360-degree photographic coverage of as much of the globe as possible, gathered by a fleet of cars equipped with nine-lens cameras raised eight feet from the ground. Rafman has spent untold hours scouring Street View and related blogs to make screen grabs of an eclectic selection of striking images. Marked with the Google copyright, and Street View's directional compass in the upper left, the images have a distinctive slightly warped perspective. Faces and text are automatically (and hence erratically) blurred.

The Street View cameras gather images purposefully but with no regard whatsoever to content. Rafman, in contrast, is a trained artist and photographer, primed with intention and ideas. His image choices break down into a number of subcategories that reflect the diverse pleasures – and ominous power – of photography. Some resonate with photographic history, evoking the aesthetics and human fascination of classic street photography or social documentary. Others capture photography's love affair with the wonders of nature, such as a moose galloping along a highway, or a sky thick with birds (Fig. 5.4). A few catch technical failures, bizarre doublings or psychedelic blazes of abstract colour. Many offer grimly candid depictions of the most marginalized members of society: prostitutes, drunks, even corpses. Showing crimes in action and dramatic arrests (Fig. 5.5), several attest to the degree to which Google's project overlaps with Michel Foucault's notions of the surveillance state. Rafman has also included a number of images in which people respond – usually with an obscene gesture – to the intrusion of Google's cameras into their lives.

There is a surreal quality to many of the images in the series. Some are stunningly beautiful, others laugh-out-loud funny. Although they are drawn from a digital archive, at a level of remove from the world, Rafman's images have a fullness, a presentness of experience, that make us look and look. While

*Figure 5.4* Jon Rafman, *330 R. Herois de Franca, Matosinhos, Portugal* (2009), from the series "The Nine Eyes of Google Street View".

*Figure 5.5* Jon Rafman, *125 Rua Maestro Benedito Olegário Berti, Mogi das Cruzes, São Paulo, Brasil* (2010), from the series "The Nine Eyes of Google Street View".

taking full advantage of these ready-made joys, Rafman also uses his selections to draw attention to darker aspects of contemporary life around the globe, not least the way in which privacy and human rights are being eroded by corporate interests. Although his images are appropriated, Rafman shares some aspects of the traditional social documentary photography: to educate and reveal.

In this project the artist is curator. As the term "curation" implies, this means that he takes on a certain responsibility both for his material and for his audience.[31] The images he draws upon constitute a potentially infinite archive from which he constructs sense and meaning.[32] Rafman has circulated the images with writing to contextualize the project and to underline his critical intent.[33] The project has appeared in several distinct formats. So far, the artist has reproduced images from the ongoing series in an artist's book and monograph and has exhibited them as archival color prints. Although the images certainly have the visual impact and conceptual complexity to hold their own on a gallery wall, this mode of presentation limits their impact and reach. Far more viewers have encountered them in the format that suits them best: online. Through the linking power of web-based media and social networking sites, http://9-eyes.com offers viewers around the world the opportunity to experience and share the digital images instantly, interactively, in the same medium in which they originally appeared. In its online form, the project operates very differently from framed wall art and offers different values. As Steyerl argues in her discussion of the poor image: "Apart from resolution and exchange value, one might imagine another form of value, defined by velocity, intensity and spread."[34] She also points out a potential downside to this kind of high-speed dematerialized circulation: it can feed straight back into the superficiality of information capitalism. In these terms, the gallery or book continue to offer valuable sites for Rafman's activities to be seen outside of the non-stop flow of the Internet, to be contemplated at greater length, perhaps with a different kind of intention and attention.

With the *Nine Eyes* project, Rafman generates contemporary art by diverting the flow of pre-existing, corporate-generated images. Our relationship to them is entirely different than it would be if we had stumbled across them while scanning Google Street View in our everyday lives. Stenram too interrupts our reception of found imagery, adding an extra level of visual invention and intention. Kenji Hirasawa's book *Celebrity* (2011) operates on a more traditional model of photography in that he has gone out in the world to shoot his images. Yet his specific subject matter and mode of working both relate back to the idea of the poor image.

*Celebrity* (2011) depicts individuals and groups interacting with waxworks at Madame Tussauds wax museum in London. This is a stereotypical subject for tourist snapshots. Advertisements for the museum show visitors using camera phones to snap each other beside the waxworks, in an acknowledgement that the attraction is pre-planned to be an extended, shared photo opportunity. Hirasawa alters the usual relationship of waxwork spectacles and spectators by using a thermographic camera that responds not to light but to heat. An apparatus devised for medical or military applications, it produces digital images in which each pixel represents a temperature. As a result, the celebrities are dim, receding apparitions. The audience, in contrast, glow luridly in red, orange, yellow and green, performing their spectatorship by posing flamboyantly beside the celebrities. Famous and non-famous are equally anonymous in these images.

*Figure 5.6* Kenji Hirasawa, *Jennifer Lopez*, final image from the book *Celebrity* (2011).

The large pixel size renders the visitors unidentifiable (incidentally freeing the photographer from the legal need for release forms). Although a list of wax-works "in order of appearance" appears at the back of the book, the pages are unnumbered and the statues difficult to identify. In the book's final image (Fig. 5.6), Jennifer Lopez is reduced to a negative space, a curvy silhouette defined only by the warmth of the surrounding visitors, none of whom pays her any attention at all.

Although Hirosawa's thermographic imaging device is not responding to traditional light and shadow, his project is deeply photographic in that it records actual moments in time and the actual physical presence of the figures. This work allows us to look at looking, with a low-res technical gimmickry that has strangely poignant results. Robbed of their iconic visual characteristics, the celebrity icons become mere lumps of matter, and the audience is endowed with radiant vitality. The photographs in *Celebrity* allow us to see something new in one of the most clichéd sites for tourist snapshots.

With pixels several millimeters across, Hirasawa's project relates to the aesthetics of the poor image, but the visual experience of the book does not feel impoverished. On the contrary, glossy baby-blue covers and neon-bright images make the book a seductive object. As a consequence of the boom in digital publishing, it is now much cheaper and easier for photographers to produce books. *Celebrity* is published by Bemojake, one of a number of small presses recently launched by photographers. Such small-edition books circulate on the fringes of the photography scene, available in gallery bookshops and at a growing number of independent publishing fairs. These activities are especially valuable in providing young photographers with ways to show their work. A book allows for an extended experience of a project that might not even be matched by a solo exhibition. Many critics and curators argue that the future of photography as an art form lies in alternative and independent forms of presentation, many of which have been made possible by developments in digital technology.[35]

Like Stenram, Rafman and Hirasawa, Richard Kolker reflects on our social use of images. Although he works in the mode of seamless digital collage, the strange disjunction between the perfection of his technique and the gritty realism of his subject matter creates a curious dissonance. Set in urban environments under bleak artificial lights, his photographs depict scenes from unexalted lives: a petrol-station forecourt, a deserted underground platform, the interior of a breeze-block garage. A recent series has turned to low-rent still life, such as a rag on a radiator or a dead fly on a table. What makes these images extraordinary is that they have no photographic source material at all. An image such as *Basin* from the 2010 *House* series (Fig. 5.7) has been constructed using three-dimensional animation software that allows forms to be built from scratch and rendered mimicking the properties of different materials and various simulated lighting conditions. The realism of the image lies partly in Kolker's skill as an animator and partly in the software program's adherence to the rules of perspective, modeling, shadow, etc.

Are these constructed images photographs at all? In many important regards they are. The virtual camera follows the same rules as a real one: film size, aperture, shutter speed. The constructed scene may or may not follow the laws of physics and may or may not be naturalistic. But given the endless manipulations possible within regular analogue or digital photography, this version merely severs the last vestigial link to a world that may or may not itself be real. Some people will not want to accept this kind of image as photography. Kolker

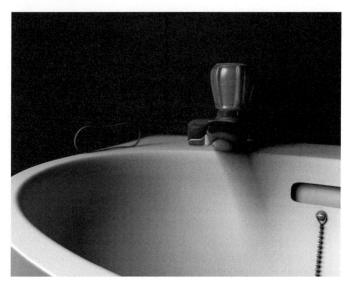

*Figure* 5.7  Richard Kolker, *Basin*, from the series "House" (2010). Reproduced with the
kind permission of Richard Kolker.

is using techniques common to commercial photography (in many cases it is
now cheaper to synthesize part or all of an image than to shoot real places,
things or people). But he is self-conscious in drawing these techniques into the
arena of art and into a specifically photographic context.

The world represented in Kolker's work is both banal and obsessive; it offers
a counterpoint to the escapism of online gaming or other virtual environments,
through the medium of the immersive image. Simulated, synthesized photo-
graphs, they hold the eye because they are forever not quite real. Kolker's
images are as seamless as Gursky's or Crewdson's, but their affect is very dif-
ferent. They have a domestic scale that engages the viewer's own body. In
contrast to the digital sublime, they offer a digital uncanny, simultaneously
familiar and unfamiliar. They may not refer to actual surfaces in the world, but
they evoke the senses. We can almost feel the cool metal of the taps.

All of the photographers discussed in this chapter use digital means to share
visions of the world that could not have been conceived at an earlier moment in
history. If we were so inclined, it would be possible to read any of these images
as drawing attention to – and thereby potentially critiquing – the many slip-
pages between image and reality that occur in our spectacular culture. The
recent theories we have looked at in this chapter offer alternatives to the tradi-
tional avant-garde formulation of art as the critical conscience of culture under
capitalism. Johanna Drucker points out that this model has become so institu-
tionalized that it makes it hard even to recognize what is most exuberant in
contemporary artistic practices.[36] Hito Steyerl identifies a vibrant new area of
cultural practice in which the distinctions between defiance and complicity, and

those between art and non-art, are totally collapsed. Jacques Rancière argues that art's political power has never been in directly opposing the culture industry but rather in reimagining the field of perception and dialogue. As he puts it, "The images of art do not supply weapons for battles. They help sketch new configurations of what can be seen, what can be said and what can be thought and, consequently, a new landscape of the possible."[37]

In a mere twenty years, digital technologies have almost completely replaced film-based photography. Former industry leader Eastman Kodak declared bankruptcy in January 2012. The majority of traditional photographic films, chemicals and papers have fallen out of production. Many photography students will never have the experience of developing their own silver-based negatives or prints. Yet the digital shift is less to do with the means of production than with the way in which process is understood. None of the works discussed in this chapter could have been made before the advent of digital photography. All of them include aspects of their digital production in their conceptual content as well as their form. The proliferation of digital technologies multiplies the number of different ways in which a photographer may work self-reflexively with their medium. Although the production values of such work may rival commercial entertainment culture, the digital sublime of Gursky and Crewdson, which might have looked shockingly new a decade ago, is starting to look rather old-fashioned, harkening back to academic painting and the fantasy of pure image. The other works in this discussion use their digital means to invite viewers into forms of visual experience that relate to their social use in the present moment. Referring to internet pornography, Google Street View, thermal imaging and computer games, these digital forms are not utopian; on the contrary, they reflect aspects of the Society of the Spectacle at its most oppressive. Yet in their specific uses they open up glimpses of unexpected ways in which we might relate to the visual culture that surrounds us. Film-based technologies may now be obsolete, but the future possibilities for photography are wide open.

## Notes

1 For a classic 1990s exhibition catalogue providing in-depth discussion of these concerns, see Hubertus von Amelunxen, Stefan Iglhaut and Florian Rötzer, eds., *Photography after Photography: Memory and Representation in the Digital Age* (Amsterdam: G&b Arts, 1996).

2 Much digital art photography continues to explore this subject matter. See, for example, the discussion of "Other Dimensions, Other Worlds" in Sylvia Wolf's book *The Digital Eye: Photographic Art in the Electronic Age* (London: Prestel, 2010), pp. 38–44.

3 For other photographers working in this mode, see Jeff Wall, who has framed his practice more explicitly in relation to art history and critical theory, or David LaChapelle, a photographer at the cusp of art and fashion photography, whose hyper-photographic montages point more playfully in the direction of kitsch and camp.

4 Fred Ritchin provided an early pessimistic view of digital photography in his book *In Our Own Image: The Coming Revolution in Photography* (New York: Aperture,

1999). For an overview of current digital debates, see Martin Lister, "Photography in the Age of Electronic Imaging," in Liz Wells (ed.), *Photography: A Critical Introduction* (London: Routledge, 2009), pp. 311–44, and Steve Edwards, "Afterword: Digital Photography," in *Photography: A Very Short Introduction* (Oxford: Oxford University Press, 2006), pp. 129–39.

5 For discussion and examples of digital and pre-digital alterations to images intended for the public sphere, see William Mitchell, "How to Do Things with Pictures," in *The Reconfigured Eye: Visual Truth in the Post-Photographic Era* (Cambridge, MA: MIT Press, 2001), pp. 191–223, and Martha Rosler, "Image Simulations, Computer Manipulations, Some Considerations," *Ten.8*, 2 (2) (1991): 52–63.

6 To address concerns about image tampering, some software programs now provide image-authentication coding to prove that an image has not been edited. In cases of suspected manipulation, algorithms can be used to detect changes in the statistical patterns of pixels. Perhaps most reliably, internet distribution brings images before many sets of eyes – audiences often spot inconsistencies in images intended to deceive them. "Image Technology: Keeping it Real," *The Economist*, 19 August 2006, p. 72.

7 Edwards, "Afterword."

8 To get a sense of the controversies and conspiracy theories that circulate around photographs on social media enter the terms "Gaddafi fake photographs" into an internet search engine.

9 Lister, "Photography in the Age of Electronic Imaging."

10 Conversation with Achim Borchardt-Hume, curator of the 2011 Whitechapel Gallery exhibition *Thomas Struth: Photographs 1978–2010*, 13 July 2011.

11 For a classic modernist treatise on photographic printing, see Ansel Adams, *The Print* (New York: Little, Brown, 1995), first published in 1950.

12 Edward Weston, "Seeing Photographically," *Encyclopedia of Photography*, vol. XVIII (New York: Greystone Press, 1965), reprinted in Alan Trachtenberg (ed.), *Classic Essays on Photography* (Stony Creek, CT: Leete's Island Books, 1980), pp. 170–5.

13 Like many of his contemporaries, Struth has his photographs enlarged at the Grieger lab in Düsseldorf, where for approximately €500 each they produce prints of up to $180 \times 300$ cm on a single sheet of paper using what their website claims is "the world's biggest laser imager." See http://www.grieger-online.de/en/products/photo-enlargement/digital (accessed 24 September 2012). For an account of Struth's printing process see Janet Malcolm, "Depth of Field: Thomas Struth's Way of Seeing," *New Yorker*, 26 September 2011. Available online at http://www.newyorker.com/reporting/2011/09/26/110926fa_fact.malcolm (accessed 24 September 2012).

14 Craig Owens, "The Allegorical Impulse: Toward a Theory of Postmodernism," in Brian Wallis (ed.), *Art After Modernism: Rethinking Representation* (New York: The New Museum of Contemporary Art, 1984), pp. 203–35, at pp. 203, 233.

15 See, for example, Alix Ohlin, "Gursky and the Contemporary Sublime," *Art Journal*, 60 (4) (winter 2002): 22–35, or Caroline Levine, "Gursky's Sublime," *Postmodern Culture*, 12 (3) (May 2002). Available online at http://pmc.iath.virginia.edu/issue.502/12.3levine.html (accessed 24 September 2012).

16 For a concise summary of the sublime in relation to landscape photography, see David Bate, *Photography: The Key Concepts* (Oxford: Berg, 2009), pp. 93–7.

17 Lucy Davies, "It's Enough to Make Your Eyeballs Sweat," *The Daily Telegraph*, 24 March 2007. Available online at http://www.telegraph.co.uk/culture/art/3663967/Its-enough-to-make-your-eyeballs-sweat.html (accessed 24 September 2012).

18 This assessment is shared by Alex Alberro in his essay "Blind Ambition," *Artforum*, 39 (5) (January 2001): 109–14.

19 Guy Debord, *The Society of the Spectacle*, Donald Nicholson-Smith, trans. (New York: Zone Books, 1994, first published in French, 1967). The full text is available online in various languages.

20 Debord, *The Society of the Spectacle*, p. 12.

21 Melissa Harris, "Interview with Gregory Crewdson," *Aperture*, 190 (spring 2008). available online at http://www.aperture.org/crewdson (accessed 24 September 2012).

22 Harris, "Interview with Gregory Crewdson."

23 Johanna Drucker, *Sweet Dreams: Contemporary Art and Complicity* (Chicago, IL: University of Chicago Press, 2005), p. 8.

24 Jacques Rancière, "The Emancipated Spectator," in *The Emancipated Spectator* (London: Verso, 2010), pp. 1–24, at p. 13. For a passionate defense of the critical mode, see Hal Foster, "Post-Critical," *October*, (winter 2012): 3–8.

25 Jacques Rancière, "The Intolerable Image," in *The Emancipated Spectator* (London: Verso, 2010), pp. 83–106, at p. 103. For an accessible discussion of the implications of Rancière's ideas for contemporary art, see Ross Birrell, "Jacques Rancière and the (Re)Distribution of the Sensible: Five Lessons in Artistic Research," *Art and Research*, 2 (1) (summer 2010): 1–11. Available online at http://www.artandresearch. org.uk/v2n1/v2n1editorial.html (accessed 24 September 2012).

26 Rancière, as quoted in Birrell, "Jacques Rancière and the (Re)Distribution of the Sensible," p. 9.

27 This statistic is drawn from a study by online security company Optenet in 2010. See www.optenet.com/en-us/new.asp?id=270 (accessed 24 September 2012).

28 For a discussion of digital photography and space exploration, see Edwards, "Afterword," pp. 129–30.

29 See Hito Steyerl, "In Defense of the Poor Image," *e-flux*, 10 (November 2009), available online at http://www.e-flux.com/journal/in-defense-of-the-poor-image (accessed 24 September 2012).

30 The "prosumer," a hybrid of the professional and amateur, has been one of the key terms in the market for digital technology, especially as prices drop and high-end hardware and software become more affordable, breaking down boundaries between those who have access to technology and those who do not.

31 For a discussion of contemporary artist as curator, see Boris Groys, "Politics of Installation," *e-flux*, 2 (January 2009), available online at http://www.e-flux.com/ journal/politics-of-installation (accessed 24 September 2012).

32 Key texts on the use of the archive in contemporary art include Hal Foster, "An Archival Impulse," *October*, 110 (autumn 2004): 3–22, and Mark Godfrey, "Artist as Historian," *October*, 120 (spring 2007): 140–72.

33 John Rafman, "IMG MGMT: The Nine Eyes of Google Street View," *Art Fag City*, 12 August 2009. Available online at http://www.artfagcity.com/2009/08/12/img-mgmt-the-nine-eyes-of-google-street-view (accessed 24 September 2012).

34 Steyerl, "In Defense of the Poor Image," p. 7.

35 See, for example, *Foam Magazine* 29 (winter 2011–12), an issue entitled, "What's Next?"

36 Drucker, *Sweet Dreams*, p. 49.

37 Rancière, "The Intolerable Image," p. 103.

# 6   Beyond Photography

Most of the photography discussed so far sits firmly within the pictorial paradigm of wall-bound pictures depicting recognizable subject matter.[1] This dominant form of photographic art is currently being challenged. This chapter looks at works that combine photography with other art forms and activities. Works by Walead Beshty and Rachel Harrison have a material, spatial dimension, overlapping with painting, sculpture and installation. Projects by Sharon Lockhart, Clifford Owens and JR include elements of action and the passage of time, opening up towards film, performance and audience participation.[2] This small selection gives a sense of the great variety of possibilities for photography within the broader arena of contemporary art. In light of such practices, many critics and art historians argue that photography as a discrete discipline is over, that art has entered a "post-medium condition" in which artists move freely among forms as suits their practice. Alongside this claim, we will examine the possibility that the photographic offers more than just a set of forms or technologies. There are still tangible benefits to discussing many such works in photographic terms.

Visual art has transformed beyond recognition in the past few decades. While traditional art forms persist, they have also combined and dissolved, often resulting in open-ended or participatory works that might not previously have been recognized as art at all. More than ever, artists are engaging with a broad range of concerns from the world at large, ranging from politics, physics, geography and history to popular music, pornography and sport. Any object, event or activity may be proposed as a work of contemporary art – even if not all audiences will accept it as such. Photographic artists have not just participated in the erosion of disciplinary boundaries and the exploration of new forms, in many cases they have led the way. The works discussed in this chapter have been chosen because they all operate within the broader framework of contemporary art while retaining specifically photographic elements.

## Image vs. object

Setting out to explore photographic works that move into three and four dimensions, it is productive to underline the distinction between photographic

image and object. An image is an infinitely reproducible visual form that can be enlarged or reduced, translated from one form to another, retaining its recognizable identity. Whether viewed on a page, wall, screen or other surface, a photograph is never *just* an image – it always takes specific material form. Our drive to read the subject matter of images frequently displaces our awareness of their properties as objects. As Geoffrey Batchen puts it, "In order to see what the photograph is 'of' we must first suppress our consciousness of what the photo 'is' in material terms."[3] As we saw in the last chapter's discussion of contemporary digital works, the particular physical manifestations of work – and often certain aspects of its making – can contribute a great deal to their meaning. There are important benefits to engaging with the physical experience of works. Attention to the material properties of photographs in time and space deepens our relation to them, encouraging us to factor in our bodies and our social and cultural context.[4] This is the case with photographs made for any purpose and is especially true with artworks whose form has been wrought in deliberate, self-reflexive ways.

## "Photography's Expanded Field"

The term "medium" has become particularly fraught in recent writings about photography. Carrying the baggage of its modernist usage, medium refers to an art form's innate characteristics and the ways in which they have been applied and adapted over time. As we will see, some contemporary artists and writers are hostile to the notion of photography as a medium. Indeed, this chapter can be read in part as a response to George Baker's "Photography's Expanded Field," an influential essay that proposes a transformed model for photography in contemporary art, articulated in stark opposition to the idea of medium. One of the first writers to provide a serious discussion of photography within twenty-first-century contemporary art, Baker is insistent that medium is no longer relevant: "we need now to resist the lure of the traditional medium and object in contemporary art, just as much as we need to work against the blindness and amnesia folded into our present, so-called 'post-medium condition.'"[5]

Baker proposes that some contemporary artists are expanding our understanding of photography in fruitful ways by rejecting photography's traditional aspects, instead treating it as one form related to other forms (such as cinema). In this view photography is defined partly by what it is *not* – rather than as a destination in itself.[6] Baker draws this argument directly from the model used by his mentor, Rosalind Krauss, to describe postmodern sculpture. He is more forceful than Krauss in denouncing medium-oriented art and criticism as "conservative," associating them with a regressive modernism that fails to create challenging new relationships or positions. An expanded model of photography does not require this rigid rejection of all its historical properties. The previous chapters of this book have traced practices with some kind of productive relationship to the traditions of photography as a medium – not only as an art

medium but also as a set of vernacular practices that can be referenced with great specificity. For many artists and audiences, the photographic aspects of these works are strengths rather than weaknesses. While several of the following case studies will overlap with Baker's general argument, they will lead towards a more inclusive model of expanded photography. We will explore the possibility that the expanded photographic works discussed in this chapter have points of continuity as well as rupture with those in the rest of the book.

Walead Beshty engages actively with process, tempering formal pleasure with a more explicitly critical edge. Exhibiting in some of the most high-profile biennials and publishing essays in publications such as *Texte zur Kunst*, Beshty has made a rapid rise to prominence in the broader field of contemporary art as well as becoming a central figure in photography.[7] His projects are all driven by indexical procedures that trace their own making. Some of his work could be described as anti-visual; he pulped a number of "failed" photographic works made between 2002 and 2008 into moldering grey slabs exhibited on the wall, drawing attention to the sheer material waste involved in making photographs. Most of Beshty's conceptual systems perform a remarkable double act: producing pleasing pictures at the same time as reflecting back on the way art is made and circulated through a global system – a set of concerns often referred to as institutional critique.[8] He is perhaps best known for large, energetic photograms made of C-type paper folded exposed to light from a color enlarger and run through the processor. Complete with roller marks and chemical drips, these cameraless abstractions reveal aspects of process concealed in regular photographic prints. Their long titles, such as *4 Sided Pull (Red/Green/Blue/Yellow), May 16th, 2007 Valencia, CA, Kodak Supra* (Fig. 6.1), provide documentation of the making of the work as a kind of process-based performance.

Beshty's procedures generate specific interpretations at the same time as they produce satisfying abstract forms. For the 2009 series *Passages*, Beshty traveled with rolls of unexposed photographic film knowing that they would be fogged and streaked by the rays from multiple airport x-ray machines (Fig. 6.2). One critic describes the resulting pictures as "thoroughly charming abstract fields of fading colour" at the same time as they document "the new systems of corporeal degradation exercised in airports since September 2001, which establish a state of exception as a civic norm."[9] Topical and timely, the project also point back to Beshty's activity as a global artist – his international circuit of exhibitions, art fairs and speaking engagements. Beshty underlined this self-consciousness of movement in a 2009 installation of the work by covering the floor of the gallery with wall-to-wall mirror that cracked under the viewer's feet, tracing their own circulation around the space.

From this description, it is clear that Beshty is not much of a "photographer." Some of his works involve images made with a camera (his ongoing project "American Passages" uses black-and-white slides to document the decline of American shopping malls), but his overall project has a very ambivalent relationship to photography. This is exactly the kind of work that might be discussed in relation to the notion of art's post-medium condition.

*Figure 6.1* Walead Beshty, *4 Sided Pull (RGBY), May 16th, 2007 Valencia, CA, Kodak Supra* (2008).

*Figure 6.2* Walead Beshty, installation view, *Passages* (2009), LAXART, Los Angeles.

## Medium/post-medium

One of the leading exponents of medium-specific art, mid-twentieth-century critic Clement Greenberg believed that art forms should evolve towards an emphasis on their own essential aspects. Thus, for Greenberg, it was desirable that painting, for example, should move away from representing realist narratives (which he saw as the proper activity of literature) and move instead towards abstractions that would focus on paint's innate flatness and optical properties.[10] Leading modernist photography curator and critic John Szarkowski made one of the most ambitious attempts to trace a formalist aesthetics for photography, based on properties such as the detail, the frame and vantage point.[11] One of the reasons why photography struggled as an art form during this period was that its essence as a medium is so hard to pin down – a fact that contributed to its prevalence within the more eclectic paradigm of postmodernism.

Some art historians describe the unfolding of art since the 1960s as a general move away from this kind of medium-specific approach towards forms that are more literal, eclectic and idea-based. This shift has been reflected in the curriculum of art schools, many of which have dropped the separation between traditional mediums, encouraging instead a "post-studio" approach in which art objects and events may take virtually any form and are just as likely to

be appropriated or fabricated as crafted by the artist. In this environment, terms such as "painting," "sculpture" or "photography" are only invoked with due sensitivity to the fact that they have been expanded, unraveled and redefined.[12]

Some writers continue to advocate attention to the residue of traditional artistic disciplines. In one of the most influential accounts of art's post-medium condition, art historian Rosalind Krauss argues that the best contemporary work retains a "differential specificity," that is, a recognition and rearticulation of the outmoded forms that it contains.[13] Many artists may leave the specific concerns of medium behind to pursue other interests, but those artists we would characterize as engaging with art's post-medium condition are those with the most intense, self-conscious relationship to medium. To look at this another way, we might notice that the terms postmodern, post-feminist and post-traumatic all imply a deep persistence of the original term, a fraught relation of overlap as well as distance. Similarly, artists invested in art's post-medium condition tend not to dispense with medium altogether. In practice, the term refers to works that explore specific aspects of pre-existing art forms either alone or in combination. We could read Beshty's overarching project in this way. From photography he chooses to examine the indexical trace and the effects of light and chemistry on paper. From painting, he pursues the dynamics of the large abstract picture on the wall.[14] From minimalist sculpture, he draws an awareness of the viewer's relationship to the work in space. His exploration is grounded in his highly self-conscious use of form, mediated by his engagement with the challenges to the work of art and its context posed by 1960s conceptualism. He makes use of familiar aspects of form specifically in order to problematize them. His work bristles with awareness of the ways specific forms have been mobilized in an art context.

Although Beshty pushes the edges of photography – and not all his works involve photographic materials or techniques – audiences frequently encounter his work in a photographic context, as in exhibitions such as "New Photography 2009," at New York's Museum of Modern Art or "Photographic Objects" at the Photographer's Gallery in London. This institutional framing positions Beshty's work – as this chapter has done – at the cusp of photography and contemporary art more broadly, a fruitful placement that contributes to the work's intellectual and critical bite in relation to traditional photography, painting and sculpture.

We might describe Beshty as a conceptual anti-photographer. Rachel Harrison, in contrast, is a non-photographer, who uses photographic images in a much more casual way. Harrison's playful art is usually discussed in relation to sculpture (in the updated terms discussed above).[15] Since the mid-1990s, her installations have combined all manner of scraps from consumer culture with artist-made shapes including vertical forms that can be seen as part-figure and part-plinth. Her favoured materials are humble: chicken wire, wood, polystyrene, cement and spray paint. Awash with visual and verbal references, the contents of each installation compete for the viewer's attention. The chaotic, campy work is also

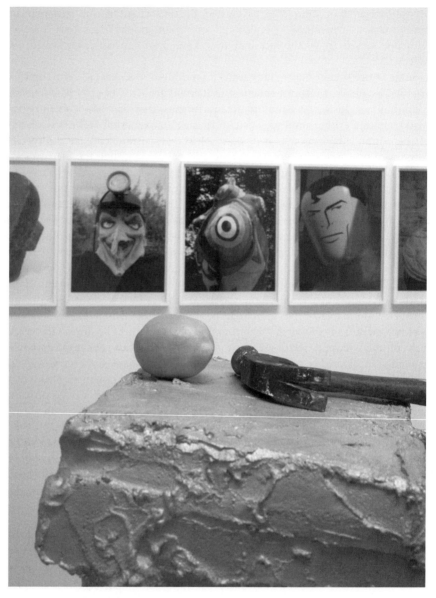

*Figure 6.3* Rachel Harrison, detail of *Hammer and Lemon,* installed in front of the
photographic series "The Voyage of the Beagle," Le Consortium, Dijon (2008).

very astute about the way that objects and images carry meaning for us.
Photographic images – usually pages torn from magazines – have appeared in
many of her works, often bearing the iconic likeness of movie or pop stars.

When a solo installation featured a frieze of fifty-seven photographs entitled
*Voyage of the Beagle* (2007) (Fig. 6.3), part of the information that circulated

around the work was the fact that the artist had undertaken a photographic "expedition," carrying an inexpensive digital camera around with her for a year, to produce a piece from the imagery she captured. Arranged into a careful sequence of visual resonances and puns, the digital prints in plain white frames offer a suite of variations on idea of the face. Installation is notoriously difficult to document, and the exhibition view of the piece *Hammer and Lemon* (2008) in front of five images from the frieze can give only the most schematic sense of the way Harrison's elements bounce off each other. It may help to know that the shape under the hammer and lemon is a lurid shade of artificial strawberry pink and that the bright yellow of the lemon is picked up in several of the photographs on the wall.

Harrison would not characterize herself as a photographer, and signals as much with her use of a low-tech camera. Is there anything particularly photographic in her work? In *Voyage of the Beagle* she takes advantage of the thing we rely on snapshot photography to do most often: to turn faces into pictures. Her playful twist on this gesture is to stretch the genre of portrait to its limits, including mannequins, taxidermied animals, a Hindu god, topiary, folk art sculptures and a tribal mask. Harrison cheerfully conflates references to popular culture and avant-garde art rather than investing in the history of fine art photography (or sculpture). Like a surrealist, she takes advantage of the camera's ability to grab a piece of the world and make it into a weird fragment. Like a pop artist, she enjoys the ways photographs can import kitsch content directly into her work. Like a conceptualist, she exploits the way photographs can provide a visual document of a self-imposed system. Her rejection of the traditional aspects of photography as art medium allows her to access its other associations and interpretive possibilities within art.

Unlike Beshty's, Harrison's work does not appear in photographic contexts. She is framed as a sculptor who uses images, rather than as a photographer moving into three dimensions. Sharon Lockhart also works across different mediums, in her case moving fluidly between photography and film, a dynamic she has sustained since the mid-1990s. Lockhart's work usually takes the form of installations in which a combination of projected film and still images allows a set of ideas to unfold over time. This makes it difficult to experience the work if you cannot attend the actual exhibitions and gives the first-hand experience of the work a privileged status that is rare in the age of mass reproduction. Lockhart's projects are disseminated through film stills, reproductions of the photographs, monographic books and art criticism. Writers do their best to convey the experience of her work in language, but the intriguing content and dramatic imagery resist easy summary. For example, a recent work, "Sharon Lockhart | Noa Eshkol," is a multi-part installation in which Lockhart responds to the work of Israeli choreographer and artist Noa Eshkol (1924–2007). Eshkol is known not only for her dance pieces and for striking modernist wall carpets but also for being half of the team that developed the Eshkol–Wachman Movement Notation (EWMN) system, which uses symbols and numbers to record choreographed movements so that they may be preserved and recreated.

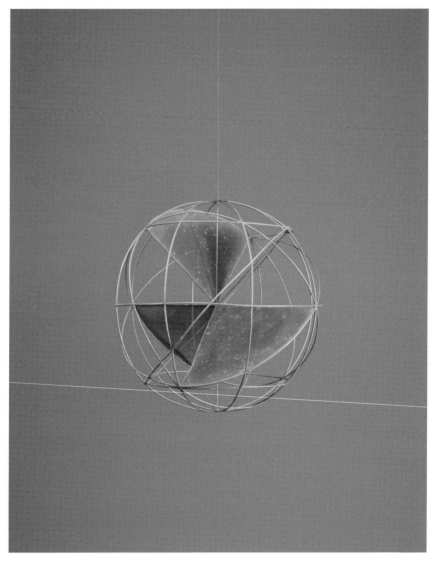

*Figure 6.4* Sharon Lockhart, *Models of Orbits in the System of Reference, Eshkol–Wachman Movement Notation System* (one of four C-prints) (2011).

Lockhart's exhibition, which takes different forms in different venues, incorporates these contributions in a number of ways. A photographic study, *Models of Orbits in the System of Reference, Eshkol–Wachman Movement Notation System: Sphere Two at Four Points in Its Rotation* (2011) (Fig. 6.4) offers multiple perspectives on wire-and-mesh models devised by Eshkol and Wachman to describe the relationships of moving limbs to a joint. Lockhart's five-screen film

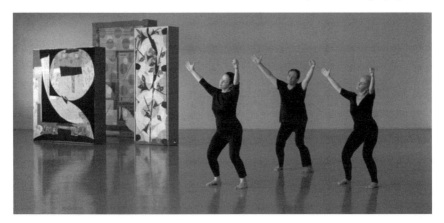

*Figure 6.5* Sharon Lockhart, *Five Dances and Nine Wall Carpets by Noa Eshkol* (2011), still from 5-channel film installation.

piece *Five Dances and Nine Wall Carpets by Noa Eshkol* (2011) (Fig. 6.5) shows dancers from Eshkol's original company performing her dances against a backdrop of her carpets. Each of the five dance pieces is performed to the beat of a different metronome. Screened all at once, the larger five-screen work produces a new rhythmic composition. Installed in combination with Eshkol's drawings, scores and carpets, Lockhart's pieces offer a multi-part reframing of Eshkol's remarkable artistic career.

The story of modernism favored by a critic such as Greenberg is one of art's constant refinement and purification. By giving Noa Eshkol greater international visibility, Lockhart emphasizes a different side of modernism, the desire to work synthetically across mediums and to create decorative as well as fine art. Celebrating Eshkol's eclectic, searching, boundary-defying creativity, Lockhart locates a precedent for her own cross-disciplinary practice. At the same time, "Sharon Lockhart | Noa Eshkol" is invested in the specific aspects of the mediums of film and photography while also engaging with choreography and textiles.

## Transmediality

Over the past few years, cultural critics have developed the term "transmediality" to refer to content being transferred, transmitted or shared across a range of media. Examples from commercial culture might include franchises like *The Matrix* or *Harry Potter*, in which books, movies, computer games, etc., all contribute to a total work that cannot be fully understood without experiencing all the parts.[16] This kind of dispersed, multi-part, multi-medium structure has begun to appear in contemporary art. Consider Matthew Barney, whose *Cremaster* series spread fantastical narrative content across five feature-length films, framed photographic stills, drawings, gallery installations of sculptural props, a retrospective exhibition at New York's Guggenheim

Museum, an encyclopedic catalogue and a website.[17] Lockhart's practice is transmedial in that each of the elements of an exhibition contributes to a larger work. As with Barney, photographs and film stills allow the work to be known about – if not experienced fully – by a broader audience. However, the transmedia model, with its commercial implications, does not fit Lockhart's practice in the same way that it does Barney's.[18] Her individual elements are discrete and focused rather than pointing to some broader imaginary universe, and she has worked in an extended manner with the dual mediums of photography and film, using them to contain any other form (such as dance) that attracts her.

In this work, photography is one medium used among others. Rather than rejecting the notion of medium, however, Lockhart uses two mediums to illuminate each other. In most of her projects she uses photography and film dialectically to create works of art with a complex, open structure. The viewer is invited into a layered, exploratory experience of the work that parallels the artist's original process of research.

The theme of research in lived, artistic form also runs through the work of Clifford Owens. Performance, rather than photography, lies at the center of his work. Yet photographs – as well as video and sound – allow him to sharpen the impact of his performative work, bringing key issues into permanent form. In his ongoing project *Photographs with an Audience*, which he has performed in several American cities since 2008, Owens gathers an invited crowd in a small, neutral room. He asks participants to come forward to be photographed in response to personal questions such as "Have you lost anyone to HIV/AIDS?" "Have you ever been in love with a black man?" "Do you trust me?"[19] The questions are keyed to the political and social tensions of each location. For example, participants in Houston, Texas, were asked whether they had voted for George Bush and whether any of them were immigrants or day laborers (Fig. 6.6). Bottles of champagne contribute to the participatory atmosphere.

The performance art of the 1960s and 1970s was often documented with amateurish black-and-white photographs, images which were intended to record the event without claiming aesthetic importance in their own right. Their value lay in the trace they carried of the performer's body and the original moment of artistic action.[20] As its title suggests, *Photographs with an Audience* alters this dynamic. The artist is present in many of the photographs, but the event has been set up as a pretext for the making of photographs, with audience participation as an explicit goal. The set-up ensures that the pictures are dramatic, with performers lined up in the center of a stage. While the audience in the foreground spill out of the edges of the frame, these well-lit performance documents have some of the self-conscious theatricality and visual fullness of *tableaux*. Owens is the most prominent figure in the images in which he appears, his role as instigator underlined by his physical relationship to participants who spit champagne in his face, stand on him, strangle him (Fig. 6.7).

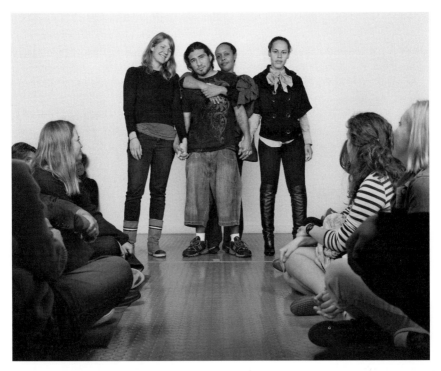

*Figure 6.6* Clifford Owens, *Photographs with an Audience (Houston), Immigrants and Day Laborers* (detail) (2011).

A generation of African-American artists, including Carrie Mae Weems, Lorna Simpson and Lyle Ashton Harris, have explored photography's power to explore the politics of identity and representation. Owens updates this project with a loosening of the frame of the photograph to include participation and its unpredictable outcomes. Although video makes it possible to document the full time-span of a performance, in this instance Owens chooses to use still photographs and their distillation of content into iconic visual form. The photographs have a striking presence yet remain contingent on the interactive performance that produced them and the anecdotal and critical writing that conveys their backstory. Thus this work participates in a push and pull between document and event, relying on the photograph's ability simultaneously to embody presence and to indicate absence.

Owens very self-consciously places his work within the frame of the museum; an important part of his project has been to raise the visibility of African-American performance artists within the canon of art history and criticism.[21] In contrast, JR generally works without permission, outside the confines of art institutions. Despite international recognition, the French artist has managed to remain semi-anonymous, withholding his full name and wearing sunglasses at public appearances. Coming out of the street-art scene, he developed the

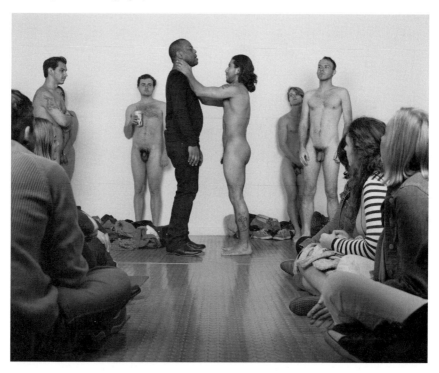

*Figure 6.7* Clifford Owens, *Photographs with an Audience (Houston), Hold no. 1 and Hold no. 2* (detail) (2011).

persona of JR in part to protect himself from legal prosecution. His work has primarily taken the form of street portraits photocopied onto paper posters, first flyposted around Paris as graffiti and later appearing around the world in a series of ambitious public projects. Although he is represented by art galleries in Paris and London and has produced mural commissions for major museums such as Tate, JR's credibility comes from work that he has produced independently.[22]

For the ongoing project *Women Are Heroes*, he has visited different communities around the world, responding to local situations and conditions by inserting large images of local women's faces into public spaces. JR's project responds to the fact that women are especially likely to be overlooked in locations experiencing economic and social hardship. Bringing women's faces into public view, he forces them to be noticed by their own community. In a *favela* in Brazil, images of the mothers and grandmothers of murdered students appeared at and near the murder site, generating both local and national dialogue. Women's eyes appeared on giant vinyl sheets covering the rooftops of the Kibera slum in Kenya. As well as providing visibility to the least privileged members of a community, the Kibera project also provides shelter for those who continue to live under it. In the Kibera site, JR also placed the lower half

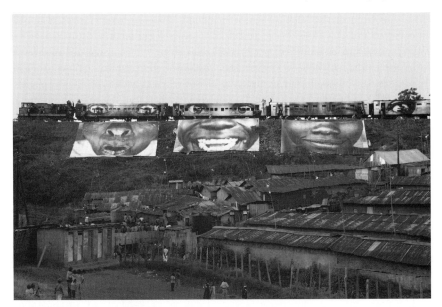

*Figure 6.8* JR, *Women Are Heroes*, Kibera, Kenya (2009).

of faces on a railway cutting and eyes on a local train so that faces were produced whenever the train passed through (Fig. 6.8). In India, JR discovered that it would be considered culturally inappropriate to post large images of local women on the street. He circumvented this taboo by silkscreening portraits onto walls using glue instead of ink. Dust kicked up by passing traffic gradually revealed the faces, by which time the artist was gone and could not be held to account.

JR's work operates on a number of different levels. For the people who agree to be photographed, and those who live alongside the resulting images, the projects produce an immediate set of social interactions. It could be described in relation to Nicolas Bourriaud's notion of "relational aesthetics," an art of participatory experiences for the audience rather than just images or objects.[23] At best, the work may produce dialogue and changed perspectives. At worst, it can be seen as exploiting its subjects, imposing the artist's intentions in contexts where they may or may not be appropriate. The work operates on the utopian assumption that photographic visibility is a positive force that leads to acceptance and understanding. There are cultural contexts where this assumption is not shared, where JR's images of women might be regarded as disrespectful and even offensive rather than as celebratory and empowering.

For those of us who encounter the work in reproduction, as photographic documents, it produces narratives about art taking place elsewhere. The bold, iconic character of JR's imagery makes it very direct for those encountering it in person but also contributes to the way the work is consumed from afar. JR's street works photograph beautifully and produce striking images for the Western

press. Embodying the idea of transmediality, *Women Are Heroes* has also appeared as a coffee-table book and as a feature documentary, screened at the 2010 Cannes film festival and on French television.[24] This range of manifestations brings the work to a far broader audience than typical gallery art and raises questions about how the meaning of the work shifts in different contexts. Is it possible to be anything other than a voyeur when looking at such an image from the more developed parts of the globe? JR is currently doing a major public project with a $100,000 grant from TED.[25] Anyone on the planet is invited to take an image, have it made into a poster and post it publicly where she or he thinks it might make a difference. Is this art? Do we need or want it to be art? What is art? Who is art for? While most of the works discussed in this chapter take a certain art context for granted, JR's activities reopen these debates in a way that happens most fruitfully when art appears outside its traditional institutions. Issues of political efficacy and cultural sensitivity raised by his work are familiar in the context of photojournalism but demand to be considered afresh in JR's unusual position at the cusp of museum art, street art and popular culture.

JR's work also raises the important question of what alternatives exist to the forms of art practice discussed in this book. Can pockets of resistance to commodification and institutionalization exist in self-published artists' books, photoblogs or other ephemeral manifestations?[26] Certainly they can; some forms of art take place outside of any institutional structures of funding and display, and on fringes that provide a vital counterpoint to mainstream practices. The field has been blown wide open, and the rapid globalization of art, with Western-style art schools, museums, auction houses, etc., opening all over the world will only increase the diversification of art activities, both inside and outside art's traditional contexts.

To art-world outsiders it might seem like anything goes in photography these days: take a snap on your phone, rip a page out of a magazine, take a screen grab from the Internet or dabble in Photoshop. As we have seen, the success of a contemporary photographer is a more complex matter, like three-dimensional chess. It relies not only on the work's form and subject matter but also on the language and concepts with which it is framed and the context in which it is presented. There are many possible routes to become a photographer, but in order to enter the contemporary conversation that dominates the market and institutions, most attend a small number of MA or MFA programmes and then progress from exhibiting at particular small galleries to particular big ones, via a series of art fairs and auctions.[27]

These factors play into the current trend for announcing the end of photography. As we saw in the introduction, the relationship of photography to contemporary art is hotly contested, with many important figures antagonistic towards the idea of a medium-specific discussion of photography as art. In 2010, the San Francisco Museum of Modern Art held a high-profile symposium with the ominous title "Is Photography Over?"[28] Several of the artists, curators, academics and critics argued that the very word "photography" becomes

meaningless at a moment of such rapid technological change and globalization. Several asserted that the term only retains usefulness for the institutions such as art schools, museums and galleries that rely on photography as a teachable, marketable form. Curator Charlotte Cotton articulated this starkly negative position: "It's about time for photography as a culturally institutionalized, ghettoized, and frankly, dull and acquiescent, photo-art-market serving 'discipline' to be over." Walead Beshty seconded this position, articulating the special interests that keep photography as a medium ticking over: "when medium specificity is staged from within academia or museums, it is really a question of paying the bills, of funding lines, departmental autonomy, curriculum, intellectual fiefdoms, library tabs, allotted real estate, and canons wrapped in the guise of a broad philosophical conundrum."

For these speakers, the question that serves as the title of this book would seem absurd, as the category of "art photography" represents a kind of special pleading for the most elitist and institution-bound photographic practices. Yet they cannot claim to be entirely independent of this context. Cotton was until recently the creative director of Britain's most important photography collection (and is the author of *The Photograph as Contemporary Art*), and Beshty is a teacher at a leading American art school. These figures work within institutional structures while attempting to sustain and pass on the cultural and political values in which they believe, day after day. Given that they both seem to maintain this struggle admirably, it is not clear why they are so gloomy about it. Built into Cotton and Beshty's statements is a resistance to institutional power, a desire to see cultural practices that are independent, hard to pin down, that originate from below as well as above and that have direct relevance for people's everyday lives. These are the utopian values of the historical avant-garde, and they are just as worthy, attractive – and elusive – as they were 100 years ago. This does not mean we are ready to give up on them entirely but rather that we need to consider them anew. Many of the artists discussed in this chapter, as well as in the book as a whole, share these aspirations.

One of the reasons I wrote this book was to provide answers for photography students who regard themselves as artists. Again and again I have encountered the same questions: "If contemporary photography is so eclectic, why can't I do what I like?" "Why does it seem like my teachers want me to repress my creativity and to feel so guilty about visual pleasure?" "Why can't I work the way photographers did in the past?" "Why is my work required to have a critical rationale?" The answers to these questions are sometimes difficult to locate. Many of the classic texts of photographic theory have become practically impenetrable to students who have not been shaped intellectually by the 1960s, 1970s or even 1980s. My own approach to photography is deeply grounded in the writing of photography theorists such as Victor Burgin, Allan Sekula, Abigail Solomon-Godeau and John Tagg. Their model of rigor, complexity and politically engaged critical analysis still has much to offer photography students. However, these texts can also represent aspects of prohibition and repression.[29] Perhaps most bewildering to contemporary students is the

antagonism of some of these figures towards the very notion of photography as a branch of contemporary art practice (rather than as a form of cultural production with multivalent applications, documentary foremost among them). Many universities still institutionalize this view, placing photography in media rather than art departments.

This book is intended to redress the balance somewhat, by making some of the arguments in favour of photography as an art form. As I hope I have made clear, I do not wish to displace the classic works of photographic theory but to build upon them, providing photographers and viewers with further tools they can use to understand and enjoy images creatively. The book articulates some of the key transformations that have taken place over the past twenty years in art as well as photography. As well as technological developments, there have been changes to the way in which works circulate and are received. As discussed in the previous chapter, a number of writers are reconsidering the role of the political in art. In providing an introduction to the state of the current field of art photography, I hope to have described artworks and theories that generate new permission and new possibilities.

The starting point of this book was the gap between the subject matter of contemporary photographs and the ideas that underpin them. Photography is generally taken as the representational medium par excellence, the medium best suited to show us the world and (usually via the inclusion of text) to tell us what it means. Postmodern theory rewrote this script to present photography as the medium best suited to show us the crisis in representation and to tell us what it means. Over the past few years, a key shift has been taking place in which many philosophers and art theorists are moving away from the theory of art as representation – or even as crisis in representation – to focus on art's affect, i.e. what it does to us when we experience it with our own bodies. This affect may be described in language but is not reducible to language and is essentially different from language. It involves a suspension of our normal perception, a shift into an alternate mode that allows us, if only momentarily, to reconsider ourselves and our relationship to the world.[30] Indeed, a good deal of the ambiguity, contradiction and refusal of clear interpretation in contemporary art could be thought of profitably in these terms. It is not that these works set out to "make sense" in a traditional way and fail to do so; rather, they invite a kind of viewing experience that is more open and undirected, at least for the viewer who is informed enough to accept the invitation to experience the work rather than to turn away bewildered. This theory turns traditional approaches and attitudes to art upside down, raising all sorts of difficult questions about what might happen to value and meaning and to the traditional roles of artist, critic and educator. I am not alone in arguing that it is high time for these orthodoxies to be challenged and that the resulting upheaval may be cause for celebration rather than anxiety.

British art historian Sarah James has described a deep pessimism about the role of art as a particularly Anglo-American state of affairs, in which critics and art historians – especially on the left of the political spectrum – assume that the

aesthetic has lost its validity as an arena for exploring serious social, political, ethical or cognitive issues.[31] James has pointed out that not all cultures have the same degree of anti-aesthetic sentiment and that many contemporary philosophers are making a spirited defense of the aesthetic domain.[32] The various chapters of this book confirm James's conviction that photography has more to offer than ever as an aesthetic form.

David Campany, author of books including *Art and Photography*, is far more sanguine about photography's potential as a medium. In a 2011 interview with Adam Broomberg and Oliver Charanin, he made bold, sweeping claims for photography's usefulness and value:

> it's interesting that historically photography has always emerged as the crucial medium in discussions not just about reproduction and originality, but also about authorship, anonymity, authenticity, agency, the status of the document, quotation, appropriation, value, democracy, dissemination and so forth. It's the medium that prompted art to rethink what's at stake in those concepts, but has also proved to be the medium best placed to articulate and express them too.[33]

More recently, Campany has argued that it may be time for artists and photographers to seek paths around what he calls the "Art Obstacle," perhaps by allowing works to drift back and forth across the borders of art and commercial practice and by leaking out of its expected art-world containers. For example, Campany admires Jason Evans's blog "thedailynice" for its "fluid, exploratory and less tormented attitude to image making."[34] Further examples of this potentially productive breakdown between art and non-art contexts can be found in the work of artists such as JR and Jon Rafman, discussed in the previous chapter.

Photography has never been one medium, but many. Over the course of this book we have seen the photographic defined in various ways. For the modernists we looked back to, it was a matter of essence: the quintessentially photographic lay variously in the physical traces of light (László Moholy-Nagy), in the decisive moment (Henri Cartier-Bresson), in the subordination of technique to individual vision (Edward Weston). For avant-garde Russian photographers, photography's nature was to make things strange. For Marcel Duchamp, photography's key characteristic was automatism – its capacity to be mindlessly mechanical. The conceptual artists of the 1960s and 1970s sought out a particular mode of photography – the snapshot – because they regarded it as anti-aesthetic. Then there are theorists who have said that to be photographic is to erode aura (Walter Benjamin), to carry narrative (Clement Greenberg), to exhibit *this-has-been-ness* (Roland Barthes) or to accrue undigested detail (Alain Robbe-Grillet). These, and many other definitions of the photographic, can provide jumping-off points for contemporary photographers. Despite the emphasis of mid-twentieth-century formalist art criticism, a medium-based approach does not have to focus exclusively on visual form. The activities of

photographers in the contemporary era have shown us that the photographic can also refer to the medium's mechanics, its physiological, psychological or sociological effects, and its relationship to the visual world or to lived experience. The argument here is not that the photographic can be *anything* but rather that it points to a broad range of possibilities that can be referred to with specificity and precision by artists who choose to do so.

Do we still need art photography? While contemporary art practices are more eclectic than ever before, they have not dissolved into one undifferentiated mass. We continue to acknowledge certain affinities for reasons of tradition and taste as well as logical divisions based on technique, presentation and context. Contemporary artists are free to select the appropriate materials for the work at hand, deciding in the moment whether or not to engage with the historical baggage that the chosen form may carry. In this chapter, we have explored the edges of art photography: work that overlaps with other mediums and that engages with more abstract notions of the photographic. We have looked briefly at some of the ways in which photography may be made and seen outside of mainstream channels. As the practices discussed in the previous chapters demonstrate, there are still plenty of artists choosing to work with photography who make explicit, direct reference to the photographic medium: its historical techniques, themes and debates. The works in this chapter demonstrate that contemporary artists using photography are not limited to making pictures for the wall. Their activities and concerns are central to the broader field of contemporary art and, indeed, contribute to its ongoing transformation.

## Notes

1 For a useful summary of the pictorial paradigm and its influences, see David Bate, "Art Photography," in *Photography: The Key Concepts* (New York and Oxford: Berg, 2009), pp. 127–45. For the major treatise on this mode see Michael Fried, *Why Photography Matters as Art as Never Before* (London and New Haven, CT: Yale University Press, 2008).

2 Some of the practices discussed in other chapters fit comfortably into this discussion of expanded photography, for example the work of Zoe Crosher, Collier Schorr, Broomberg and Chanarin or Walid Raad. Most of the practices in the previous chapter could be read as extending the domain of art photography into an engagement with digital media.

3 Geoffrey Batchen, *Photography's Objects* (Albuquerque, NM: University of New Mexico Museum, 1997), p. 2.

4 Elizabeth Edwards and Janice Hart (eds.), *Photographies, Objects, Histories* (London: Routledge, 2004).

5 George Baker, "Photography's Expanded Field," *October*, 114 (autumn 2005): 120–40, at p. 138.

6 Baker, "Photography's Expanded Field," p. 138.

7 For example, Walead Beshty, "Neo-avantgarde and the Service Industry: Notes on the Brave New World of Relational Aesthetics," *Texte zur Kunst*, 59 (September 2005). Available online at http://www.textezurkunst.de/59/neo-avantgarde-and-service-industry (accessed 24 September 2012).

8 There is a certain irony in the fact that works of institutional critique are popular both with art institutions and buyers. Many key texts of institutional critique in art

are gathered in Alexander Alberro and Blake Stimson (eds.), *Institutional Critique: An Anthology of Artists' Writings* (Cambridge, MA: MIT Press, 2009).

9 Sarah-Neel Smith, "Walead Beshty," *Frieze (online review)*, 2 April 2009, available online at http://www.frieze.com/review/walead_beshty (accessed 24 September 2012).

10 For a concise account of the role of medium in Greenbergian modernism, see Hal Foster, Rosalind Krauss, Yve-Alain Bois, Benjamin H.D. Buchloh, *Art Since 1900: Modernism, Antimodernism, Postmodernism* (London: Thames & Hudson, 2004), pp. 439–44.

11 John Szarkowski, *The Photographer's Eye* (New York: The Museum of Modern Art, 1966).

12 For a valuable account of sculpture's transformation in these terms, see Alex Potts, *The Sculptural Imagination: Figurative, Modernist, Minimalist* (New Haven, CT: Yale University Press, 2000).

13 Rosalind Krauss, *"A Voyage on the North Sea": Art in the Age of the Post-Medium Condition* (London: Thames & Hudson, 2000), p. 56.

14 Beshty's photograms could be read in relation to work by artists such as Lucas Blalock, Sam Falls and Liz Deschenes, who also investigate the materiality of their photographic works to produce painterly presence. For a discussion of this recent tendency, see Chris Wiley, "Depth of Focus," *Frieze*, 143 (November–December 2011): 84–9; and Rebecca Robertson, "Building Pictures," *Artnews* (March 2011): 76–83.

15 For a discussion of Harrison's work in sculptural terms, see Catherine Wood, "The Stuff: Rachel Harrison's Sculpture," *Afterall*, 11 (spring–summer 2005), available online at http://www.afterall.org/journal/issue.11/stuff.rachel.harrisons.sculpture (accessed 24 September 2012).

16 One of the key figures in the evolving discussion of transmediality is American academic Henry Jenkins, author of *Convergence Culture: Where Old and New Media Collide* (New York: New York University Press, 2006).

17 Nancy Spector (ed.), *Matthew Barney: The Cremaster Cycle* (New York: Guggenheim Museum, 2002). See also http://www.cremaster.net (accessed 27 September 2012).

18 Critic Michael Kimmelman, who is generally a great supporter of Barney's imaginative work, has described the photographs, sculptures and drawings belonging to the Cremaster cycle as "souvenirs," underlining their role as commercial by-products of the project. See http://www.nytimes.com/2003/02/21/arts/art-review-free-to-play-and-be-gooey.html?pagewanted=all&src=pm (accessed 24 September 2012).

19 Amalle Dublon, "Clifford Owens: Context," *African American Performance Art Archive*, December 2009. See http://www.aapaa.org/artists/Clifford-owens/about-clifford-owens (accessed 24 September 2012).

20 Mary Kelly provides an influential account of the role of the photographic performance document in relation to modernist aesthetics in her essay "Re-viewing Modernist Criticism," in Brian Wallis (ed.), *Art After Modernism: Rethinking Representation* (New York: New Museum of Contemporary Art, 1984), pp. 87–103.

21 Owens' 2012 New York exhibition "Clifford Owens: Anthology" at the Museum of Modern Art's PS1 site involved the artist enacting performance scores that he had solicited from twenty-six African-American artists. See http://momaps1.org/exhibitions/view/340 (accessed 24 September 2012).

22 JR's London gallery, Lazarides, specializes in street art, presenting such work is highly collectible as well as youthful, cool and accessible.

23 See Nicolas Bourriaud, *Relational Aesthetics* (Paris: Presses du Réel, 2002).

24 JR and Marco Berrebi, *Women Are Heroes* (New York: Harry N. Abrams, 2012); JR, Director, *Women Are Heroes*, 2010.

25 TED is a nonprofit organization devoted to "Ideas Worth Spreading" in technology, entertainment and design. See "JR's Ted Prize Wish: Use Art to Turn the World Inside Out," at http://www.ted.com/talks/jr_one_year_of_turning_the_world_inside_out.html (accessed 24 September 2012).

26 A brief roundup of such activities is provided in the second edition of Charlotte Cotton's *The Photograph as Contemporary Art* (London: Thames & Hudson, 2009).

27 For a study of the correlation between specific art schools, galleries and markets, see Rebecca Hopkinson, "So You Want to Be an Art Photographer?" *Source: The Photographic Review*, 66 (spring 2011): 22–5.

28 "Is Photography Over?" was a symposium held at San Francisco Museum of Modern Art in April 2010. The quotations in this section are drawn from videos and transcripts available at http://www.sfmoma.org/about/research_projects/research_projects_photography_over (accessed 24 September 2012).

29 The potentially paralyzing effects of the photographic theory of the 1980s and 1990s have been acknowledged even by key practitioners; see, for example, Victor Burgin's admission that his lectures routinely left photography students unable to make a picture. Victor Burgin, "'Messages for Western Union,' Interview with Naomi Salaman," in Naomi Salaman and Ronnie Simpson, eds., *Postcards on Photography: Photorealism and the Reproduction* (Cambridge: Cambridge Darkroom, 1998), pp. 91–9.

30 Simon O'Sullivan, "The Aesthetics of Affect: Thinking Art Beyond Representation," *Angelaki: Journal of the Theoretical Humanities*, 16 (3) (December 2001): 125–35.

31 Sarah James, "The Ethics of Aesthetics," *Art Monthly*, 284 (March 2005): 7–11. In this piece, James discusses philosophers, including Andrew Bowie, Isobel Armstrong and Jacques Rancière, who argue for the ongoing relevance of the aesthetic domain.

32 Sarah James, "What Can We Do with Photography?" *Art Monthly*, 312 (December 2007–January 2008): 1–4.

33 David Campany, "Adam Broomberg and Oliver Chanarin: When Is a Photograph Not Photography?" *Art Review*, 50 (May 2011): 80–83, at p. 83.

34 David Campany, "Out in the World," *Frieze*, 143 (November–December 2011): 96–100, at p. 100.

# Select Bibliography

Adams, Ansel. *The Print*. New York: Little, Brown, 1995.

Agamben, Giorgio. "The Face." In *Means without End: Notes on Politics*. Translated by Vincenzo Binetti and Cesare Casarino (pp. 91–100). Minneapolis, MN: University of Minnesota Press, 2000.

—— "What Is the Contemporary?" In *What Is an Apparatus? And Other Essays*. Translated by David Kishik and Stefan Pedatella (pp. 39–55). Palo Alto, CA: Stanford University Press, 2009.

Alberro, Alexander and Blake Stimson, eds. *Institutional Critique: An Anthology of Artists' Writings*. Cambridge, MA: MIT Press, 2009.

Austin, J. L. *How to Do Things with Words*. Cambridge, MA: Harvard University Press, 1962.

Azoulay, Ariella. *The Civil Contract of Photography*. Cambridge, MA: MIT Press, 2008.

Baker, George. "Photography's Expanded Field." *October*, 114 (autumn 2005): 120–40.

Batchen, Geoffrey. *Photography's Objects*. Albuquerque, NM: University of New Mexico Museum, 1997.

—— ed. *Photography Degree Zero: Reflections on Roland Barthes's* Camera Lucida. Cambridge, MA: MIT Press, 2009.

Barthes, Roland. *Image–Music–Text*. Translated by Stephen Heath. New York: Noonday Press, 1977.

—— *Camera Lucida*. Translated by Richard Howard. New York: Noonday Press, 1981.

Bate, David. "After Thought: Part 1." *Source*, 40 (autumn 2004): 30–3.

—— "After Thought: Part 2." *Source*, 41 (winter 2004): 35–9.

—— *Photography: The Key Concepts*. New York and Oxford: Berg, 2009.

Baudrillard, Jean. *Simulations*. Translated by Paul Foss, Paul Patton and Philip Beichman. Los Angeles, CA: Semiotext(e), 1983.

Baxendall, Michael. *Patterns of Intention: On the Historical Explanation of Pictures*. New Haven, CT: Yale University Press, 1985.

Benjamin, Walter. "The Work of Art in the Age of Mechanical Reproduction." In *Illuminations*. London: Fontana, 1979.

Bial, Henry, ed. *The Performance Studies Reader*. London and New York: Routledge, 2004.

Birrell, Ross. "Jacques Rancière and the (Re)distribution of the Sensible: Five Lessons in Artistic Research." *Art and Research*, 2 (1) (summer 2010): 1–11.

Bishop, Claire. *Participation*. London: Whitechapel Art Gallery, 2006.

Bolton, Richard, ed. *The Contest of Meaning: Critical Histories of Photography*. Cambridge, MA: MIT Press, 1993.

Bourdieu, Pierre. *Photography: A Middle-Brow Art.* Translated by Shaun Whiteside. Palo Alto, CA: Stanford University Press, 1990.

Bourriaud, Nicholas. *Postproduction: Culture as Screenplay – How Art Reprograms the World.* Translated by Jeanine Hermann. New York: Lukas & Sternberg, 2002.

—— *Relational Aesthetics.* Paris: Les Presses du Réel, 2002.

Bright, Susan. *Art Photography Now.* London: Thames & Hudson, 2006.

Brilliant, Richard. *Portraiture.* London: Reaktion Books, 1991.

Buchloh, Benjamin H. D. "Conceptual Art 1962–69: From the Aesthetic of Administration to the Critique of Institutions." *October,* 55 (winter 1990): 105–43.

—— "Portraits/Genre: Thomas Struth." In *Thomas Struth: Portraits* (pp. 150–7). Munich: Shirmer, 1990.

Bürger, Peter. *Theory of the Avant-garde.* Translated by Michael Stone. Minneapolis, MN: University of Minnesota Press, 1984.

Burgin, Victor, ed. *Thinking Photography.* London: Macmillan, 1982.

—— *The End of Art Theory: Criticism and Postmodernity.* London: Palgrave Macmillan, 1986.

Butler, Judith. *Gender Trouble: Feminism and the Subversion of Identity.* London and New York: Routledge, 1990.

Campany, David. *Art and Photography.* London: Phaidon, 2003.

Cartier-Bresson, Henri. *The Mind's Eye: Writings on Photography and Photographers.* New York: Aperture, 1999.

Chevrier, Jean-François. "The Tableau and the Document of Experience." *Click Double Click: The Documentary Factor.* Edited by Thomas Weski (pp. 51–61). Cologne: Walter Konig, 2006.

Coleman, A. D. *Depth of Field: Essays on Photography, Mass Media and Lens Culture.* Albuquerque, NM: University of New Mexico Press, 1998.

Cotton, Charlotte. *The Photograph as Contemporary Art,* 2nd edn. London: Thames & Hudson, 2009.

Crow, Thomas. *Painters and Public Life in Eighteenth-Century Paris.* New Haven, CT: Yale University Press, 1987.

—— *Modern Art in the Common Culture.* New Haven, CT: Yale University Press, 1996.

Curtis, James. *Mind's Eye, Mind's Truth: FSA Photography Reconsidered.* Philadelphia, PA: Temple University Press, 1991.

Debord, Guy. *The Society of the Spectacle.* Translated by Donald Nicholson-Smith. New York: Zone Books, 1994.

Demos, T. J., et al. *Vitamin Ph: New Perspectives in Photography.* London: Phaidon, 2006.

de Duve, Thierry. *Kant after Duchamp.* Cambridge, MA: MIT Press, 1998.

—— *Pictorial Nominalism: On Marcel Duchamp's Passage from Painting to the Readymade.* Minneapolis, MN: University of Minnesota Press, 2005.

Doy, Gen. *Picturing the Self: Changing Views of the Subject in Visual Culture.* London: I. B. Tauris, 2004.

Drucker, Johanna. *Sweet Dreams: Contemporary Art and Complicity.* Chicago, IL: University of Chicago Press, 2005.

—— "Making Space: Image Events in an Extreme State." In Francis Frascina (ed.), *Modern Art Culture: A Reader* (pp. 25–45). London and New York: Routledge, 2008.

Durden, Mark and Craig Richardson, eds. *Face On: Photography as Social Exchange.* London: Black Dog Press, 2000.

Edwards, Elizabeth and Janice Hart, eds. *Photographies, Objects, Histories*. London and New York: Routledge, 2004.

Edwards, Steve. *Photography: A Very Short Introduction*. Oxford: Oxford University Press, 2006.

Eisinger, Joel. *Trace and Transformation: American Criticism of Photography in the Modernist Period*. Albuquerque, NM: University of New Mexico Press, 1995.

Elkins, James, ed. *Photography Theory*. London and New York: Routledge, 2007.

Empson, William. *Seven Types of Ambiguity*. London: Pimlico, 2004.

Evans, David, ed. *Appropriation*. London: Whitechapel Art Gallery, 2009.

Fogle, Douglas, ed. *The Last Picture Show: Artists Using Photography, 1960–1982*. Minneapolis, MN: Walker Art Center, 2003.

Foster, Hal. *Recodings: Art, Spectacle and Cultural Politics*. Port Townsend, WA: Bay Press, 1985.

—— "Obscene, Abject, Traumatic." *October*, 78 (autumn 1996): 107–24.

—— *The Return of the Real*. Cambridge, MA: MIT Press, 1996.

—— "An Archival Impulse." *October*, 110 (autumn 2004): 3–22.

——"Post-Critical." *October*, 139 (winter 2012): 3–8.

Foster, Hal, Rosalind Krauss, Yve-Alain Bois and Benjamin H. D. Buchloh, *Art Since 1900: Modernism, Antimodernism, Postmodernism*. London: Thames & Hudson, 2004.

Foucault, Michel. "What Is an Author?" In *Language, Counter-Memory, Practice* (pp. 124–7). Translated by Donald F. Bouchard and Sherry Simon. Ithaca, NY: Cornell University Press, 1977.

Fowler, Alastair. *Kinds of Literature: An Introduction to the Theory of Genres and Modes*. Oxford: Oxford University Press, 1982.

Fried, Michael. *Why Photography Matters as Art as Never Before*. New Haven, CT: Yale University Press, 2008.

Godfrey, Mark. "Artist as Historian." *October*, 120 (spring 2007): 140–72.

Godfrey, Tony. *Conceptual Art*. London: Phaidon, 1998.

Goldie, Peter and Elisabeth Schellekens, *Who's Afraid of Conceptual Art?* London and New York: Routledge, 2009.

Grant, Catherine and Lori Waxman, eds. *Girls! Girls! Girls! in Contemporary Art*. Bristol: Intellect, 2011.

Green, David, ed. *Where Is the Photograph?* Brighton: Photoworks and Photoforum, 2003.

Greenberg, Clement. *The Collected Essays and Criticism: Modernism with a Vengeance, 1957–1969*. Edited by John O'Brian. Chicago, IL: University of Chicago Press, 1993.

Gronert, Stephan, ed. *The Düsseldorf School of Photography*. London: Thames & Hudson, 2009.

Groys, Boris. *Going Public*. Berlin: Sternberg Press, 2010.

Grundberg, Andy. *Crisis of the Real: Writings on Photography Since 1974*. New York: Aperture, 1999.

Guignon, Charles. *On Being Authentic*. London and New York: Routledge, 2004.

Hall, Stuart, David Held and Tony McGrew, eds. *Modernity and Its Futures*. Cambridge: Polity Press, 1992.

Heikkilä, Marta. *At the Limits of Presentation: Coming-into-Presence and its Aesthetic Relevance in Jean-Luc Nancy's Philosophy*. Frankfurt: Peter Lang, 2009.

Hirsch, Robert. *Seizing the Light: A Social History of Photography*, 2nd edn. New York: McGraw-Hill Higher Education, 2009.

Hopkinson, Rebecca. "So You Want to Be an Art Photographer?" *Source: The Photographic Review*, 66 (spring 2011): 22–5.

Hughes, Alex and Andrea Noble, eds. *Phototextualities: Intersections of Photography and Narrative*. Albuquerque, NM: University of New Mexico Press, 2003.

James, Christopher. *The Book of Alternative Processes*, 2nd edn. New York: Delmar, 2008.

James, Ian. *The New French Philosophy*. London: Polity, 2012.

James, Sarah. "The Ethics of Aesthetics." *Art Monthly*, 284 (March 2005): 7–11.

—— "What Can We Do with Photography?" *Art Monthly*, 312 (December 2007/January 2008): 1–4.

—— "Photography's Theoretical Blind Spots: Looking at the German Paradigm." *Photographies*, 2 (2) (September 2009): 255–70.

—— "Subject, Object, Mimesis: The Aesthetic World of the Bechers' Photography." *Art History*, 32 (5) (December 2009): 874–93.

Jenkins, Henry. *Convergence Culture: Where Old and New Media Collide*. New York: New York University Press, 2006.

Keen, Suzanne. *Narrative Form*. New York: Palgrave, 2003.

Kermode, Frank. *The Sense of an Ending: Studies in the Theory of Fiction*. Oxford: Oxford University Press, 1967.

Krauss, Rosalind. *The Originality of the Avant-Garde and Other Modernist Myths*. Cambridge, MA: MIT Press, 1986.

—— *"A Voyage on the North Sea": Art in the Age of the Post-Medium Condition*. London: Thames & Hudson, 2000.

Marien, Mary Warner. *Photography: A Cultural History*, 3rd edn. London: Laurence King, 2010.

Mitchell, William. *The Reconfigured Eye: Visual Truth in the Post-Photographic Era*. Cambridge, MA: MIT Press, 2001.

Mora, Gilles and John T. Hill. *Walker Evans: The Hungry Eye*. London and New York: Thames & Hudson, 1993.

Nancy, Jean-Luc. *The Sense of the World*. Translated by Jeffrey S. Librett. Minneapolis, MN: University of Minnesota Press, 1997.

Newhall, Beaumont. *The History of Photography: From 1839 to the Present*, 5th edn. New York: Museum of Modern Art, 1994.

Osborne, Peter. *Conceptual Art*. London: Phaidon, 2002.

O'Sullivan, Simon. "The Aesthetics of Affect: Thinking Art Beyond Representation." *Angelaki: Journal of the Theoretical Humanities*, 16 (3) (December 2001): 125–35.

Potts, Alex. *The Sculptural Imagination: Figurative, Modernist, Minimalist*. New Haven, CT: Yale University Press, 2000.

Rancière, Jacques. *The Emancipated Spectator*. London: Verso, 2009.

Robbe-Grillet, Alain. *For a New Novel: Essays on Fiction*. Translated by Richard Howard. Evanston, IL: Northwestern University Press, 1989.

Roberts, Russell. "A Matter of Fact: The Rhetoric of Documentary 'Style'." In Patrick Henry and Russell Roberts (eds.), *Fabula* (pp. 15–18). Bradford: National Museum of Photography, Film and Television, 2003.

Rosler, Martha. *Decoys and Disruptions: Selected Writings, 1975–2001*. Cambridge, MA: MIT Press, 2006.

Salaman, Naomi and Ronnie Simpson, eds. *Postcards on Photography: Photorealism and the Reproduction*. Cambridge: Cambridge Darkroom, 1998.

Salvesen, Britt and Robert Adams, eds. *New Topographics*. Göttingen: Steidl, with Center for Creative Photography and George Eastman House, 2009.

Scruton, Roger. *Modern Philosophy: An Introduction and Survey*. London: Penguin, 1994.

Shinkle, Eugenie. "Boredom, Repetition, Inertia: Contemporary Photography and the Aesthetics of the Banal." *Mosaic*, 37 (2004): 165–85.

Singerman, Howard. *Art Subjects: Making Artists in the American University*. Berkeley, CA: University of California Press, 1999.

Smith, Terry. "Contemporary Art and Contemporaneity." *Critical Inquiry*, 32 (summer 2006): 681–707.

Solomon-Godeau, Abigail. *Photography at the Dock: Essays on Photographic History, Institutions, and Practices*. Minneapolis, MN: University of Minnesota Press, 1991.

Sontag, Susan. *On Photography*. New York: Farrar, Straus & Giroux, 1979.

—— *Regarding the Pain of Others*. New York: Farrar, Straus and Giroux, 2002.

Stellabrass, Julian. "Museum Photography and Museum Prose." *New Left Review*, 65 (September–October 2010): 93–125.

Sterling, Susan Fisher, ed. *Role Models: Feminine Identity in Contemporary American Photography* (New York: Scala, 2008).

Steyerl, Hito. *The Wretched of the Screen*. Berlin: Sternberg Press, 2012.

Stimson, Blake. *The Pivot of the World: Photography and Its Nation*. Cambridge, MA: MIT Press, 2006.

Strauss, David Levi and John Berger. *Between the Eyes: Essays on Photography and Politics*. New York: Aperture, 2005.

Szarkowski, John. *The Photographer's Eye*. New York: The Museum of Modern Art, 1966.

Tagg, John. *The Burden of Representation: Essays on Photographies and Histories*. Minneapolis, MN: University of Minnesota Press, 1993.

—— *The Disciplined Frame: Photographic Truths and the Capture of Meaning*. Minneapolis, MN: University of Minnesota Press, 2009.

Taylor, Charles. *Philosophical Arguments*. Cambridge, MA: Harvard University Press, 1995.

Thornton, Sarah. *Seven Days in the Art World*. London: Granta, 2009.

Trachtenberg, Alan, ed. *Classic Essays on Photography*. Stony Creek, CT: Leete's Island Books, 1980.

Trilling, Lionel. *Sincerity and Authenticity: The Charles Eliot Norton Lectures, 1969–1970*. Cambridge, MA: Harvard University Press, 1972.

Van Gelder, Hilde and Helen Westgeest, eds. *Photography Between Art and Politics: The Critical Position of the Photographic Medium in Contemporary Art*. Leuven: Leuven University Press, 2008.

Von Amelunxen, Hubertus, Stefan Iglhaut and Florian Rötzer, eds. *Photography After Photography: Memory and Representation in the Digital Age*. Amsterdam: G&B Arts, 1996.

Wakefield, Neville. "Second-Hand Daylight: An Aesthetics of Disappointment." In Elizabeth Janus (ed.), *Veronica's Revenge: Contemporary Perspectives on Photography* (pp. 239–46). London: Scalo, 1998.

Wall, Jeff. "Marks of Indifference: Aspects of Photography in, or as, Conceptual Art." In Ann Goldstein and Anne Rorimer (eds.), *Reconsidering the Object of Art, 1965–1975* (pp. 247–67). Los Angeles, CA: Museum of Contemporary Art, 1995.

Wallis, Brian, ed. *Art After Modernism: Rethinking Representation*. New York: New Museum of Contemporary Art, 1984.

Wells, Liz, ed. *Photography: A Critical Introduction*, 4th edn. London and New York: Routledge, 2009.

Wolf, Sylvia. *The Digital Eye: Photographic Art in the Electronic Age*. London: Prestel, 2010.

Wolff, Janet. *The Social Production of Art*. New York: New York University Press, 1981.

Wright, Elizabeth, ed. *Feminism and Psychoanalysis: A Critical Dictionary*. Oxford: Blackwell, 1992.

# Index

Please note that page numbers relating to Notes will have the letter 'n' following the page number. References to figures or photographs will be in *italics*.